852
32-

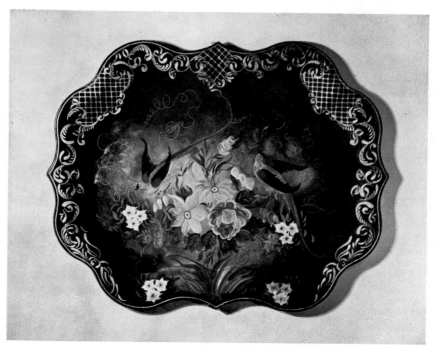

A Chippendale tray with a "smudged" background of bronzing powders; gold-leaf, scroll-type border; and hand-painted floated central unit. (*Courtesy of American Home Magazine*)

The Art of
TRAY PAINTING

MARIA D. MURRAY

BRAMHALL HOUSE · New York

Photographs by Jack Pomeroy, except
where otherwise credited.
Drawings by the Author.

This edition published by Bramhall House, a division
of Crown Publishers, Inc., by arrangement with
The Viking Press, Inc.

(A)

DEDICATED TO THE MEMORY OF
MY DEAR FRIEND AND TEACHER
HELEN CONE McCARTHY
of Bronxville, New York

Preface

Man's natural yearning for beauty has always set him apart from all other living matter. The story of his accomplishments carries with it romance and poetry, but above all, it is his religious faith which leads him to have confidence in himself and his accomplishments, and in his fellow men. The arts, today, are more meaningful, in the daily life of the individual, than they have been since before the turn of the century. They have become essential for many. Art is international in scope. We may draw inspiration from all parts of the world and from all periods and times in history.

Material advantages, gained by our industrial age, could give us greater leisure for study and research, resulting in a very nearly complete artistic awakening. The present is, perhaps, just entering upon the threshold of a new era. The peaceful periods in history have been those during which people hungered for intellectual, artistic, and spiritual achievement. Their ideas were transformed into realities which perpetuated civilization. The arts can contribute abundantly to the enrichment of the spirit and to contentment of mind. Superficial interests must, however, give way to a broadening appreciation of the beauties which surround us and to the will to create perfection in all things.

Science continually produces new substances. There is a great need, today, for thorough and practical research by two joint forces—the mind and abilities of the chemist and the technical skill of the artist, who is constantly searching permanence for his works of art. In the late seventeenth and throughout the eighteenth and nineteenth centuries, these two forces worked together and left us a great heritage. The magnitude of the scientific findings of those times was impressive. The inventions were handled by a few students and artists who worked together in small guilds. Often each artist was his own chemist. Many of the discoveries died with their inventors for, more is the pity, some did not pass on their formulas to future generations.

Because of the large variety of supplies currently available, it is no longer

possible for individuals to combine forces on an experimental basis. The independent artist, because of his limited time, prefers to use the products which have proven successful in his previous work with them. The newer synthetics offer many inspiring possibilities. Firms which produce them should do the experimenting, and after thorough tests made by chemists and artists working together, they should be able to guarantee the practicality of their new products.

Today's great interest in the revival of past modes of decoration was given its first impetus by Esther Stevens Brazer. Her scholarly research, during recent times, has made it possible for many to acquire a first-hand knowledge of past techniques along with a vast amount of cultural information. Her tremendous intellect and extraordinary artistic skill, combined with her appreciation for antiques, were largely responsible for keeping these techniques alive. But for her many efforts the old-time methods would have been lost. Of even greater importance was Mrs. Brazer's influence on her pupils and their followers. These are zealously guarding and perpetuating the decorative masterpieces of the past. They generously share with others their observations as well as their technical and cultural information.

Art is constantly in a state of evolution. Each period attains greater stature through knowledge of the achievements and the creations of past decades. In writing this book it is my intention to help the reader by suggesting ways of developing many types of technical skills. The order in which these techniques are described is based upon their historical evolution. It is my hope that many may enjoy successful achievement, accompanied by a great measure of happiness and inward satisfaction.

MARIA D. MURRAY

Acknowledgments

I wish to acknowledge my thanks to certain members of the Esther Stevens Brazer Guild and the Historical Society of Early American Decoration, Inc.

Mrs. Gordon Scott, the first Chairman of Standards and her judging committees, for their many worthwhile suggestions for improving my work so that it would meet the high requirements they have set toward earning a Master Craftsmanship.

The following members, who have been my teachers:

Mrs. Vinton E. Ziegler who started me on the study of the decorative arts and who also introduced me to the guild.

Mrs. William McCarthy, to whom I dedicate this book, for her extraordinarily generous and painstaking interest during the many happy lessons she gave me, even after her health began to fail.

Mrs. Walter Burrows, whose generosity with patterns and with her decorative antiques helped me to clarify many phases of painting.

Mrs. George DeVoe for teaching me new skills with bronzing powders and paint and for generously sharing with me her experiences in research.

Mrs. Max Muller for lessons at "Innerwick," which houses Esther Stevens Brazer's treasures, and of which Mrs. Muller is the Curator, and at her own home where her exquisite antiques and her own works of art evoke such inspiration.

Many others helped to give me confidence and taught me to view new methods of painting in a more purposeful way. Among them are:

Mrs. Carroll Drury and her committees whose exhibits at our Guild meetings have always been so well-planned and so very instructive.

Mrs. S. Burton Heath for the confidence she showed in me by requesting an article on Oriental Lacquer for the *Decorator* of which she was editor.

Mrs. Andrew M. Underhill who taught my friend and teacher, Helen Cone McCarthy, and indirectly greatly influenced me.

Mrs. Herbert Coggins at whose home I was privileged to meet with the organizers of our Present Fairchester Chapter.

Through Departmental Chairmanship and as a member of several committees of the Woman's Club of New Rochelle, I first learned about this form of painting and began more thorough research when Miss Elizabeth Bryan, Editor of the *Club Candle,* requested an article on the decorative arts.

During my research for information on oriental lacquer work, I was privileged to study the Texts and Illustrative Panels of Steps in Lacquer Finishing, done by Mr. Kojiro Tomita, Curator of the Oriental Wing, Boston Museum of Fine Arts. I am deeply indebted to Mr. Everett P. Lesley, Jr., Chairman of the Exhibits Section at Cooper Union, for sending me a copy of Mr. Tomita's texts.

My sincere thanks go to the New Rochelle Public Library, whose Chief Librarian, Miss Josephine Edwards, and her assistant, Mrs. Griffith V. Little, offered me so many opportunities to exhibit my work. My appreciation and thanks are also extended to the Misses Louise Burdett and Jean Ross for aiding me, on so many occasions, by locating references and unusual material.

My thanks also to Mrs. Mary Lyon, Editor, and her assistant, Mrs. Margaret Todd, who offered me the first opportunity to write commercially for their magazine *Craft Horizons*. I also wish to thank them for permitting me to use pictures of my work which they had photographed. I am deeply indebted to them for other opportunities they sent my way. Among them this book, an article for *American Home* magazine and permission to reprint, by Special Services Division of the Adjutant General's Office, United States Army, the article I wrote for *Craft Horizons* which was distributed for instructional purposes to rehabilitation camps throughout the world.

My appreciation and thanks go to Mr. James Wylie, Executive Editor of *American Home* magazine, Miss Marion Mayer, Managing Editor, and Mrs. Dorothy Lambert Trumm, Editor of the Arts and Crafts Section, for consenting to the use of their color photographs of my trays and drawings, which illustrated my article for their magazine.

My thanks are extended to Miss Janet R. MacFarlane, Curator of Farmer's Museum, New York Historical Association, Cooperstown, New York, for a photograph which was specially taken for me of the Butler Bread Tray. The tray was recently donated to the Museum by Mrs. Theodore Whitbeck, a decendant of the Butlers of Greenville, New York.

I am most indebted to Mr. Carl Drepperd who, as a member of the Consulting Staff of the *Spinning Wheel* magazine and as the Consulting Director of the Pennsylvania Farm Museum of Landis Valley, Lancaster, Pennsylvania, so generously shared his knowledge in the field of Pennsylvania Dutch

Antiquities with me. I also extend my thanks to him for photographs of tinware and of wooden Lehn ware.

To Miss Alice Winchester, Editor of *Antiques* magazine and to her assistant, Mrs. Edith Gaines, I am indebted for the use of photographs of painted tinware which appeared in past issues of their magazine.

My warmest acknowledgments also go to Mr. and Mrs. Earl Robacker for their enthusiastic consent to the use of the photographs taken of the decorative Pennsylvania Dutch pieces which they own. The illustrated articles written by Mr. Robacker have appeared in *Antiques* magazine.

Also, my thanks to Mrs. Meryle Renie Evans, Supervisor of Public Relations of the New York Historical Society in New York City, for her generosity in the use of photographs taken of articles which are in the Exhibit of Early American Arts and Crafts in the New York Historical Society Building.

My sincere thanks and appreciation go to Mrs. Samuel C. Steinhardt for her encouragement, confidence and great faith in an ability I did not believe I possessed. Her valuable help in aiding me to prepare the Index and in proofreading my book, were of inestimable worth.

Last but not least, I acknowledge the great affection shown me by my two sisters, Mrs. Gertrude M. Parmly and Miss Anita Murray and their great interest in my new venture. I am especially grateful to my sister Anita, for typing the manuscript and for her helpful suggestions.

Contents

I	SURFACES, BACKGROUNDS, AND FINISHES	1
II	EQUIPMENT AND TOOLS: THEIR CARE	21
III	PLANNING THE DESIGN	34
IV	THE TECHNIQUE OF METAL-LEAF DECORATION	43
V	METALLIC POWDERS AND DRY BRONZING IN THE FREE-HAND MANNER	58
VI	THE STENCIL—ITS DECORATIVE INFLUENCE	74
VII	FREEHAND BRUSHWORK TECHNIQUES	96
VIII	PAINTED STYLES OF LAYMAN AND APPRENTICE IN AMERICA	110
IX	REVERSE DECORATION ON GLASS PANELS	132
X	DECORATIVE MODES OF HEIRLOOM PIECES	143
XI	TECHNIQUES OF MASTER CRAFTSMEN	150
XII	GOOD CRAFTSMANSHIP IN MODERN DESIGN	159
	APPENDIX	
	WHERE TO BUY ARTISTS' AND DECORATORS' SUPPLIES	164
	WHERE TO BUY TIN AND WOODEN ARTICLES TO DECORATE	165
	BIBLIOGRAPHY	166
	INDEX	169

"To live a really gorgeous human life
is like living on the threshold of a future
equally gorgeous spiritual life."
(Philosophy of the Era of Engi, A.D. 901–922)
from Fenollosa, *Epochs of Chinese and Japanese Art*

I. *Surfaces, Backgrounds, and Finishes*

PREPARING WOODEN SURFACES

Before any kind of decoration can be applied, or the groundwork done, the surfaces must be satiny smooth. This smoothness is attained by hand-rubbing with fine sandpaper (which is obtainable at all hardware stores). Begin with a coarser grade, number 300, and proceed with the finer, or number 600. The wet-dry type of sandpaper is preferable and should be used just slightly moist, since wood absorbs and retains water. Moisture, unless completely dried out, may later cause the design and the protective coats of varnish to blister.

A wooden piece which has had several coats of paint and which is to be redecorated must be examined carefully before additional paint is applied. If the former coats are checked (cracked), chipped, or otherwise damaged, the old finish must be removed. Use a good paint remover and follow the directions which come with it. The remover will also affect the new coats when they are applied. It must therefore be thoroughly cleansed from the surface. Warm water, a scrubbing brush, and a fine scouring powder are advised. Follow this by thorough rinsing and many days of drying in the sun. In some instances a good dry cleaner like Carbona or benzine is excellent to use for it cuts the wax that is present in some removers. The softer and more porous types of wood, treated with paint remover and dry cleaner, may swell and the grain may roughen. This can be corrected by rubbing with sandpaper after the article is thoroughly dry. Some porous woods require a coat of filler when the flat paint is applied, even after paint has been removed.

How to Repair Holes or Breaks in Wood

It is usual to fill in a hole or a crack in wood by using *Plastic Wood,* which may be purchased in tubes or in small cans. It is used a little at a

1

time in a built-up sort of way. It becomes extremely hard and is difficult to rub down. *Wood dough* is an excellent substance to use.* This product comes in several colors to match the wood on which it is to be used, i.e., mahogany, maple, etc. It may be used to build up any section which has been broken off. It is sufficiently pliable so that it can be carved or turned on a lathe. A little is used at a time. It is kneaded and pressed into the place it is to repair. It should be smoothed by sanding as is any other wooden piece. Wood primer is then used. See below.

Sizes, primers, or wood fillers. A wooden article which has never been prepared for decoration and is of new wood requires a filler. The filler, also known as a wood size or primer, is absorbed by the pores and prepares the wood for japanning. It helps to level and smooth the surface, prevents checking and makes the japan paint adhere better. Fewer coats of paint are required when a filler is used.

Some advocate the use of shellac diluted with fifty per cent alcohol for preparing wood to be japanned. It has been my experience that shellac can do irreparable damage to the decoration, after the protective or finish coats of varnish are applied. Direct heat, such as sun through a window, extracts moisture from the shellac. The moisture is imprisoned by the varnish coats and causes the many layers of paint and varnish to separate from the shellacked surface, forming blisters which destroy the design.

If the wooden article is to be japanned or painted, the best filler to preseal the wood pores is one made from an oil-paint base and intended specially for wood. This filler may be purchased in white and may be tinted in any of a number of colors. It must be applied as a thin coat which merely fills the wood pores and does not give a solidly painted effect. Thin it with turpentine to the consistency of India ink. Twenty-four hours after applying it rub it down with fine, number 600, sandpaper (use the variety known as "Wet-dry" Sandpaper, slightly moistened). This type of filler prepares checks in wood and also tones down the wild grain. Two thin coats may be necessary if the wood is extremely porous.

The clear, commercial fillers fill the pores of wood which is not to be painted. They even up the grain differences caused from spring and summer growth of wood, and prevent checking. These clear fillers are excellent as a means of preparing the foundation for stained wood because they help to tone down any irregularities in its graining. Care must be taken when using these. Some have an alcohol base, similar to shellac, and should not be used with products made with turpentine such as oil paints and resin varnishes.

A wooden article, whose grain is to be part of the decorative beauty, must be of top quality. A good filler for this is raw linseed oil. (Always use the *unboiled* type, obtainable at paint stores.) It fills the pores while it also protects and feeds the wood. Rub it into the smooth, dusted wood with a clean

* Suggested to me by Mrs. Eleanor Carlisle Cobb of Franklin, Massachusetts. See "Where to Buy" section.

2

rag. One coat a day, for at least six days, should be followed each time by a fine sandpaper rub-down and a thorough wiping with the tack-rag. (Tack-rags are squares of specially prepared cheesecloth which are tacky or sticky to the touch. They are composed of certain quantities of linseed oil, varnish and turpentine. Their purpose is to pick up all dust particles from an article which is to be varnished or painted, so that the finish will be smooth and free of foreign matter and lint. Some automobile supply houses carry them and also the art stores listed at the back of this book. These are a must for the decorator. Store them in a tightly closed jar. When they are not to be used for a while put in a few drops of turpentine to help keep them moist.) Linseed oil tends to form little globules after the third application. These oxidize and harden into tiny lumps. A golden smoothness is assured, however, if care is taken to rub in only the amount of oil the wood will absorb. Note: *Raw linseed oil is a slow drier.* At least a week should elapse before decoration is begun.

Commercial wood paste fillers are intended to fill the pores only and do not protect the wood in any way. They may be purchased in natural color or in stains and are thick, viscous substances which must be thinned with turpentine before they are applied. Directions come with each jar.

Another satisfactory wood filler, for both natural-grain and japanned articles, is a quick-drying Spar varnish, diluted with twenty-five per cent turpentine. A varnish filler should be smoothed over by sandpaper twenty-four hours after it is applied. Japanning or decoration may begin soon after.

Varnishes may be classified as fast-drying and slow-drying. Hour varnish dries in sixty minutes; Man O'War varnish dries in six to eight hours and may be rubbed in twenty-four hours. Both of these are produced by the Mc-Closkey Varnish Company and may be used in combination very satisfactorily when a quick-drying and a slow-drying varnish are both needed. Spar varnish and Super Valspar both dry in six to eight hours, and may be rubbed in twenty-four hours. They are both produced by the Valentine Company. Other companies produce resin varnishes similar to these.

Whenever turpentine is needed, be sure to use the pure spirits of turpentine rather than the synthetic product. The paints used for the decorative work described in this book have some turpentine as a base, while the synthetics or lacquer types usually have alcohol as a base. The two substances will destroy each other when used in combination, even when the surfaces they cover are dry. *Never use alcohol* to dilute paints, etc.

Modern methods, used by the peoples of the Western Hemisphere, though they seem time-consuming, are really rapid when compared to the Oriental way of laying lacquer on a wooden surface. Genuine Oriental lacquer is the sap of the *Rhus vernicifera,* a shrub or small tree of the sumac family. It is not to be confused with the transparent amber colored substance sold today which is called lacquer. The Oriental product is painstakingly gathered, both in its fluid and hardened state, and is heated and strained to remove impurities. It is stored in tightly covered jars. It hardens best in a damp at-

mosphere. China and Korea use their natural lime caves for the purpose, while Japan prepares special chambers which are dampened regularly. It may be both transparent or opaque.

The *varnish* we use today which comes closest in final results to genuine Oriental lacquer is composed of resins and volatile oils. It hardens best in a dry atmosphere. Oxidation of the volatile oils must take place rapidly in the first hour after varnish has been applied. On a rainy or a humid day the varnish will remain "tacky," indefinitely. Tackiness refers to the degree of stickiness reached by certain substances before they completely harden. These substances are largely composed of varnish—Black Service-Seal, enamels, Plax, and all the Spar varnishes.

The Oriental craftsman lays the lacquer foundation for his designs on wood, and other materials. His wooden pieces are filled with a native mixture and are reinforced by the placing of a layer of hemp cloth upon a layer of lacquer which is mixed with glue. The cloth helps to prevent the wood from splitting and warping. Over this he applies as many as eight layers of opaque lacquer. Actually, thirty-five processes are involved. Each layer of lacquer is rubbed down with abrasives (coarse at first, becoming finer as the final coats are laid). Certain native animal antlers are calcified by burning. The resulting fine powder is used, at the end, to smooth and polish the lacquered piece. (See Fig. 1.)

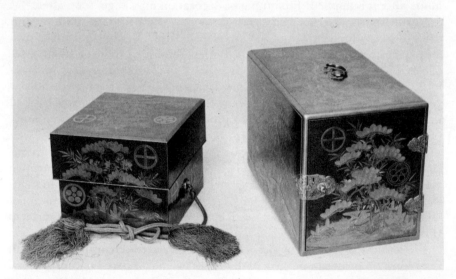

Fig. 1. Lacquer boxes, part of a marriage set. Japanese, XVIII century. *(Courtesy of Metropolitan Museum of Art)*

The methods we employ today are outgrowths of Oriental practices. Geographic and personality differences have resulted in the use of new materials

and have effected decorative tendencies. Since so much went into the preparation of the background for the design, there was little need for the Oriental artist-craftsman to use protective finishes. We use comparatively few steps in preparing our grounds. Our designs are the result of surface application, as opposed to a type of inlay method used in the East. A cross-section of an Oriental lacquered piece is almost one-quarter of an inch thick, while the depth of our finished surfaces is less than one-sixteenth of an inch. The measurement for Oriental lacquer work does not include the wood on which the finish is applied.

Our six or more coats of protective transparent, quick-drying Spar varnish are proof against chemical or heat damage but not against chipping. The Oriental lacquer is not as brittle as our finish and therefore is not easily injured. It, too, is heat-resistant. The results of our endeavors with our modern supplies are equally beautiful and to the unpracticed eye are similar to the Oriental lacquer work. Our flat paints, in black and in color, do not resemble a lacquered piece before varnish is applied, but they do lay the foundation for that lacquered appearance which our amber-like varnish produces when it is flowed over our level pigments and designs.

Metallic Surfaces

Metals are treated in much the same way as wood. The same japan paints are used and the rubbing for smoothness is similar to that on wood. Tin and iron, or steel, are subject to rust and, therefore, must be specially treated. Before any preparation takes place, the piece must be checked for smoothness, and dents should be hammered out. Old paint must be removed, taking care not to destroy a design if it is an antique piece. Such a design should be copied for the file. One way to remove paint is to soak the article in a lye bath—one or two cans of lye in a laundry-tub full of water. (This should not be used for wooden articles.) The paint will come off metal within a few days and the piece may then be washed off with soap and water. Be careful to place the lye bath out of reach of children and pets. Wear rubber gloves while working with this chemical. Handle articles with long tongs and be careful not to splash. Ordinary paint remover can also be used.

To remove and prevent rust we use Rust-i-cide (purchased from art stores mentioned at the end of this book), a liquid chemical which is rubbed on with fine steel wool. Unless there are deep rust pits, ordinary rubbing with fine steel wool is sufficient to remove and prevent rust. If rust is deeply imbedded, it may be necessary to rub with very coarse sandpaper and coarse steel wool in combination with Rust-i-cide. No rust must be permitted to remain, for the smallest speck is malignant.

The Rust-i-cided piece must be washed thoroughly in a tubful of warm, soapy water to which a generous amount of bicarbonate of soda has been added. It should be dried thoroughly before the metal primer is applied. For

more thorough drying, rub turpentine over the entire piece with a clean cloth. Allow it to stand for a short while and apply the primer as soon after it is dry as is convenient.

Aluminum does not rust, but soap and water are not sufficient to remove a kind of oiliness which sometimes clings to the surface. While this remains, the primer and paint will not adhere. The best antidote for this is ordinary cider vinegar. Wipe the piece with vinegar, rinse and dry thoroughly.

How to Repair Breaks, Tears or Holes in Metal

Metal Surfacer #1 for repairing holes, tears, breaks and even dents in metal articles is most satisfactory.* This substance does not require heating as solder does, and is more easily handled than liquid solder. A palette knife forces the surfacer into the place it is to repair. It may be used to strengthen any metal article. Metal Surfacer should be sanded down to smoothness before the metal sanding primer is painted over the repaired piece. Always use metal surfacer after Rust-i-cide when the latter is necessary.

Metal primers. Various types of metal primers are available. There is a red sanding primer, about the color of red earth, and a gray primer. Both are satisfactory.

All metals must be primed before they will accept more than one coat of paint. The primer has certain cohesive properties which can be likened to roots. The primer is not applied merely to prevent rust; it must also be used on rust-proof metals, like aluminum. If one neglects to use a primer, the first coat of paint will be very smooth but, when the second coat is applied, the two layers will curdle in the wet state and then flake off when they dry.

The can of metal primer must be stirred thoroughly. Then a little of the primer is strained through a double thickness of nylon stocking into a small, clean, disposable can. Spirits of turpentine is added to make it about the consistency of India ink. It is painted on the metal with a medium stiff brush which is reserved for this purpose. Twenty-four hours later the primer is rubbed to smoothness with number 600 sandpaper, of the wet-dry type, which should be used wet. Rinsing the piece off in running water removes all loose particles. When thoroughly dry, wipe with the tack-rag and never use turpentine. If the piece is a tray, do the underside before proceeding with the flat or japan coats. Sometimes a second coat of metal primer is advised.

BACKGROUNDS FOR DECORATIVE PURPOSES

Japanned Backgrounds

Japanning, so called because of its resemblance to the lacquer work of the Orient, is applied over the wood filler or over the metal primer. The surface

* Made by Webb Products Company (see "Where to Buy" section).

to be japanned should be velvety smooth. The paint used should be a flat, no-gloss variety also known as "Ground in Japan." It should be strained and diluted in turpentine to about the consistency of India ink. Many colors are obtainable in flat oil paint. As soon as you open the can, stir two tablespoons of quick-drying varnish into each half pint. The varnish gives flat oil paint better cohesive qualities and prevents the pigment from powdering excessively when sandpaper is used. It is not advisable to increase the proportion of varnish, since too much would result in an enamel-like finish, not satisfactory for decorative purposes.

Usually five or six coats, and perhaps more, of this thinned flat or japan oil paint, are preferred for that velvety-smooth, final finish. One or two coats of thick paint will leave brush ridges which are difficult to rub out. There is actually less hard labor involved if this rule is adhered to, even though it takes more days to prepare the background. Several pieces can be done at once during this time.

Each coat of flat paint must be permitted to dry twenty-four hours. Rub the surface down with wet-dry sandpaper. Remember to use it wet on metal but only moist on wood. Rinse the metal article under running water, but wipe the wooden piece with a damp cloth. At this point, pay no attention to the appearance of the article; smoothness to the touch is essential.

When an off-shade of white, such as ivory, is the color chosen, use pure white for all of the coats. Protective varnish, which is applied later, will turn the white into ivory and give it somewhat the texture of fine china. When colors are used, choose them a shade or two lighter than the desired finished color. Varnish will not only darken them, but will also tone these colors down. Time also darkens varnish and all finishes acquire an antique look.

NATURAL WOOD GRAINS: THE USE OF STAINS

When wood is to be kept as light as possible, no stain should be used over the filler. Varnish applied over the design will act as a magnifier of the grain and of the design and will also tone them down. If a darker tone than the natural is chosen the wood stain should be rubbed in after all applications of linseed oil or other fillers have been completed.

Wood stains may be purchased from hardware stores. Care must be taken to use those which require turpentine rather than alcohol as a solvent.*

When our American forebears built wooden accessories from native orchard woods they did not select them for their graining. Either their pieces were given all-over coats of lamp black before the decoration was applied or they were given a simulated graining which was intended to look like mahogany. The wooden article which was treated in this manner first received

* The United States Plywood Corporation (Industrial Adhesive Division, 55 West 44th Street, New York 36, New York) has done much research in this field. Write for their instruction sheets for finishing with Firzite and Satinlac.

7

a coat of a special shade of Venetian red not now obtainable. It was a color which today is known as "barn red." We can mix our own shade by combining Vermilion in japan with ascot red also in japan and adding a little raw umber in oil. These thoroughly mixed pigments are thinned with turpentine to the consistency of India ink. A few drops of varnish are added to give the paint better cohesion. A foundation coat of this color is applied to the wooden article. Twenty-four hours later it is rubbed to smoothness with fine sandpaper and thoroughly wiped off. Apply a second coat if necessary. Flat black paint is diluted with turpentine to a consistency much thinner than India ink. Before applying the black pigment, prepare the tool which is to be used for the grained effect. Crushed newspaper or a paper dinner napkin may be used. If a swirled effect is sought, cut even teeth-like grooves along one side of a sturdy piece of cardboard, 4 inches by 2 inches wide. Apply the thin black paint smoothly and, while it is very wet, wipe out some of it, either with the paper, or use the cardboard in a swirling sort of way. The red will show where it was wiped out and will also show slightly under the thin black coat. It must be remembered that this effect will be magnified when varnish is applied. When natural wood grain is sought care must be taken to avoid too sharp a distinction between the red and the black. Fine graining requires skill. Any decoration which is done on this finish should be applied on panels which are solidly painted. The beauty of the design is thereby intensified.

SMOKED GROUNDS (see Fig. 2)

Smoking must be done against pastel colors or white. When the background has been prepared for the design, hold the article to be smoked close to the flame of a candle so that the smoke settles on the surface. Be careful to avoid picking up melted wax and do not handle the surface until protective varnish has been flowed on, since the smoked effect can be easily destroyed. The decoration usually done on this ground is that known as freehand bronzing, but other types could be applied. Care must be taken to distribute the smokey swirls evenly. For protection, cover the surface with two coats of varnish before rubbing the surface smooth for doing the design. (See section which describes the method of flowing varnish in this chapter.)

ASPHALTUM

Asphaltum is a coal-tar substance. The type used for painting is a kind of varnish and is more black than brown when used as it comes from the can. When diluted with Hour varnish, which is extremely quick-drying, it becomes lighter in color—transparent and brownish. It should be used directly on shiny metal after the Rust-i-cide has been applied and has been washed off. Used in this way its transparency gives a jewel-like appearance. Early American tinware was coated with this substance and the decoration which was done over it was usually not protected with varnish coats. Many such

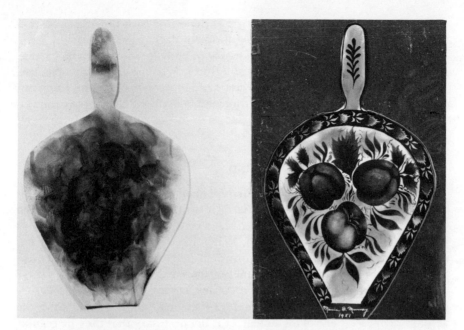

Fig. 2. Smoked background of a bellows design. At left, the effect of smoking; at right, a freehand-bronzed design with a repeat stencil border.

pieces have withstood the ravages of time because they were not of the utilitarian variety. Gold-leaf decoration on asphaltum of the Lace Edge type was often completely rubbed off because of the lack of protective varnish.

Asphaltum is known as a substance which never really hardens. Certain makes can be purchased which are better than others. Sherwin-Williams B Asphaltum is excellent. The drying possibilities are greatly increased if no turpentine is used for diluting it. Quick-drying Hour varnish should be used for diluting. *Hour varnish only should be used on an asphaltum base for protective coats as well as thinning. It should never be combined with other varnishes* except Man O' War which may be used in combination with oil paints for doing the design.

To imitate asphaltum one can use quick-drying Spar varnish tinted with alizarin crimson oil paint which is toned down with raw or burnt umber. This mixture would result in a reddish transparency. For a yellowish transparency use Indian yellow and burnt umber oil paint, with Spar varnish. The colors are mixed with a little turpentine in a large jar cap, using a brush. They are then strained through a double thickness of nylon stocking into a clean small can, and the varnish added. Immersing the can of tinted varnish in boiling water to heat it helps to give a smoother coat when it is used.

When asphaltum, or its imitation, is applied, a one-inch ox or badger hair varnish brush should be used. The substances must never be stroked on as one would stroke or brush paint. The loaded brush lightly glides along the

9

surface and the varnish or asphaltum is deposited by a flowing-on sort of motion. Never go over parts already done, for dark ridges will surely form. If the article to be treated is heated to about body temperature the varnish or asphaltum will flow on more satisfactorily. *Never rub directly on asphaltum, for it scratches very easily.* Apply two coats of Hour varnish before doing any rubbing. (Be sure the asphaltum is thoroughly dry before you apply the varnish. A week or more may be necessary.)

"TORTOISE-SHELL" BACKGROUND

The Lace Edge tray with the "tortoise-shell" background (see Fig. 3) is done with asphaltum. You must have a smooth black foundation before the tortoise-shell is begun. The floor is given a coat of Man O' War varnish, or patches are done, as in the picture. When the varnish has become tacky, spots or patches of silver or palladium leaf (see top right of Fig. 3) are applied. Three or four of these are usual but more patches are required if these are applied on a very large round or rectangular tray. These patches measure about two or three inches in diameter; they need not be larger than the actual size of each page of metal leaf. It is not necessary that they be regular in size or shape. A week after they are applied they are covered with a wash of alizarin crimson (see top left of Fig. 3). The alizarin is not toned down and is mixed with a little Hour varnish in a large jar cap. The complete tray can be painted with this mixture using a broad brush or only the patches given a wash. Since alizarin crimson is a slow drier, the tray is again set aside for a few days, perhaps a week. When it is thoroughly dry, pour a little asphaltum in the center of the tray. Now dip a one-inch brush into Hour varnish and, working rapidly, blend the asphaltum and varnish together so that no sharp edges remain on the metal-leaf patches. Wipe the brush off on a nylon stocking each time it is dipped into the varnish to remove all the excess asphaltum. This will help to keep the varnish in the can clean. The patches of silver leaf should look like highlights which appear and disappear with no sharp edges in evidence. (The bottom tray in Fig. 3 shows subdued patches after asphaltum and Hour varnish were sloshed on unevenly.) When this is thoroughly dry (a week or more later) apply two coats of Hour varnish. Rub down the second coat so that there will be no shiny spots and it is smooth to the feel.

Lace-edge trays are sometimes given an all-over floor covering of silver or palladium leaf over which alizarin is painted. The tortoise-shell is then acquired by the skillful blending of thick, semi-opaque asphaltum with the transparent Hour varnish. Also apply two coats of the same varnish when the asphaltum is thoroughly dry. This will protect the asphaltum so it will not scratch. By using Hour varnish you also help the asphaltum to harden more evenly. Rub the second coat of varnish with wet sandpaper until it is dull before decorating on it. Designs which are painted on such a back-

10

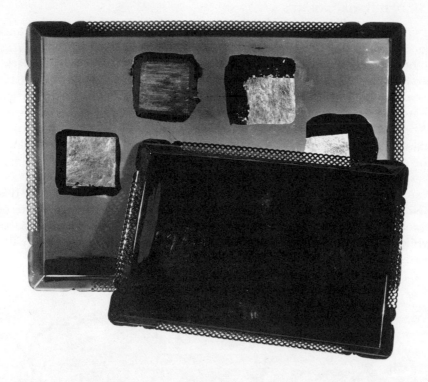

Fig. 3. Steps in applying tortoise-shell background to lace-edge trays.

ground appear to be floating as if on a pond, with highlights of rosy bright-
ness between the flower, fruit, and bird ornamentation.

 Another way of acquiring the effect of tortoise shell without using asphal-
tum is to paint the entire floor of the tray with a coat of thin flat black cover-
ing the patches which have been washed over with alizarin. With an ordi-
nary paper dinner napkin, wipe off some of the black paint while it is very
wet. Do this where the patches have been placed. If the tortoise-shell effect
results in contrasts which are too sharp, the entire floor may be covered with
varnish, after the gold-leaf border has been done. While the varnish is still
wet a little black service-seal may be floated into the varnish where a more
subdued effect is required taking precautions to keep the service-seal away
from the border. The coat of Spar varnish is usually flowed on a week after
the gold-leaf border has been done and is intended to protect the gold leaf
while the rest of the design goes on.

11

GILDED BACKGROUNDS

Gilded backgrounds often appear as bands or borders over which transparent painting or painting of the freehand-bronzing type is done. The area to be gilded must be carefully marked with a lead pencil, when the background color is light, or with an indelible Eagle-brand silver pencil, when it is dark. With a broad poster brush cover the entire area with a smooth, even coating of quick-drying varnish of the Spar variety or with black service-seal. When this becomes tacky, cover the entire section with gold, silver or palladium leaf. (See Figs. 4 and 5.) Brush off extra particles of loose leaf along the edges and set the piece aside to dry for at least a week. When it is dry, wash the piece carefully with running water. Touch up the spots where unwanted gold still appears, using black service-seal. Before decorating on this delicate background it is wise to cover the entire piece with two coats of varnish followed by a rub down with wet sandpaper. Any erasures necessary, while the decoration is in progress, can then be done without damaging the metal leaf.

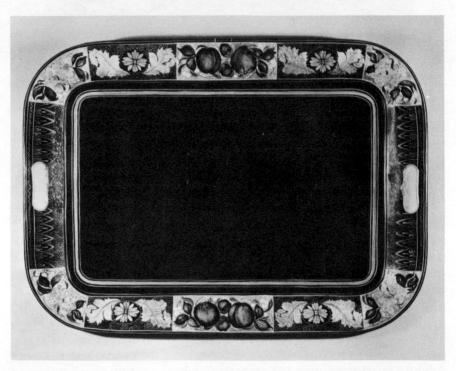

Fig. 4. Pontypool rectangular tray with gold-leaf bands at the corners, beneath the fruit and on the acanthus leaves. At the ends, the "squiggles" are rubbed with copper bronze lining powder, and the brushstroke border is a rather transparent off-white. The fruit is freehand bronzed with a wash of transparent alizarin shading to greenish-yellow. Striping is white and pale gold on the flange, two shades of gold on the floor.

12

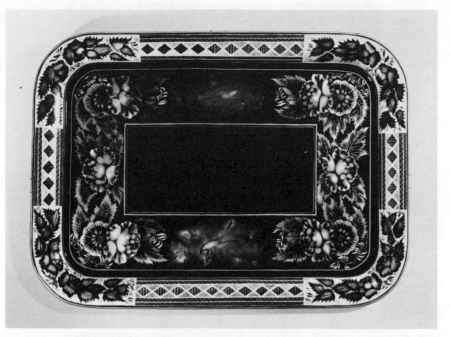

Fig. 5. Freehand bronzed tray with flange corners banded in gold leaf. The bronzing is done on black with gold and silver lining powders. The rest of the border consists of squiggles combined with fine line work. The floor border is bronzed in gold, silver, and copper tones, with the silhouette bird stenciled on and clouded, with brushstrokes of black on the clouding. Striping is white and gold on the flange, gold on the floor. Brushstrokes at the corners on the floor, and flanking the birds are in gold leaf.

SMUDGED GROUNDS (see Figs. 6, 7, 8, 9, 10 and 11)

Smudging is done with bronzing powders of the very fine type called lining powders. Lining powders give smoother results than the coarser bronzing powders do. An article so treated shows a light golden background behind the main decorated unit. This ground shades off delicately to copper and silver leaving an attractively shaded section of the black ground for accent along the outer edges. The floor of some Chippendale trays is covered solidly with polished bronzing powders. The shading breaks on the rim or flange of the tray. Others are heavily polished with bright gold in the center and also shade to copper and silver which blend into the background before the flange is reached.

To smudge, apply a coat of varnish over the entire piece. When this is tacky, rub in the bronzing powders as follows: with a piece of pure silk velvet which is made into a tightly stuffed cushion with cotton batting, begin at the center of the article, using pale gold lining powder and working it into the

13

Fig. 6. Kidney Chippendale tray design which shows the smudged background as it goes up into the flange. Brushstrokes on the border, basket effect, and the bases for the two fountains are in gold leaf. Burnt umber brushstrokes are used here and there for accent. The water from the fountains is in off-white.

Fig. 7. Detail of central flower unit of Fig. 6, showing typical "floating" and "veiling." The center roses, the canterbury bells, forgot-me-nots, and primula are floated. The center rose is veiled and is done in light shades of pink and yellow. The iris is in off-white, shading into green, with deep maroon petals. The leaves are of various shades of opaque green, veined in burnt umber, with here and there a touch of transparent white. Notice the curlicues which are green and the tendril moss which is done in gold leaf. All the coloring is delicate, yet rich in contrasts, reminiscent of Jean Louis Prévost's method of painting flowers.

Fig. 8. Chippendale design known as the "Glamour Birds." The scroll-like border, interspersed with small, delicate flowers, is done first in deep brownish red and is edged with gold-leaf brushstrokes. The birds' wings are in silver and gold leaf with transparent color over the leaf to give a translucent appearance. The birds at the top have tails of creamy white; the middle bird is in deep rose and yellow tones. The center flowers are white with blue and yellow and deep red with yellow. Leaves are in several shades of green with veins of white stubby strokes and overstrokes of lighter green and burnt umber. The original trays had "glitters" added to the tail of the center bird. The set is owned by Mrs. Arthur Chivers.

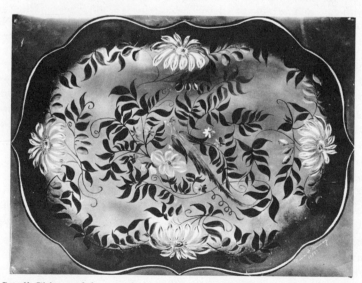

Fig. 9. Small Chippendale tray design with blue and yellow daisies, green leaves, and gold-leaf bird modeled by overstrokes of transparent greens, blues and alizarin tints, done on a smudged background.

15

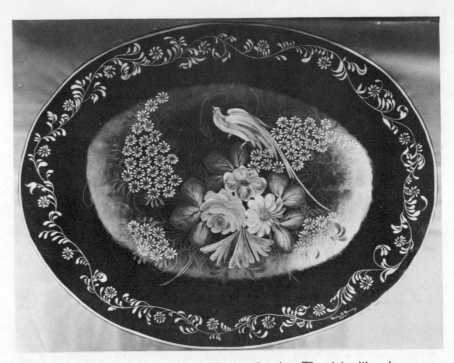

Fig. 10. Oval Windsor tray with decorative drawing. The daisy-like clumps were stamped on with a design carved into a piece of cork. The background is black with an unusual type of smudging. The border is gold leaf, the leaves in the central unit are dusted with pale gold metallic powders. The coloring is in soft tones of yellow and yellowish greens; the daisies are white, washed with yellow shading into blue. Note the arrangement of the curlicues. *(Courtesy of Miss Luanna De Catur; photograph by Herbert Studios)*

varnish with a polishing motion. Increase the area gradually, always working from the center outward. As the bronzed section approaches the outer edges, mix copper lining powder with the gold on the velvet. Apply the powders less heavily, adding silver to the outer edges. Smudging should never end abruptly but should blend gradually from the highly polished gold center into the copper and silver which should gradually disappear into the black background.

Twenty-four hours later wash the article carefully under warm, running water, stroking gently with the finger tips. Never use a brush or cloth or the tack-rag on the bronzing for these will scratch the delicate surface. Washing removes all loose powder. Do not sponge dry but allow it to drip dry where no dust can settle on it. A few hours later apply two coats of protective varnish. Follow these with a rub-down with wet sandpaper. Decoration may proceed a few days later. (To give a more mellow appearance to the smudging, add a little black service-seal to the varnish, mixing it in thoroughly.)

16

PROTECTIVE FINISHES: HOW TO APPLY THEM

Quick-Drying Spar Varnishes

It is wise to start with a quick-drying Spar varnish for mixing artists' oil paints, while doing the design and to use the same kind on any one piece for protective coats and whenever varnish is required. If the slow-drying kind is interchanged with the fast-drying a crackling of the surface may result. This may occur a few months or a few years later. The crackling occurs because each type of varnish dries at a different speed. Slow-drying varnish which requires more than eight hours to dry, has the disadvantage of gathering more dust particles while drying than the faster-drying Spar variety and stenciling with bronzing powders is more satisfactory when done on a fast-drying Spar varnish. (*Never use Hour varnish or Clear Service-Seal for stenciling. These dry too fast and do not remain tacky long enough to stencil into. Always use a good Spar varnish.*) When the design is completed the article is ready for the protective varnish coats. There are shiny and dull-finish varnishes. The following shiny-finish varnishes are alcohol- and heat-resistant and are,

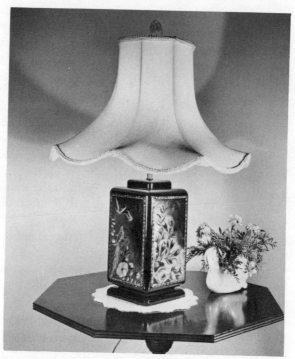

Fig. 11. Decorated wooden lamp base on which the smudged ground is kept within bounds by a fine gold-leaf border on each panel. The colors are blue, rose, and yellow, with soft green used for the leaves.

17

therefore, good for protective finishes on trays, tables, and all utilitarian pieces: Hour varnish, Man O' War, Spar varnish and Super Valspar. The following are dull-finish or rubbed-effect varnishes. They should never be used on trays or tables because they are not heat- or alcohol-resistant: DeVoe Rubbed-Effect varnish, Valentine's Duncan Phyfe varnish and Valentine's Chippendale varnish which is a semi-gloss varnish with slightly more sheen than the Duncan Phyfe.

Do not stripe any piece (see Chapter III for rules on striping) until the second coat of varnish has been applied and has been rubbed down. Errors made while striping may be erased with Carbona without injury to design or background. Never use turpentine for it will leave a mark and removes the background finish. Use Carbona rather than carbon tetrachloride for all erasures even though the former is more expensive. Carbon tetrachloride can be dangerous. After striping the tray, apply four more coats of varnish using a Spar variety if this was used before. At least six coats should cover the design.

Never shake the supply can of varnish before using it! Shaking causes bubbles which will mar the surface.

Into a small clean can, which is to be discarded, strain some varnish through a double thickness of nylon stocking. This is important, for it removes any oxidized lumps which may have formed in the supply can. Set the can with the strained varnish into a small pot with water in it and heat it, being careful not to allow the water to boil up into the varnish. Stir gently with the varnish brush which has been prepared for the first use and cared for as explained in Chapter II.

Be sure the article is warm, not hot, and never cold. Warm varnish applied on a warm article will result in a smoother surface. Wipe it with the tack-rag. Do this in the room best suited for the drying of varnish. The bathroom is suggested. By running hot water and so steaming the room before it is to be used, dust particles in the air settle. A varnished piece can be set on a stool or a small table placed in the tub behind the shower-curtain where it is less likely to be disturbed. Ventilation and a minimum of dust are essential for drying varnished articles.

Use warm varnish. Apply it on a warm article. This will make it flow more easily. Never use varnish which is old and gummy and under no circumstances add turpentine to dilute old varnish. For fine finishes use a freshly opened can of varnish. It is best to buy varnish in the smallest can obtainable.

Leave the discardable can with the varnish in it in the hot water while applying varnish to the article. To remove excess varnish from the brush never rub the brush against the side of the can, but hold the tip of the brush so it just touches the varnish. Let the excess liquid drip out. Rubbing against a surface to remove excess liquid will cause bubbles. If it is a tray which is being varnished begin at the flange. *Do not brush the varnish in.* Use no more

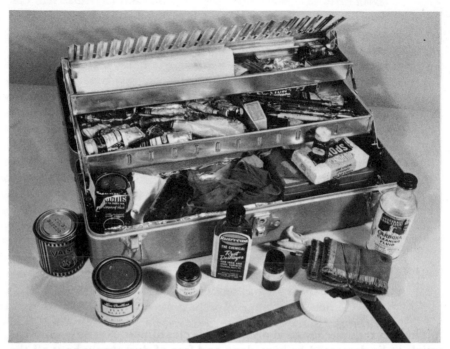

Fig. 12. Metal box for tools and supplies. Brushes and boxes for holding extra quills and pen nibs are in top compartment; oil paint tubes and small tools for tracing, etching, cutting, etc. in the middle; cans of varnish, aluminum foil and nylon stocking for straining and wiping are at the bottom. The rolled bronzing powder palette is in front of the box with a piece of foam rubber used for stippling and pouncing.

PIGMENTS AND PAINTS: THEIR PROPENSITIES

OIL PAINTS IN CANS

Oil paints come in tubes and in cans of several sizes. The canned fall into the following classifications:

Flat oil paint. Dries with no gloss. It is the kind most commonly used for backgrounds. Flat oil paints may also be purchased in tubes marked "Ground in Japan." These paints do not have varnish in them and may also be purchased canned in concentrated form, to be diluted with turpentine before they are used.

Semi-gloss oil paint. Dries neither flat nor shiny. This type is good for backgrounds. It is available in a wide range of colors and shades.

Enamel paints. High gloss. These are not satisfactory for decorative purposes since they do not rub down smoothly. They should be shunned for this work.

22

Rub with a circular motion and also criss-cross in gentle strokes. No automatic polisher will give the finish which well-applied varnish and hand-rubbing can produce. The rubbing should remove any high spots or blemishes which may have appeared when the last coat of varnish was applied. No amount of diligent rubbing will remove those which appeared earlier in the varnishing process. These will be magnified because varnish, while it intensifies the design also enlarges the flaws unless they are removed as the varnish is applied. Rubbing with the oils and abrasives after the last coat is applied may be repeated for several days until the surface is smooth as satin.

DULL-FINISH VARNISHES

Varnishes which produce a dull finish are thick opaque substances which have wax in them. Remember that they must *never* be applied to utilitarian pieces like trays. To use, stir them thoroughly and dip the brush directly into the supply can. *Never use that very special varnish brush with a dull-finish varnish.* Keep a separate brush for this type of varnish, another for asphaltum and a fourth for Hour varnish. Do not interchange them.

The dull-finish varnishes must be used only for the last coat. Since they dry in a rather grainy way they do require rubbing down. Wait twenty-four hours after application to rub down, even though they appear to dry faster. The rubbing-down is done in the same way as for the shiny-finish varnishes. Dull-finish varnishes do not bubble even when brushed on and are therefore easier to apply. Some may be used for the last two coats.

WAX FOR ADDED PROTECTION AND BEAUTY

Any worth-while piece, whether metallic or wooden, is given added beauty by waxing. A good hard wax, either liquid or paste, but not the self-polishing kind, may be used for good results. Apply as a thin coat and let it dry; then polish it with a soft cloth. Rub in and polish as many coats as you can for utilitarian pieces like trays and tables. The wax adds further protection to their finish. When a piece like a tray is used regularly, do not be afraid to wash it with plenty of soapy water as you would china. Dry it immediately and rub wax in—frequently.

Never allow a painted piece to soak in water!

20

METAL LEAF; METALLIC POWDERS AND THEIR PALETTE

Metal Leaf versus Metal Leaf Foils

Among the genuine metal leaf products there are gold leaf, silver leaf and palladium leaf. These vary in shade according to the metals with which they are alloyed. Palladium leaf, similar to platinum, may be substituted for silver leaf, since the latter will tarnish, even under six or more protective varnish coats.

Leaf of the precious-metal type may be purchased in books of twenty-five sheets each measuring 3⅜ inches square. There is the 23-karat gold which is specially made for gilding on glass. It is uniform in weight and thickness and has almost no pinholes in its structure. Another type is the lemon yellow gold leaf of 18½-karat gold. These two types come unmounted. (Ways of handling the different types of leaf, and their special uses are discussed in Chapter IV.) A third type is also a 23-karat gold leaf, called Patent, which is a shade darker than lemon-yellow gold. This comes mounted on separate papers and each sheet only needs to be lifted out of the book. However it is likely to present a problem due to its pinholes. Palladium and silver leaf come only unmounted. Metal leaf should be used carefully and the scraps remaining on the papers, after large sections have been consumed, should be saved. When there is a sufficient accumulation it may be sold to dealers for scrap.

The J. T. Murphy Company of Philadelphia, Pennsylvania, an engraving concern, has recently put out a new 23 karat gold product. It is called Sig-nette and it comes in single sheets, 3 inches by 4 inches and also in rolls about one inch wide and several feet long. With this product it is possible to sign your name in gold leaf on any kind of surface. It is wonderful for doing the Stormont work of the Pontypool type of border, i.e., the squiggles which must be done very delicately on a black surface. It can also be used to make those delicate "drips" of the Chippendale class of painting. When it is used, the gold side of the paperlike substance is up. As you draw in the detail which you want to reproduce with either a very sharp, hard lead pencil or the tip of a not-too-sharp crochet hook, the gold is deposited on the surface to be so decorated. Heavy pressure with the tool is essential for best results. No tacky surface is required for this golden subtance to adhere to! (May be purchased at art stores or direct from manufacturer.)

There are imitations of the genuine metal leaf which are much coarser. There is aluminum leaf which may be used as a substitute for silver leaf, except on very fine work. It is also excellent when used on patterns for the file. Aluminum leaf does not tarnish. There are also the metal foils known as Dutch or Spanish. These must never be used for fine work because it is im-

possible to make them adhere to the tendrils and to the exquisitely delicate gold borders of those classes of painting known as Chippendale and lace-edge. For these, and all other types of delicate work, nothing but the genuine karat leaf must be used. The foils are good only for patterns and even then only for large units because they are extremely coarse and rather brittle. All foils, including the aluminum, lack the patina of genuine metal leaf.

The metal leaf foils may be purchased for less than a third the cost of the genuine precious metal leafs. Each book of foil measures about 5½ inches square and also contains twenty-five sheets. The best quality of these metal foils, including the aluminum, lack the patina of genuine metal leaf for fine work.

METALLIC BRONZING POWDERS: THEIR PALETTE

These bronzing powders come in a wide range of shades and colors. The greens and blues are not generally used for this type of decoration. When green-gold is required a little of this shade of lining powder is mixed with pale gold. Usually when these colors are required washes of transparent oil paints are applied over gold bronzing to obtain green and over silver for an opalescent blue.

There are two types of bronzing powders. The regular, which is coarsely ground, should be avoided for fine work. The other, called lining powder, is extremely fine and is excellent for every kind of bronzing. These come in an assortment of shades from silver to the palest gold and range through brilliant gold, orange, copper, and almost brownish tints. They may be purchased by the ounce in paper envelopes, or in small jars, or by the pound, in cans. There is aluminum lining powder which is excellent for stenciling and freehand bronzing. It does not tarnish as the genuine silver lining powder does.

The essential lining powders for fine decoration are:

Uhlfelder Brand of Richgold Lining Bronze. (*A requirement.* It is the best gold obtainable today. It compares favorably with the old-time gold bronzing powders.)

Baer's Brand: Milwaukee Richgold Ink (not a liquid), Wisconsin Palegold Lining No. 64, Orange Lining, and Special Light Matt Green Lining.

Hastings and Company Brand: Lining powders in Palegold, Richgold, Deepgold, Copper, and Silver.

Among the shades which are occasionally used because of their brilliance but which do not come in lining, are Baer's Brand: Klondike, Vernis Martin No. 12, Antique Copper No. 16, and Special White Gold No. 42.

The powders should be kept stored in jars or cans. The amount which may conveniently be taken on the tip of an artist's palette knife should be placed on the bronzing palette. This palette is made of a fine closely-woven mohair-type velvet which measures about 15 inches by 9 inches and is bound

on all four sides to prevent raveling (see Fig. 13). A little of each shade of bronzing powder is placed along the middle, lengthwise, of the velvet palette. When not in use, this palette may be folded through the middle, also lengthwise, and rolled up with a piece of elastic. As this palette is used, the bronz-

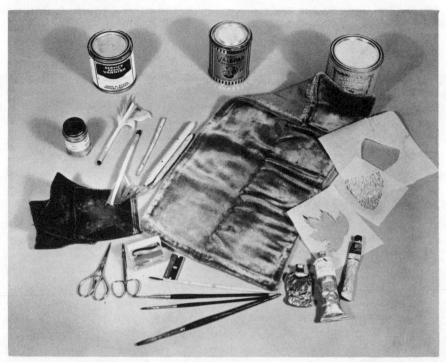

Fig. 13. Bronzing palette and tools and supplies for using it. The velvet squares for stenciling and freehand bronzing are on the left of the palette; the "stumps" and velvet-tipped quills or buttons are above the squares. Below the squares are the scissors and razor blades. The varnishes, brushes and black service-seal are needed when black and bronze colors are used. The oil paint is used when Chippendale leaves are highlighted by the freehand bronze method. The cut stencils show the margin around them.

ing powders mingle with each other on the edges and thus form their own interesting mixtures.

To stencil, use a piece of *real silk* velvet about 4 inches square, carefully hemmed around the edges. Be sure the velvet is not so old that the nap disintegrates. Poor quality velvet will not produce good stencil work. Do not use rayon or any other synthetic velvet. The static from the scientifically produced fabrics makes these unsatisfactory for good bronzing. For storing, these squares of velvet may be rolled up with the palette (see Fig. 12).

BRUSHES: THEIR PREPARATION AND CARE

KINDS OF BRUSHES (see Fig. 14)

One of the most important tools for decoration is the brush. There is one for every type of stroke and every type of painting technique: the delicate tendril and curlicue, the many shapes, sizes, and types of brush strokes and not least important are the brushes for the wider masses which form the preliminary backgrounds for individual leaves, flowers, birds, fruit, and other motifs. No design is complete without stripes and for these there are special brushes, also. It is important to know when a certain brush is necessary. This comes with practice. However, there are rules which must be adhered to while experience is being gained.

For large areas which must be smooth, free of brush ridges and whose outlines are determined by the design or motif, there is the *show-card brush*. It comes in red sable and in light ox hair and may be purchased in several sizes. One large ⅜-inch wide brush with its long hairs is required. The artist should also have a *red sable short flat brush* about ¼ inch wide. These two brushes make quick work out of painting the backgrounds in white or in color, for flowers, leaves, etc. The longer bristle brush is also excellent to use when the floated color technique (see Chapter XI) is done, while forming flowers and other motifs. A large water-color brush is also good for this work.

For the essential brushstrokes (see Chapter VII), there is the *square-tipped French quill* in numbers 1 and 2, and in number 5 for extremely large strokes. The hairs of these are about ⅝ of an inch long and do not require too frequent loading. With this square-tipped quill it is possible to start at the wide end of the brushstroke and to end with the fine tail which makes these strokes unique. To select these brushes at the art store, dip them in water and test them on cardboard while making strokes. These French quills often come without handles. To attach one, use a wooden swab in a small size to fit the quill. These may be purchased in bundles from the druggist and may be whittled down if necessary. Soak the open end of the quill in warm water for a few minutes before inserting the swab-stick which has been dipped into glue at one end. Soaking the quill prevents splitting. These quills may also be purchased pointed, for making fine lines.

French quills come short and stubby and also short and pointed and are obtainable in various sizes. The former are particularly good for the lace-edge type of painting which calls for many short, stubby strokes. The pointed are good for certain types of fine lines.

Long strokes which are like fine lines, such as the stems in lace-edge designs, can best be made with a *red sable script or scroller brush*. The brush box must include at least one of these—the thinnest obtainable is a necessity. It is composed of only a few hairs which are about ⅝ of an inch long.

Striping (see Chapter III) may be done with two types of brushes. There

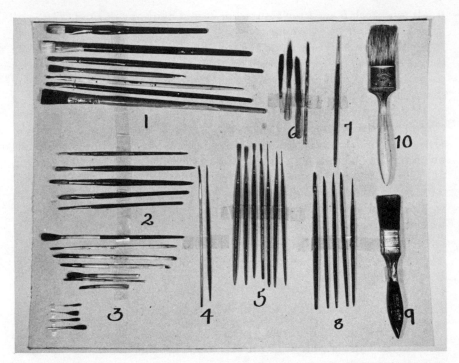

Fig. 14. Brushes used in the decorative arts. (1) Short, flat red sable and white ox hair brushes. (2) Red sable show-card brushes. (3) French quills, ¾-inch length, square tipped, large and small. No. 2 size are at bottom left. (4) Pointed, ¾-inch length, No. 2 French quills. (5) Red sable scroller and script brushes. (6) *Left:* long, square-tipped striper (French quill); *center:* two sizes of sword stripers with wooden handles; *right:* 1-inch French quill sword striper. (7) Short-tipped script brush for veiling. (8) Short, pointed French quills with pointed water color brush at right. (9) Ox hair brush, 1-inch width, for priming and flat coats. (10) White bristle brush, deeply chiselled, 1½-inch width, for varnishing.

is the *sword striper,* shaped as its name implies and obtainable in six or more sizes. These are 1½ to 2 inches long and will hold a large quantity of paint. This type of brush, depending on its size, will make a fine line or a wide band according to the way it is used. The other is a *camel hair striper,* sold without a handle, similar to the French quills. The hairs are 2 inches long and are square-tipped. If a finer striper is needed than can be purchased, it can be made. Carefully gather together as many camel hairs as are needed from a larger brush, then dip the ferrule end into a good heavy glue and tie them with silk thread. This end may be inserted into a quill from a discarded brush and then tied again.

For metal-leaf work (see Chapter IV) it is necessary to own a special brush which may be used to remove the excess leaf without causing damage by scratching this delicate substance. A *gold-leaf duster* is excellent. Any other

29

small soft brush made from squirrel or camel hair may be used. *This brush should never be used for any other purpose.*

Metal or wood primers and black background paints (see Chapter I) should each have a brush reserved for their use. Another should be kept for painting light or colored grounds. *Ox hair stroke brushes,* from ¾ to 1 inch wide should be used for these paints.

To flow varnish onto an article (see Chapter I) whose design has been completed, the best type of brush is a *white bristle brush with a deeply chiseled edge.* Any other bristle brush with this edge may be used but not the soft-bristled camel hair variety. Their soft hairs break too easily and they drop off. The brush must be 1 or 1½ inches wide. Some decorators are successful with *ox hair* bristle brushes. Don't buy too cheap a brush for this work. A well-made brush will seldom shed hairs after it has been prepared. It may be used for years, if properly cared for.

Keep in reserve one brush for Spar varnish, another for Hour varnish, a third for asphaltum and a fourth brush for dull-finish varnish. *Never interchange them.*

PREPARATION, STORAGE, AND CARE OF BRUSHES

Artists' brushes. New brushes, both large and small, should be washed in warm soapy water or with Boraxo and water. They should be carefully rinsed and gently but thoroughly dried.

For storing, select a shallow box. Cut a piece of cardboard and a piece of transparent Supersee plastic (see page 32) to fit the bottom of the box. Using round elastic, weave loops in through holes which have been punched into the cardboard and plastic. The handles of the artist brushes may be inserted into the elastic loops, thus anchoring them and preventing the bristles from becoming crushed or bent. The plastic prevents the cardboard from becoming soggy from the lard oil (see below) with which the brushes are impregnated.

After each use artists' brushes should be cleaned in turpentine and then dipped into lard oil. The oil will keep the bristles soft and will prevent any hardening of paint which may have remained in them. Be sure to wash this oil off carefully in turpentine before using the brush again; otherwise the paint on the design will not dry. Lard oil may be purchased at art stores and at some drug stores, but mineral oil or vaseline may be used when lard oil is not available. Even mineral oil and vaseline must be thoroughly washed off with turpentine before the brush is used again.

Every once in a while wash these brushes in warm water and Boraxo to remove all the paint and varnish.

The chiseled varnish brush. Most new brushes are likely to have a few bristles which are loose or broken. Rub the new brush gently across a piece of coarse sandpaper. When no more loose bristles appear, wash the brush in warm

soapy water, rinse, and set it aside to dry thoroughly where no dust particles can reach it. Do not wipe it dry, to avoid picking up lint.

Before using the varnish brush for the first time on a specially decorated piece, give it a work-out by varnishing the backs of several tack-ragged trays, being careful to use it without bearing down on it. Any lint or dust which may have remained in the bristles after it was washed will flow out of it.

Store the varnish brush in turpentine. Never wash out or clean this brush after using it. Store it in a small container of turpentine; insert the container of turpentine into a tall, tubular can, with a lid. The turpentine should be changed frequently. Hardware stores have special containers for this purpose. They are large, however, and may present a storage problem. Never store this varnish brush with other brushes. Every precaution should be taken so that lint and dust particles will not get on this brush, either while it is in use or while it is stored.

If proper care is given this brush, *and the turpentine in which it is stored is changed frequently,* there is no need to ever wash or clean this special tool. Undue cleaning, with the accruing pressure, will form those dreaded bubbles. Never bear down on it, either, to remove excess turpentine or varnish. Always allow these liquids to drain out. The little turpentine that is left will mingle with the varnish while it is being heated and the brush can be used to gently stir the varnish. It is wise to give the brush a few work-out strokes on a lintless and clean surface to insure complete removal of turpentine before the varnish coat is applied upon a special piece.

Priming and background brushes. New brushes should be treated like artists' brushes—washed in warm soapy water or Boraxo and water, carefully rinsed, and thoroughly dried.

They may be stored in separate cans with turpentine. The commercial type of brush-holder is excellent, and both types of brush may be stored together. Never store these brushes with lard oil. They are large and the oil cannot be removed from them thoroughly. Aside from the oil, these brushes should be treated like artists' brushes.

MISCELLANEOUS TOOLS AND EQUIPMENT

Croquille pens for tracing with India ink.

Either stencil knives or a pair of sharp, pointed manicure scissors. (Revlon No. 2043, curved blade, are extremely satisfactory, if scissors with sharp points that close well are selected. See Fig. 13.)

Architect's linen for stencils.

Tracing paper in pads or in a roll. The thinnest paper available is best and this usually comes in rolls, both narrow and wide. The padded paper is usually too thick for this type of work. For extremely difficult-to-see work use the plastic tracelene, described below.

Needle-etching tools for metal leaf, with one, two, three, and four prongs

(see Fig. 15). You can make these yourself (directions given under the discussion of metal-leaf laying) or they can be purchased from E. P. Lynch, Inc. (see listing of suppliers at end of book).

Artgum erasers.

Carbona for erasures and cleaning. Turpentine is not recommended for this since it will also remove the flat background paint.

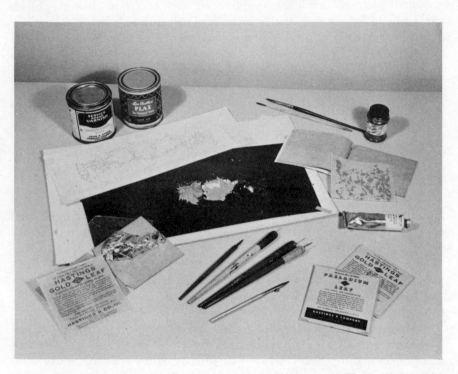

Fig. 15. Steps for laying gold leaf with tools and supplies required. The media on which to lay gold leaf are shown at top left; below them is the tracing of a design, a design with the etched unit, and one showing the gold leaf before it has been brushed off. The tools are a crow-quill pen, three needle etchers and an architect's ruling pen. While the picture was being taken a slight breeze caused the unmounted leaf (lower left-hand corner) to crumple.

Acetate sheeting. This can be bought in both transparent and frosted finishes and in several thicknesses. It has various names—Protectoid, Supersee, and Tracelene, for example. The frosted type is excellent for painting on and for recording old designs. The painting must be done on the frosted side. Protective varnish applied on it later makes it transparent. The best thickness to paint on is 300-ply, or heavy weight. The medium weight, 150-ply is too thin to paint on, but it is excellent for tracing, especially when it is used on an old article, whose design is not very distinct. This sheeting comes in rolls 20 inches wide and 12 feet long; it is also available in 40-inch widths.

32

It is both shrinkproof and moistureproof. The transparent type may be used as a covering for protecting designs.

Stylus, fine ball point, which may be purchased at stationery stores. It is ordinarily used on office stencil work. Other types of stylus tools may be bought from hobby shops. They are excellent for edging gold-leaf designs on glass and some may even be used to etch gold-leaf on glass.

Leather tracer, a tool which is not too sharp and which has a small and smoothly rounded tip. It may be purchased at hobby shops. It is used by the leather-work hobbyist for tracing a design upon moistened leather which is to be tooled or carved. This tool is necessary for tracing the design upon an article to be decorated. Since its tip is smoothly rounded it will not scratch or dig into a japanned surface as a stylus will.

III. *Planning the Design*

Before decoration can begin, the wise artist must plan the arrangement of units in the ornament chosen. These must fit the article without appearing crowded. The appropriateness of the design to the style of the piece is an important factor. Rules for this are included in the following chapters. Today's trend toward greater simplicity of design makes it all the more important, perhaps, that emphasis should be placed upon good symmetry and that artists adhere to the rules of good composition.

MARKING THE GUIDE LINES FOR STRIPING
(see Fig. 16)

Guide lines for striping are marked in pencil directly on the flat or japanned ground before the design or any varnish is applied. These guide lines also help to keep the design within bounds. All articles, trays, boxes, etc. must be striped at least once. The type of striping depends on the design and upon the type of piece which is being decorated. Striping should augment the design but should never detract from it.

Use a flexible plastic ruler. For black or other dark grounds an Eagle brand silver pencil is best. Some silver pencils are not indelible and lines made with them will disappear when the varnish goes on. On white or other light grounds a medium-hard lead pencil is best. Measure the distance for the line and then draw it firmly while making as fine a line as possible. Use the straight edge of the ruler for the straight sides. For curves at corners, etc., accurate measurements and a steady hand are necessary. Some decorators successfully use a compass or a divider for this purpose. If errors are made they should be immediately erased with a soft pencil or an artgum eraser, lest they be forgotten until after the varnish is on.

Fig. 16. Guide lines used for striping; tracing the design; tools.

RULES FOR SPACING STRIPES

OBLONG TRAYS WITH OR WITHOUT HANDLE HOLES

FOR SINGLE BORDERED TRAYS having a stenciled border done on a normal ground:

1. *On the flange:* One stripe on both sides in toned-down yellow paint (chrome yellow with burnt and raw umber) 3/16 inch inside the inner and outer edges of the flange. The stripe should be not more than 1/16 inch wide.

On the floor: One ⅝ inch band placed ½ inch inside the flange. May be stenciled on or painted with gold powder and varnish. Also one fine 1/16 inch yellow painted stripe ¼ inch inside of the band.

2. A stenciled border which covers the entire flange and extends partly on the floor may have only two gold stripes, 1/16 of an inch wide. One stripe is placed ⅛ of an inch inside the outer edge of the tray. Another is on the floor. It is spaced at an equal distance from the design as the outer stripe (see Fig. 17).

3. Single borders done on gold-leaf bands or painted designs (see Fig. 4).

On the flange: One stripe on both sides of the flange, with bronzing powder and varnish 3/16 inch inside the inner and outer edges of the flange. Each stripe about 1/16 inch wide or finer.

A metal leaf band starts ⅛ inch within the above two stripes. This band is

35

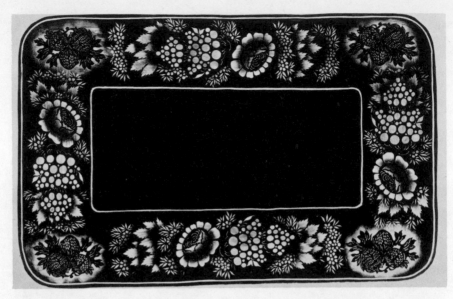

Fig. 17. Stenciled strawberry silhouette tray design. The strawberry silhouette is smudged or clouded in silver with the detail in silver washed with alizarin crimson. The other units are in gold. The leaves are washed in transparent green, and the grapes in shades of green blending into transparent mauve by mixing Payne's gray with alizarin crimson. The large flowers are washed with alizarin, darkened with burnt umber. The gold-striped border starts on the flange and curves over it onto the floor of the tray.

later striped on the edges with off-white (titanium mixed with a little yellow ochre and raw umber) in 1/16-inch stripes or finer.

4. Painted borders directly on the ground are striped 3/16-inch inside the inner and outer edges of the flange. These may be in gold or in a color to blend with the design.

On the floor: One band 3/16 inch wide painted with gold bronzing powder mixed with varnish, placed ⅜ inch inside of the flange. Also on the floor and placed just 3/16 inch inside this stripe one or two 1/16 inch (or finer) stripes in gold of another shade to give a blended effect. These two stripes should be placed ⅛ inch apart.

5. Painted borders with stripes in color should repeat the stripe in darker or lighter shades to contrast with the stripes on the flange. Use the same measurements as above.

For Double Bordered Trays

On the flange: Same as for the single bordered tray.

On the floor: One ⅝ inch gold band ½ inch inside the flange of the tray. One fine stripe in pale gold bronzing powder or in a contrasting color pigment,

36

painted on both sides of the border. Also one wide stenciled band ⅝ inch wide or more which may be polished either on the side nearest the border or nearest the center of the tray and fades off. The center of the tray is in solid black. Trays of the scenic variety must carry a wide band (¼ inch) painted with bronzing powder and varnish. This band is placed about ⅝ inch inside the bend of the flange on the floor. No other stripe appears on the floor of this type.

COUNTRY-TIN COFFIN TRAYS

The stripes on these are always done in toned down yellow paint. These should NEVER be done with bronzing powders or with gold leaf.

1. For the center motif and the flange-border type (see Fig. 18):

On the flange: One stripe on both sides of the flange ⅛ inch away from the edges depending on the size of the tray. Done in toned-down yellow. It should be a very fine stripe.

On the floor: One fine stripe, also yellow, placed just ⅛ inch to ⅜ inch inside the bend depending on the size of the tray.

2. For the double-bordered type:

On the flange: Same as above.

On the floor: The band is bordered by yellow stripes on both sides.

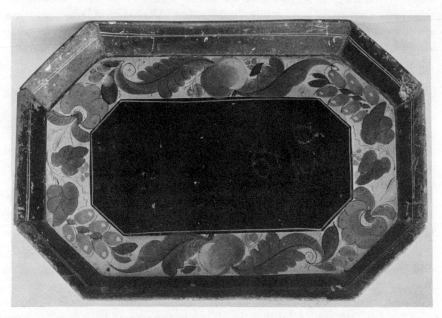

Fig. 18. Coffin tray type, early XIX century, Pennsylvania, with japanned and painted decoration. *(Courtesy of Metropolitan Museum of Art)*

37

Cut-Corner Trays

These must always be striped with gold-leaf or with bronzing powders. Occasionally off-white stripes appear on them. (Titanium white mixed with a little yellow ochre and raw umber.) These off-white stripes may be done in combination with gold stripes.

1. For the double-bordered type, each border is sometimes striped in off-white, or with a gold band ⅜ inch wide, either done with gold-leaf or gold powder. This gold band completely covers the outer edge of the tray and gives the appearance of solidity on the edges.

2. For the single-bordered type:

On the flange: Same as above.

On the floor: One band, in gold ½ inch inside the bend—and one or two fine lines within this, ¼ inch apart.

Lace-Edge Trays (see Figs. 19, 20, and 21)

Only one stripe 1/16 inch wide appears just ⅛ inch inside the bend of the floor. It must be done with gold-leaf. Some old trays appear to have been done in color and no gold-leaf shows. It is thought that the metal wore off since these trays were not protected with varnish coats as ours are today. On the old trays, gold-leaf was usually laid on pigmented varnish while it was tacky. When the gold-leaf wore off the border remained in color (see Chapter IV). The brushstroke border follows the stripe. All shapes of lace-edge trays are striped in this way—oblong, round, and oval. Stripes are made much finer on the small trays.

Oval Gallery Trays (see Fig. 22)

1. The double bordered type is striped the same as the cut-corner trays. Gold-leaf and paint in colors are used.

2. The single-bordered type with the floral center (see Fig. 10) is striped in the same way on the flange as the cut-corner type. It has a wide band ½ inch from the bend and one or two fine stripes within it.

Chippendale Trays (see Figs. 8, 9, and 23)

1. One gold-leaf band ⅛ inch wide on the outer edge painted to give a solid effect may be used. It may be substituted by a fine gold stripe in leaf or powder ⅛ inch within the outer edge of the tray.

2. For trays of the double-bordered type, each border is striped on each side by a fine line which follows the shape of the tray. These may be done with gold-leaf or bronzing powders.

Fig. 19. Round lace-edge tray showing scattered nosegays in contrasting light and dark tones. This picture shows the quality of brushstroke used for this type of painting as well as the formation of brushstrokes for the border. The outer edge of the flange is tipped with gold leaf to match the border. The coloring is in soft green tones, off-shades of white and soft blues with touches of English vermilion. The central rose is floated with Indian yellow shading into alizarin. The center is black and the veiling is done with softened creamy white and pure black. The flower has a modeled white base with black added to form the dark sections. The tortoise shell is not visible.

Fig. 20. Rose lace-edge tray by the author. This design is a copy of an old tray. Notice the unique border in gold leaf which is also copied from an authentic tray of this type.

39

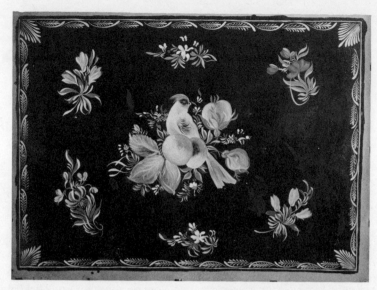

Fig. 21. Blue Jay lace-edge tray design. The inclusion of peaches and flower buds in the central unit, the feathery-looking bird shading from soft, creamy white to lace-edge blues, the detail of the leaves, the nosegays and border are all typical of this class of painting. *(Photograph by Craft Horizons)*

Fig. 22. Oval Windsor tray, portrait type, English, about 1800. Black background with conventionalized gold-leaf border; portrait painted in soft rich tones. *(Courtesy of Cooper Union Museum)*

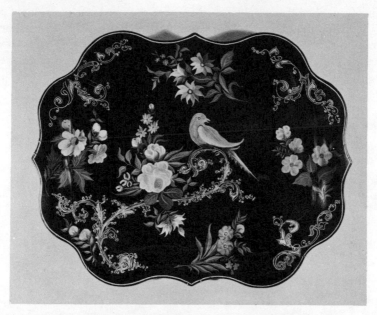

Fig. 23. Red rose Chippendale tray with filigree gold leaf, done with a fine pen and Plax. The red rose is floated on an English vermilion base and veiled over the alizarin. The bird is also done on an English vermilion base with semi-opaque and transparent colors ranging from yellow-ochre to gray-blue on the tail.

PREPARING THE DRAWING AND APPLYING THE TRACING (see Fig. 16)

Cut a piece of good quality tracing paper the exact size of the surface to be decorated. On this make an accurate drawing, using India ink. For dark grounds rub lithopone on the back of the tracing, using a wad of cotton batting. Blow off the excess lithopone powder from the tracing paper. For light grounds draw soft-lead pencil lines on the back of the drawing. Do not use carbon papers of any kind for they leave a greasy film which is difficult to rub off.

Lithopone is finely ground, soft magnesium, similar to French chalk. It will adhere closely to the back of a drawing done on tracing paper because it is not grainy. The surface does not become marred by it for particles which do not wash off with soap and water disappear when varnish is applied.

Fasten the prepared drawing in the exact position required. Use small strips of masking tape. *Never use Scotch tape.* The latter adheres too closely to the surface and is apt to lift the finish when it is removed. Using a small, ball-point stylus or a leather tracer, follow the lines of the drawing, bearing down gently. Be accurate and avoid going over lines a second time. The lithopone will leave a fine white guide line (see Fig. 16) which is not rubbed

41

off easily even when the article is dusted off to remove loose particles of powder. When varnish is applied these tracing lines disappear. The lead pencil drawings must be traced even more carefully. These lines will wash off with soap and water after the painting is dry if they are done lightly and are not too deeply imbedded in the background.

IV. *The Technique of Metal-Leaf Decoration*

Ancient Egyptians used gold lavishly. They carved their designs into both solid and sheet forms. Gold was scarce in China and her early decorators devised ways to extend it. They cast their alloy, bronze, and were largely responsible for the original use of gold mixed with other metals. Chinese decorators also extended gold by hammering sheets of it between two pieces of specially prepared membrane from the ox. The golden metal substance was used as inlay for decorating lacquer religious idols.

Chinese gold appeared in much thinner form and was used in flatter relief than it had ever been in Egypt. The Egyptians acquired raised effects by their carving while the Chinese embossed their gold. They built up the design unit by laying several coats of thick lacquer before applying gold. Much later the Japanese artist shunned the Egyptian mode of scratching in detail on golden designs. The Orientals considered this method inferior and therefore painted all detail in. They used fine brushes with the thick viscous lacquer. Their brushwork became a highly developed skill.

Asiatic artists of a still later era, used gesso for their embossed effects. It was a type of plaster of Paris which permitted the artist to build his design forms on a flat surface. The substitute for lacquer was easier to use. Articles so decorated required less time to do than had those decorated by the raised lacquer technique (see Fig. 1).

The gold standard of current times has resulted in a gold-leaf product of extremely thin quality. Metal leaf is now beaten mechanically and not manually as heretofore. It is unfortunate that our product often comes with many pinholes. Today it takes a good deal of skill to apply metal leaf. It is interesting to know how to use it for its artistic as well as its authentic design effects.

FUNDAMENTAL REQUIREMENTS

The foremost essential for satisfactory metal-leaf work is a clear, dry day. On a damp day the volatile oils in the varnish base of the media used to form the design will not oxidize rapidly enough to allow the leaf to be laid on. The painted units tend to remain sticky indefinitely and they dry unevenly. It is also much more difficult to work during inclement weather when the humidity is high.

Metal leaf must be laid on a background surface which is completely free of any sticky or tacky spots. These may be caused by overhandling the article with moist or soiled hands. It may also be due to incomplete erasures with Carbona when errors are made while painting the design. *(Never use turpentine for erasures.)* If the flat paint which is used for the background is too old it will form sticky spots on the background. Leaf is quick to affix itself where it is not wanted though at times it cannot be persuaded to adhere to the decorative unit. When a design requires metal leaf in combination with other forms of painting, it is essential that the leaf units be done first. This will avoid ugly metal blemishes on units which do not require gilding. The only exception to this rule is found in advanced forms of decoration of the Chippendale type which often employ gold-leaf accents on a painted acanthus-like scroll or on painted units of classic influence. Special treatment of the surface helps the artist to be successful (see Chapter XI).

Good brushwork is essential for doing the painted units on which metal leaf is to be applied (see Figs. 24 and 28). A unit must be flat and smooth. It must never be lumpy or ridgy. Select the correct size brush for the type of unit which is being done. A large unit requires a broad, flat brush, one which will cover a large area quickly and evenly. Brushstrokes and small units must be done carefully and accurately. Flaws become magnified when protective varnish is applied over metal leaf. Do not load the brush too heavily. This would leave puddles which take longer to dry and cause the design to become spotty, after the metal leaf is laid. (See Chapter VII for a discussion of brushwork.)

HANDLING METAL LEAF

When not in use, the book of metal leaf should be stored flat in its envelope. It should be placed in a box reserved for this purpose.

Leaf which comes mounted on tissue, and is marked "for gilding in the wind," does not present as much of a problem, while handling, as do the loose varieties. Each sheet of the mounted kind needs only to be lifted out carefully, so that the remaining pages are not disturbed. This type is excellent to use when the weather is hot. It is of darker gold than the unmounted lemon-gold leaf but unfortunately has more pinholes than the unmounted kind marked for "gilding on glass."

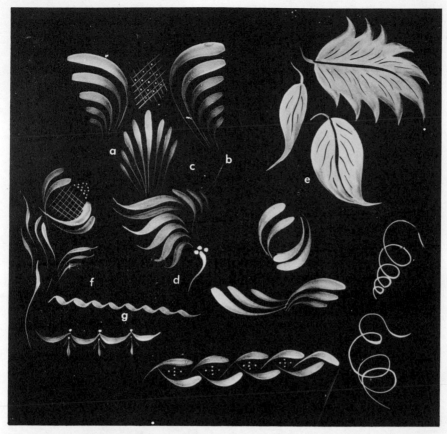

Fig. 24. Brushstrokes, showing their shape and texture. (a) Left-to-right stroke. (b) Right-to-left stroke. (c) Straight stroke. (d) Elongated S-stroke. (e) Wide leaf-forming stroke. (f) Slim long-line stroke. (g) Continuous S-stroke line decoration. The other designs are variations of these.

The unmounted leaf is tricky to handle. Prepare in advance several pieces of wax paper, a little larger than the book. Turn to the end sheet in the book, being careful not to flip the other sheets. In order to prevent damage, do not touch the leaf with your fingers. Hold your breath! Any motion of air, a breeze, or heavy breathing upon it will cause it to wrinkle and it will fly out of control. Place a square of wax paper on the metal and press gently with the finger tips. The wax and the warmth of the fingers combine to pick up this delicate material. If the day is hot it is not wise to use this type. The wax tends to melt in spots upon the article being decorated and leaf adheres to the waxy areas. At all times, when using this variety, wipe the fingers frequently with Carbona to remove the wax which will adhere to them. This will avoid depositing wax upon the article and it will prevent the leaf from appearing where it is not wanted.

45

BACKGROUND MATERIAL FOR LAYING
METAL LEAF

The background material for laying metal leaf must be of the type which becomes tacky before it fully dries. It is important that the background of the unit to be so treated, should have the correct degree of tackiness before the leaf is laid. Test the painted design unit by pressing the finger gently on a section of it. If an imprint remains, wait a little longer before applying the leaf. Care must be taken not to leave too many of these imprints for they will show beneath the leaf. If the finger is sticky after testing, wait even longer. It will take practice to determine the correct degree of tackiness but bear in mind that Hour varnish or clear service-seal will *never* give you the right surface because they do not remain tacky long enough and they dry too quickly. Metal leaf which is laid too soon disintegrates on a too-wet media. On the other hand, if the area is too dry, the leaf will not adhere evenly and the unit will be incomplete.

BLACK SERVICE-SEAL

Black service-seal is a product made from a varnish base to which black pigment has been added. It is excellent to use for large areas which are to be gilded. It has one drawback—it tends to spread if it is used too heavily. Because of this it is not satisfactory for fine lines or for delicate detail. If it is allowed to thicken, by leaving the can open, it may not flow satisfactorily from the brush or tool being used even though it does not spread as much after it is painted on.

To use black service-seal, place a little in a small discarded bottle cap. Dip a clean brush into it and, before beginning the design, work the service-seal into the brush by doing a few strokes, over and back, on a small piece of aluminum foil or on a scrap of paper. *Never use the brush too heavily loaded.*

SPAR VARNISH WITH TUBE OIL PAINTS

Quick-drying Spar varnish mixed with a little oil paint, from a tube, permits smooth painting of the design. Only enough oil paint is required so that the painting may be easily seen against black. It must not be used heavily. Light chrome yellow is excellent because it blends with the gold leaf. If you wish to give your leaf units an added warmth, apply gold leaf on English vermilion mixed with varnish.

To use this medium, place a small dab of oil paint on a square of aluminum foil. Pour a little varnish into a bottle cap. Dip the brush into the varnish and mix it with the pigment on the foil until it is smooth and neither too dry nor too wet. Use very little pigment and never have the brush too heavily loaded so that you avoid forming those puddles. In this instance the oil paint is merely the vessel which keeps the varnish within bounds.

Spar Varnish with Bronzing Powders

Quick-drying Spar varnish mixed with a little bronzing powder may also be used to paint the design. Select a powder to match the metal-leaf, either gold or silver. Place a tiny heap of powder on the palette. Dip the brush into the capful of Spar varnish and mix a little powder with it. Do this over and back so that the brush is filled evenly but is not too heavily loaded. This mixture is excellent for doing fine lines or small detail because it can be seen readily while it is being painted but will not spread after it is applied. Apply the metal leaf when the design is tacky. (See Figs. 20, 25, and 26.)

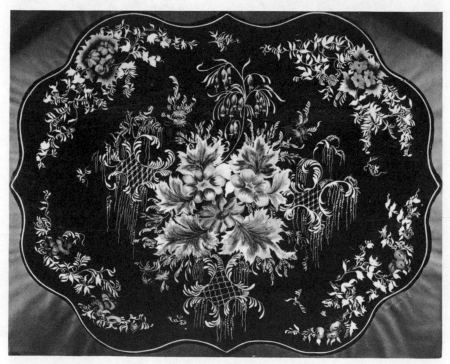

Fig. 25. Drippy moss Chippendale with etched metal-leaf leaves. Flowers in the central unit and those interwoven into the gold-leaf border are floated in soft yellows and blues. The large leaves are in silver and gold leaf; those surrounding the smaller flowers in the upper corners are medium green dusted in pale gold bronzing powder. Everything else is in gold leaf. Note the tiny curlicues, drippy moss effects, and the brushstroke formations.

Other Media and Tools for Fine Details

Architect's ruling pen. An architect's ruling pen or tool, adjusted to its closest point, may be used for fine detail which is to be done with metal-leaf. This requires a medium which will flow from it in a controlled yet free way. It must also be a medium which will remain as it is applied and not spread

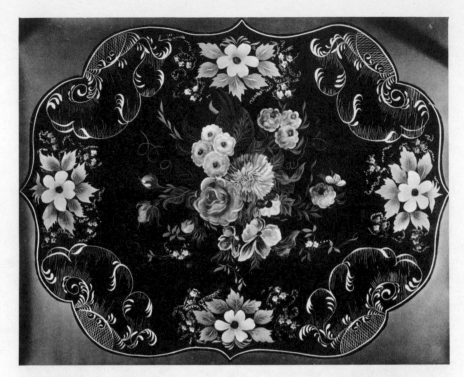

Fig. 26. Blue chrysanthemum Chippendale tray design on a black background. The delicate brushstrokes and line combinations at the four corners lend charm to this old design and provide a contrast to the gold-leaf etched and shaded flowers with their free-hand-bronzed leaves which are placed between the corners. Note the tiny curlicues. The central arrangement includes a blue chrysanthemum, a soft pink rose, and other flowers in shades ranging from yellow through salmon. The leaves are in several shades of green with fine details done over their opaque shapes.

or widen while it becomes tacky. Enamel paint of a good quality *from a* FRESHLY OPENED CAN, in any suitable color, may be used. Mix the paint in the can thoroughly and fill the tool with the tip of a brush. While using the tool, clean it often with turpentine, being careful to dry it well each time. (See detail of squiggles, Fig. 30.)

Small ball-point or plain pens. A small-size ball-point pen or a medium-size ordinary pen may also be used. The medium best suited for these is called Plax, an enamel made by the Lowe Brothers Paint Co. It comes in a variety of colors, and is excellent for extremely fine detail. It flows readily from a pen (if the Plax is not too old and the can has been kept tightly covered). It can be thinned with a *little* turpentine to increase the flow (too much turpentine causes the Plax to spread). The pen must be cleaned with turpentine often, and dried thoroughly while in use. (See Fig. 25.)

French quills. Square-tipped No. 2 French quills (see Figs. 14(3), 20, 25, 27, and 29), used with Spar varnish mixed with artists' oil paints, or with

gilding powder, are also satisfactory. Mix the medium with the quill, flattening the brush like a knife blade. Do the lines with the quill held in the position of a knife used for slicing purposes. The mixture on the brush must be neither so wet that it puddles nor so dry that it leaves unfinished sections. A pointed quill is also satisfactory especially when it is held in a horizontal position for doing the curlicues over which leaf is to be laid (see Figs. 10 and 24).

Sig-nette (see page 25) may be used on any kind of surface.

APPLICATION OF METAL LEAF ON A DESIGN

PROCEDURE

Since the large units will take longer to become tacky than the smaller ones, they are painted first. It is not necessary to do them all at once on the complete piece which is being decorated. This would incur a waste of valuable metal leaf since it would then necessitate the use of additional sheets for the smaller detail. Do two or three large units in one area; then proceed to

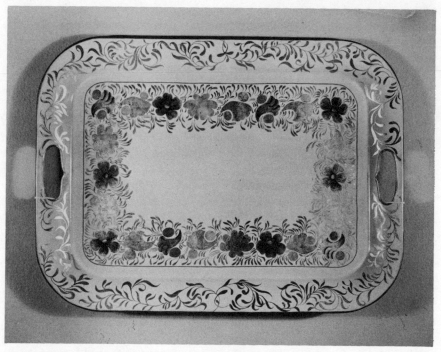

Fig. 27. Double-bordered tray with a shell design on a cream-white background. The design is in etched gold leaf with transparent blue and alizarin washes. The flower forms are in the blue and every other shell is accented with alizarin.

the units next in size and do, last of all, the tiny tendrils or stems. When the complete area is tacky, lay the metal leaf over it as follows: Lift the metal leaf from the book on either wax paper or on its own tissue, depending on the type used, and place the sheet metal-side down on the tacky, painted decoration. Gently stroke the paper side with the finger tips. Lift off the paper. If metal-leaf particles of large enough size remain, use the paper again on another design unit. Be careful that all the units have been covered with the metal. Continue with the painting and metal-leaf laying until the entire piece is done. Set the article aside for a few hours.

Brushing Off Excess Metal Leaf (see Fig. 15)

Excess metal leaf must never be brushed off immediately after it has been laid. Wait two or three hours; then use a soft camel hair brush which you reserve for this purpose only. Brush off the excess gently, taking care not to scratch the leaf. The design will appear in flat relief. With a small piece of cotton pick up the waste leaf, being careful not to damage the design. Save the cotton in a box. When there is an accumulation of gold leaf waste it can be sold.

Some craftsmen advocate waiting for at least twenty-four hours before brushing off excess leaf. But when that much time elapses any sections to which metal leaf did not adhere will remain uncovered because the medium on which it was laid will have become too dry to accept more leaf. The painted design is likely to remain sufficiently tacky after two or three hours so that it will still accept leaf during the gentle brushing-off process.

ETCHING INTO THE LAID LEAF (see Figs. 28 and 31)

Etching gives contour and adds perspective to otherwise flat units. *It must be done within the first twenty-four hours after the leaf is laid* and before the medium upon which it was laid has dried too much. Etching may be simply done or it may be elaborate. It is a method of scratching in lines which break the metal leaf and permit the dark undercoats to show. Imitation of etching may be done with pen and ink if too much time has elapsed after laying the leaf. The latter method is coarser in appearance and should be done after the excess leaf has been washed off, and a protective coat of varnish has been applied.

Single-Line Etching

Single-line etching marks in the veins of leaves and makes the petal divisions of flowers. It also helps to give form to classic objects like baskets, urns, and cornucopias (see Figs. 31, 32, and lower right of 33). This type of etching is done by bearing down, not too heavily, on the newly laid leaf while the medium beneath it is still semi-soft. When etching is done within twenty-four hours after laying, the metal leaf will not crack off or split. The tool re-

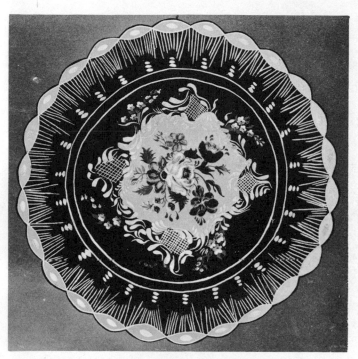

Fig. 29. Design for a small card tray. The background behind the central floral unit and the border within the oval lines are of light turquoise blue. The central rose is floated on gold leaf. All highlighted detail is in gold leaf.

them too abruptly. Then cross these lines at right angles to the first group done. Each needle will leave a mark. The three or four needles will work in unison to cover more space, making evenly spaced lines. (See Figs. 31 and 32.)

PREPARATION FOR TRANSPARENT DECORATION

Set a freshly gilded article aside, after it has been etched, for at least one week. This is important. Place it where it will not be disturbed and where no dust will attack it. Do not, however, place it in an air-tight place such as a closed drawer for, to dry properly, varnish must oxidize in fresh air. Because metal leaf covers the medium upon which it is laid, the varnish cannot dry as rapidly and extra time is, therefore, allowed. If the background of the design unit is not thoroughly dry, when the protective varnish is applied, the metal leaf will disintegrate or it will become spotty.

Wash the article thoroughly one week or more after all the leaf has been laid and etched. Place the article under slowly running warm water and rub it gently with the finger tips. If there are a few stubborn, unwanted spots, use a little Ivory soap on the finger tips. Spots or blemishes which do not come off at this time may be painted out or gently scratched out, later.

52

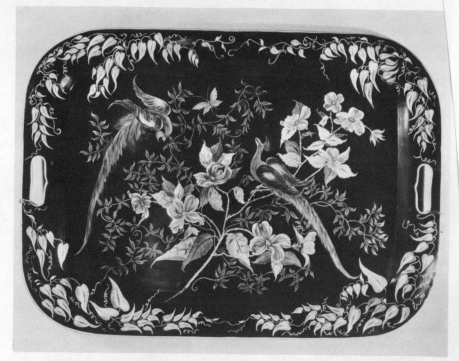

Fig. 28. Etched gold leaf and painted bird and dogwood tray. The author won an A award for gold leaf from the Esther Stevens Brazer Guild and a first prize at an exhibit of the New Rochelle Art Association for this tray. Etched gold leaf is used for the border, stems and large leaves of the central unit, and the birds' wings. Paladium leaf is used for the butterfly and the darker large leaves in the center. Soft transparent green is used over the etching on the leaves and delicate yellows over the etching on the butterfly. All other units are given shape and shadow with burnt umber which is also used for veinings. Floated color and painting are used on the birds. Small leaves are freehand bronzed on their tips in gold powder on a soft green. The dogwood flowers are given their form with transparent and opaque shades of white. They are also veiled and have a delicate floated wash of light pink shading into green. Their centers are of stippled yellow and green-brown.

quired for this is a single No. 8 sewing needle inserted into a pen-holder and soldered in. These lines form the unit and should always be done first. (These tools may now be purchased. See page 164 [E. P. Lynch, Inc.].)

Cross-Hatching

Cross-hatching (see Figs. 28, large leaves, 31, 34, the bowl, and lower right of 33) is done where a shaded effect is needed. It gives perspective to a unit. Use a three- or four-pointed needle tool made by inserting three or four No. 8 sewing needles, evenly and close together, into a penholder and also soldering them in. To cross-hatch do lines going one way being careful not to end

Fig. 30. Enlarged squiggles and line work of Fig. 5. This work is done with enamel paint from a freshly opened can and with an architect's ruling pen adjusted to its closest point. Gold leaf was laid when the area became tacky. The white lines within the diamonds were later partly covered with black India ink. The striping is in white and pale gold powder. *(Photograph by Herbert Studios)*

Fig. 31. Design for a white bellows, gilded with gold leaf and painted. The two large leaves and the design for the back of the bellows are in gold leaf. Note the detail of etching and the accents of lines and brushstrokes done in burnt umber on the leaves and the brushstroke composition for the back. The morning glory is in deep Prussian blue; the rose has the talisman coloring; other flowers are of deep yellows and orange tints. The painting is all done in transparent colors on the off-white ground.

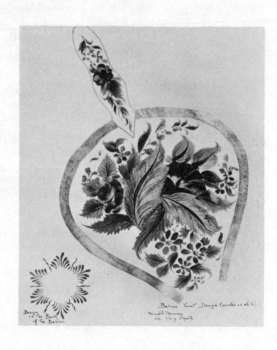

Fig. 32. Gold-leaf cornucopia with freehand-bronzed fruit. This is part of a twelve-foot board. The background is a deep, soft orange-red. The cornucopia is etched in cross-hatching to give a shaded roundness and is accented by black brushstrokes. Additional color contrast and form are achieved by a shading in of raw umber. The fruit is freehand bronzed on black. The pineapples, peaches, and melons were given sharp detail by the use of specially cut stencils. A fine, gold-painted stripe borders each of the three sections of the cornice board. Decorated and designed by the author.

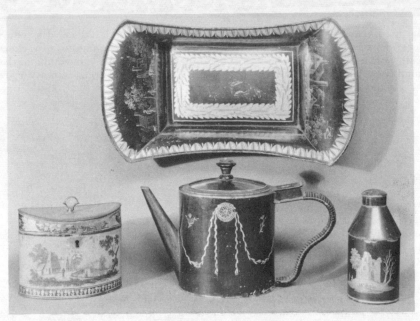

Fig. 33. Tole accessories. *At top:* Bread tray with painted rural scenes at the ends and etched gold-leaf borders accented with burnt umber strokes. Black ground. England, about 1810. *Lower left corner:* Tea caddy. Buff ground. Painted design with gold-leaf borders. Wales, about 1810. *Bottom center:* Tea pot. Brown ground, possibly asphaltum with a simple and interesting gold-leaf design. England, about 1870. *Lower right corner:* Tea canister. Green ground with an etched and exquisitely painted gold-leaf design. The shading is done skillfully with burnt umber which gives the castle great depth and realism. England, about 1820. *(Courtesy of Cooper Union Museum)*

54

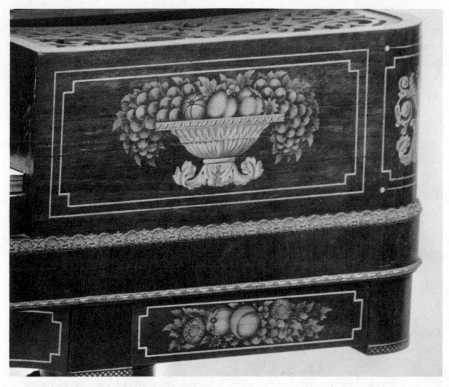

Fig. 34. Detail of piano case made by John Tallman (ca. 1825). Made in New York. The profuse stencil and etched gold-leaf decoration are done on mahogany. The photograph shows the clever shading of one unit behind another and the combined stencil and freehand-bronzed techniques with bronzing powders. Note the exquisite etching detail of the bowl which gives it an almost three-dimensional appearance. *(Courtesy of Metropolitan Museum of Art)*

After washing a metal-leaf article permit it to *drip dry. Do not rub it dry lest you injure the delicate metal-leaf units.* If the article which is being decorated is a wooden one, do not continue with further work for another week (see Chapter I).

CORRECTING MISTAKES; REMOVING BLEMISHES

There are two methods for correcting mistakes and for removing unwanted spots and blemishes. Very small errors may be scratched out with the rounded edge of a sharp knife. Care must be taken not to injure the background. Extremely stubborn spots or areas which have not kept within the bounds of the decoration may be painted out. Use a fine brush with black service-seal. Holding a magnifying glass while making repairs often helps to detect the infinitesimally small metal-leaf grain which is hardly visible at this stage but which becomes magnified under protective varnish coats. If an

article is flat black, the service-seal will be shiny on it when corrections are made, but as soon as the varnish has been applied the shininess disappears. If a white or a colored ground is used, do the repairs with the same color of flat paint that was used for the background. *Repairs must be done on the flat-painted ground before protective varnish is applied so they will not show. Never do them over a varnish coat!*

If metal leaf did not take on a particular unit, or a section became spotty, it is best to carefully sand down the area with wet No. 600 sandpaper. Do this until the area is smooth. Paint the design unit or section again and lay leaf on it when it is tacky.

Protective Varnish

Two coats of protective varnish must be applied twenty-four hours apart before proceeding with the rest of the decoration. Rub down the second coat very lightly, using wet No. 600 sandpaper. This will give a smooth, very dull and unattractive surface. Transparent painting and other decorative techniques can be applied with better results because the surface is slightly roughened and is not shiny. The paint will also cling better.

Always apply protective varnish over the entire piece when metal-leaf decoration is done before proceeding with further steps. It protects the tender leaf if erasures with Carbona are necessary later on.

APPLYING TRANSPARENT COLOR ACCENTS

The beauty of metal-leaf designs is heightened when the large etched units are accented or shaded with transparent paint. For a monotone effect, use burnt or raw umber, mixed with varnish. Burnt umber is a warm reddish brown color which gives gold leaf a still warmer glow, while raw umber, being of a grayish cast, will tone down the yellowness of gold leaf. Veins along the centers of leaves are usually accented with a well-formed, slim brush-stroke of burnt umber. When shading appears, it is blended in such a way that there are no sharp or marked distinctions.

Silver and palladium leaf may be given the appearance of gold by a wash of transparent yellow. A gold-leaf unit may be made to seem even more golden by a wash, or shading, done by mixing Indian yellow with a little burnt umber. This color is used primarily over gold-leaf roses and helps to give them added form and color contrast over the etching.

ANTIQUING METAL-LEAF DECORATIONS

Before applying the second coat of protective varnish *(never apply an antiquing coat of varnish directly on the design)*, add a little black service-seal to it.

Stir it into the varnish thoroughly, but gently, with the varnish brush, while the liquid is being heated over hot water. The addition of black in the varnish will take away the metallic qualities of the leaf but it will not detract from its glow, or change its color as raw or burnt umber will.

The addition of raw umber to varnish will give metal leaf a brown cast, while burnt umber results in a reddish brown. Burnt umber is not generally used for antiquing purposes.

Some decorators prefer to add small quantities of Prussian blue in combination with equal quantities of alizarin crimson. This method is similar to using black but requires more careful handling.

V. *Metallic Powders and Dry Bronzing in the Freehand Manner*

ORIENTAL AND EUROPEAN METHODS, PAST AND PRESENT

Pure-karat gold powder will not remain grainy as will powders produced from other metals and their alloys. The latter are harder and less malleable than gold. They do not pack down as karat-gold powder will. The precious type of powder or dust was at first used by the Orientals to obtain solid effects. It was pressed into the tacky surface and then was burnished with tools made from specially shaped stones which smoothed, packed the gold down, and polished the design. Much later, the Japanese discovered that their fine abrasives, made from charcoal and from calcified antlers, could be used to rub out parts of these burnished units. This polishing out or rubbing out of the gold powder resulted in softened effects and gave exquisitely beautiful and subtle chiaroscuro against the dark lacquer. It was a change from the hard contrasts of former designs which, including sheet gold, also employed such substances as semi-precious stones, cinnabar, and mother of pearl for delicate inlay purposes.

The method called freehand bronzing is a reversal of the Japanese way— instead of rubbing out gold, to acquire shadings, the powder was sparingly rubbed into a given unit and thereby shaded to give the same effect of chiaroscuro which had been done by the Oriental in his rubbed-out method. This type of bronze decoration was invented by Thomas Hubball of Clerkenwell, England in 1812. His scenic trays done with bronzing powders were well-known and are museum pieces today. The powder used was no longer karat-gold but a more sturdy alloy, ground to extreme fineness and possess-

ing the permanent glow and sparkle of karat gold as well as many other metallic shades (see Figs. 35, 36, and 37).

SUITABLE BACKGROUNDS

The beauty of the freehand-bronze technique is dependent upon the background. Light backgrounds serve as an interesting contrast to the black designs which are given form and substance with bronzing powders. Units whose outer edges remain black must be done on light grounds. Outer edges of a unit done on black or dark grounds must be polished to make the design stand out.

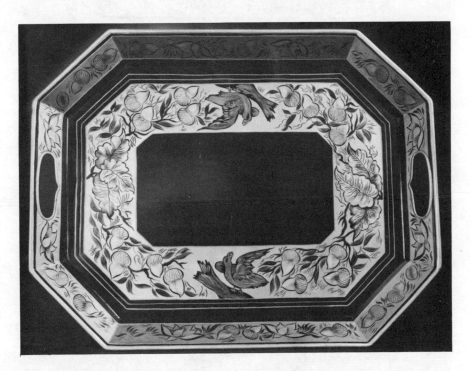

Fig. 35. Freehand-bronzed bird and acorn octagonal tray. Copper, shades of gold, brown, and black are the colors emphasized. The striping is English vermilion and Venetian red. A painted and polished gold band binds the outer edge. The detail of the leaves and acorns, which are shaded from black to orange and yellow-gold, is done in fine black linework. The smaller leaves, brushstrokes and stems are in burnt umber. The birds on the logs are done in the wet, freehand-bronzed method on black, with a mixture of pale-gold powder with burnt umber and varnish. White lines are used for added accents and detail. The bronzing is done on polished copper bands. A stencil is used for the somewhat conventionalized flower in the border. (*Photograph by Grishman Studio*)

Fig. 36. Scenic freehand-bronzed tray, "Shepherd and Sheep," done on a white ground. The sheep, shepherd, house, and tree-trunks are bronzed on black service-seal. The stone fence, tree-foliage, clouds, hills, and ground, are done in bronzing powders. Brushstrokes are in black and burnt umber. The band on the flange is a repeat stencil done in pale gold on a black painted band; the copper is then polished in to cover all remaining black. Striping is in white on the flange which is banded by dark burnt umber and in Venetian red and English vermilion. The coloring is in gold, copper, and silver tones blended into black on white.

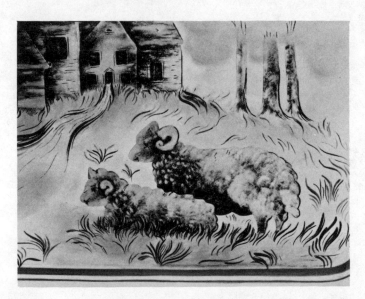

Fig. 37. Detail of stump work for freehand bronzing of sheep of Fig. 36. Lining powders are pale gold and silver. The house is mostly silver with gold and a little copper. The ears of the sheep are done with a stump, not a stencil.

60

Gold and Silver-Leaf Bands Against Black

Gold and silver-leaf bands against black appear singly or in pairs. Usually there is one on the flange and often another on the floor of a tray. These bands are often broken to permit other painted forms of decoration on the flanges. (See Fig. 5.) Boxes may be designed in many banded combinations. Articles so decorated are known as Pontypool because they originated during the eighteenth century in the town in Monmouthshire, England which bears the name. These bands add elegance to pieces so designed. They offer rich textural contrasts as well as color to the designs fashioned upon them. These bands appear on rectangular and cut-corner trays. Such trays, coffee urns (see Fig. 38) and other accessories are rich in the decorative techniques of the Orient, modified by western ideals. (See Figs. 4 and 5.)

Fig. 38. Coffee samovar and tray, decorated by the author on a cream buff ground. The design units employ a combination of techniques: etched gold leaf, freehand bronzing, and painting. The coloring is in light blue and rose with green. The accents, the border brushstroke design, and the striping are in burnt umber. The handles of the tray and the samovar are in orange bronzing powders to blend with some of the units which are also done in this shade.

Bands of Polished Bronzing Powders Against Black

No gold or silver bronzing powders are used when solidly polished bands appear behind the freehand-bronzed units. Powders in silver and gold are used only for a smudged effect (see Figs. 6, 8, and 9). If gold and silver powders are solidly polished they look like cheap imitations of bands made from

61

genuine karat silver and gold leaf. When a bronzing powder is used in this way it is usually of a color which is distinctly unlike the precious metal variety. Copper tones and pink as well as orange bronzing powders are used for this effect. The decoration over them blends beautifully with the shade of powder used on this type of band. The decoration is often of a monotone quality with sharp but delicate black contrasts. The decorative units blend with the black background behind the bands. A great deal of burnt umber appears as transparent painting for added detail. (See Fig. 35.)

BANDS OF WHITE AND COLOR AGAINST BLACK

Freehand bronzing is often done on bands of solid white and on other colors. Chief in the color range is the orange-red also known as Chinese red. White usually turns creamy when varnish is applied. This helps to unify the designs and makes the white look like fine china.

SOLID WHITE AND COLORED BACKGROUNDS WITH BLACK BANDS

When solid white is used as a background upon which to do freehand bronzing, the designs are often of the scenic variety. The designs range also from the pastoral to the purely conventional. (See Figs. 36 and 37.) These latter require many stripes to finish off the double borders. The scenic trays are often combined with flange borders done with stencils (see Figs. 35, 36, and 37). The stenciling is applied on painted black bands which are done with black service-seal.

BLACK BACKGROUNDS

Completely black trays may be bordered with a simple stenciled unit which is repeated all around and made more interesting by a combination of stripes. The central unit may be a pastoral scene or it may comprise a grouping of fruit and flowers done to actual size. They carry bright color accents either by striping or by painted-in brushstrokes. The fruit designs usually carry a transparent wash of color to make them more realistic.

SMOKED BACKGROUNDS ON WHITE

Smoked backgrounds on white (see Chapter I) which are done with a candle flame are extremely beautiful for freehand-bronzed designs. This background can be made to look like marble or like an old piece of beautifully weathered parchment. Smoking should be done on wooden objects. The bronzed designs never take transparent washes when done on wood. Varnish should be applied over the smoking for protection before the design is done (see Fig. 2).

Black service-seal is an excellent medium upon which to do dry bronzing in the freehand manner. See Chapter IV for the proper way to use it. Modeling with bronzing powders is done when the design unit is tacky.

Black artists' oil paint in tubes (lamp black or ivory black which are both semi-transparent) mixed with Hour varnish may be used for a very special transparent and semi-transparent process. Lamp and ivory black take longer to dry than black service-seal so we mix them to a thin consistency with Hour varnish.

The designs for the semi-transparent type of bronzing must be done on light colored grounds like Chinese red. For the sections of a unit which are intended to be in front of the remainder of the unit, due to perspective, use very little black in varnish, only enough to make the tone slightly darker than the background. These units are modeled with bronzing powders when they become tacky. A day later, the back sections, perspectively speaking, are done in a much darker tone of black but still in a semi-transparent manner. These are also modeled with bronzing powders. The bronzing on this type is done lightly so that the background color and the thin black show behind the design.

Tube oil paints in colors such as green and red may be used to paint the units to be freehand bronzed. Both opaque and transparent colors may be used in this manner. This method appears in exquisite variations on green leaves and some types of roses of the Chippendale class.

BASIC PRINCIPLES

When the design includes metal-leaf laying this is done before anything else. When metal-leaf does not appear, the bronzing is then the first thing to be done. Do not allow bronzing powders to adhere to units which are not supposed to have the powder. Of course, it is understood that the background and the marking in of all striping lines are done first of all. The laying of leaf precedes the bronzing in the actual design.

TACKINESS OF SURFACE

True freehand-bronzing effects are acquired without a stencil or theorem. The results are freer, less set and no two units of the same shape are ever quite alike, thereby lending charm to the design as a whole. When stencils are used, their purpose is to give a sharp edge or to mark off sharp distinctions in shading. These require less skill and thought to do than the more distinctive method which requires imagination as well as a first-hand knowledge of design forms and of tacky surfaces versus bronzing powders. The stencil is often used, however, for a border on the flange. It helps give a tailored effect to the freer form of decoration within its bounds. (See Fig. 36.)

Most freehand bronzing, when metal leaf or bronzed bands appear, is done on a varnished surface which forms a protective covering for the bands. This surface should consist of two varnish coats and a smoothing off with wet sandpaper, after the second coat is thoroughly dry. Bronzing powders are controlled more readily than is metal leaf. The surface for the technique being described in this chapter must be as free of tackiness as possible so that clean-cut results may be attained. For best final results any painted unit must be done upon a dry surface—otherwise a certain crawling of the paint is likely to result.

OVERLAPPING UNITS ARE DONE SEPARATELY

The degree of tackiness required for freehand bronzing depends largely upon the type of bronzing and the tool being used. When the velvet square is employed there should be only a little powder on it. If the surface is too wet the velvet adheres to the design and the powder will not polish in evenly. Too much powder on the velvet square results in a spotty and ugly type of shading. When a knob or button of velvet is used the tacky surface must be neither too wet nor too dry. This form of tool cannot be used too heavily loaded with bronzing powder though it should carry more than the velvet square. The surface to be bronzed should result in highly polished sections contrasted by well-blended dark portions (see leaves of Fig. 35). A charcoal stump or a brush must be heavily loaded with bronzing powder. They require a wet-tacky surface. Be as direct and positive in the handling of these tools as you can. Any extra motion will dislodge the powder from the tool and it will mar a section it is not intended for. *When using bronzing powders in these heavily loaded techniques apply the powder on the correct spot, by polishing or forcing it in; then* DO NOT RUB OVER IT. *Allow the surface to dry thoroughly and twenty-four hours later wash off the excess powder under running water.* The results will be gratifyingly beautiful, for you will have retained the dark contrasts behind the finely polished detail of bronzing.

Good perspective in design units which overlap one another requires that each unit should be done separately. The one in the foreground should be done first and should be more highly polished than the one behind it. There should be dark shading behind the unit to form its shadow on the back unit. *Touching units must always be done separately and at least twenty-four hours apart.*

WET BRONZING

Frequently, for contrast in tone and texture, wet bronzing appears for cer-certain units (see the birds and the logs of Fig. 35). The units of these are painted solid black with black service-seal. This is allowed to become tacky. The correct shade of bronzing powder (in this instance pale gold) is mixed with Spar varnish and burnt umber on the palette with a No. 2 French quill. Detail is painted on in brushstrokes (which should look slightly ragged or

brushy), over the tacky surface of black. Placing these strokes at the correct angles will give added form and substance to a design unit. Black sections must be retained for contrast. When the detail is completely dry tiny off-white brushstrokes are applied for added accent (see the birds of Fig. 35).

TOOLS FOR DRY BRONZING (see Fig. 13)

The Velvet Square

With the exception of the charcoal stump, the tools used for freehand bronzing must be prepared by the artist. The square of velvet must be made from the best quality *real silk velvet* available. It must be tightly woven so that the pile will remain imbedded in the weave and not become loosened by the tacky surface it is to polish. It must be four inches square and hemmed carefully on all four sides to prevent ravelings from adhering to the design unit. The static created by the synthetic velvets makes them unsatisfactory. If a square from grandmother's trunk in the attic is used it must be strong enough to withstand hard polishing. The velvet square is carefully wound around the index finger. The tacky surface must not be too wet.

The Button and the Knob

The velvet knob or button may be made in two ways. For a very small knob get the tail feather of a goose (perhaps you know a farmer who can tell you when the moulting season is). Cut off the tip opposite the feather end of the quill and carefully insert a tiny piece of that extra-special velvet. A fine strip of good English or French chamois can also be inserted for extremely fine work. Tie these strips in with a strand of silk thread to secure them in place. The buttons are slightly bigger and can be used in various sizes. The smallest consists of folding a small piece of velvet into a point and fastening the section above it by winding it with silk thread thus forming a stem with which to hold it. Larger sizes may be made by folding small wads of cotton batting into the pointed section of velvet. The quantity of cotton used will determine the size of these buttons or knobs. These should also be wound with silk thread to form their stems and to hold the cotton in the required space. The knobs and buttons are used for bronzing small areas when other tacky sections of the design should be avoided. Use a dry-tacky surface with these (see "Units Used Most Frequently" below).

The Charcoal Stump (see Fig. 13)

The charcoal stump may be purchased in various sizes. The smallest are sold in bundles. These stumps are made of a kind of blotting paper which can be unwound to make the tip as sharp or small as the design unit requires.

Stumps are excellent for effects such as the wool on sheep or veinings on leaves (see Figs. 36 and 37). They can be used most satisfactorily for bronzing extremely small units. To make the tip of the stump even finer than it is possible to do by the unwinding process, rub the tip on a piece of No. 600 sandpaper, then twirl the tip between the fingers to remove bits of dust and lint. The tacky surface must be wetter for stumps than for other tools because, for best results, they must be used more heavily loaded with bronzing powders. (See below.)

The Brush

A French quill, moistened in the mouth, will pick up bronzing powders. Bronzing powders of the kind called lining can be deposited in fine lines for forming veins and other detail. The tacky surface should be wetter for these than it is when the velvet square is used (see below). Lines done in this way are a little fuzzy and lend charm to a unit so treated. They are not as set looking as they appear when they are painted in the wet technique which is done by mixing varnish with bronzing powders.

Units Used Most Frequently

Certain design units appear most frequently in this technique. Methods for forming them will be described. Black service-seal is the medium upon which the bronzing is done. (Varying degrees of tackiness are required for each type. *Dry-tacky* is the degree reached just before the service-seal becomes too dry to accept powders. *Medium-tacky* means that the service-seal is at the usual stage and that it will remain tacky for some time before it will not accept the powders. *Wet-tacky* means that the service seal is still very wet or sticky to the touch and cannot be stenciled into but that it will accept the *heavy application* of powder when a stump is used. *No unit must be rubbed or touched for at least twenty-four hours after it has been bronzed. It must then be washed under running water to remove all excess powder.* Only then do the design units become distinct.)

Fruits

For peaches (see Fig. 40f) paint the front "cheek" section first. When dry-tacky, polish in the middle of this area with the velvet square, using a little silver powder mixed with pale gold. Very gradually shade this highly polished area to nothing allowing no sharp division to form and leaving the outer edges black, if the peach is to appear on a light background. Use a little powder on the edges when it is done on black or dark grounds. Twenty-four hours later, paint the section behind the "crack." Polish this in lightly, using a button. The entire peach form can also be painted at once. The front

66

cheek can be sharply outlined using a button tool or a thick charcoal stump. Finish the fruit by using the velvet square to polish in the powders and to shade them off.

Persimmons are distinctive because the "bud-end" of the fruit gives it unusual design qualities. (See Figs. 40g and 42.) Use a medium-tacky surface. After painting the fruit form, begin by placing the "dot," using a small charcoal stump loaded with pale gold and holding it in a horizontal position. Then do each of the three sections below the "dot," beginning at one side of the dot but not touching it and shading it downward with the pale gold. Wait a short while so the black service-seal will become drier and then polish in the cheek of the fruit using the velvet square with pale gold mixed with a little silver to give it an interesting highlight. Shade this off gradually into the section forming the "bud end," leaving all edges black around the fruit if it is to be done on a light ground (see Figs. 40g and 42).

Grapes which overlap are done singly. Paint the grape and when it reaches the dry-tacky stage place a highlight of silver in the center using the stump

Fig. 39. Enlarged freehand-bronzed rose of Fig. 5 showing formation of highlights and stump work outlining the middle petal and forming dots in the center. The powders range from silver for the highlights, to pale and deep gold. Note the stump-work veins on part of the leaf at lower left-hand corner and in the flower beneath the rose. (*Photograph by Herbert Studios*)

67

or the velvet square folded so that it forms a sharp point. Then polish from the highlight outward, using pale gold. Do the grapes which appear to be behind others after the front grapes are done, allowing them to shade off to nothing before they reach the outlines of those in front of them. Wait twenty-four hours before doing those which touch other grapes. (See Figs. 40b, 41, and 42.)

Apples are done in the same way as peaches but with no sections (see Fig. 40b).

For strawberries polish center highlights using the velvet square; shade them off as they approach outer edges. Paint on, or stencil in, small dots to represent small seeds (see Figs. 40c and 42).

To do freehand bronzed flowers you must know exactly how the flower is put together and what each part, and the whole, look like. Roses, for example, should be done so that their highlights form contrasts and their petals are placed at correct angles to give them their true shapes. A combination of all tools is advised. (See Figs. 39, 40a and b.)

Fig. 40. Units done in freehand-bronzing technique. (a) Rose with highlights stenciled for accents (see Fig. 39 and compare). The leaves have turnbacks which are stenciled in. (b) Apples, each done separately because they are touching units. (c) Strawberries with superimposed painted seeds. (d) Grapes of freehand-bronzed method with super-imposed white brushstrokes in paint for accent. (e) Flower with painted accents. (f) Peach done without a stencil. (g) Persimmon done without a stencil. (h) Leaves with brushed-in veining done in the dry-bronzing method. Turnback of middle leaf is in gold leaf, etched.

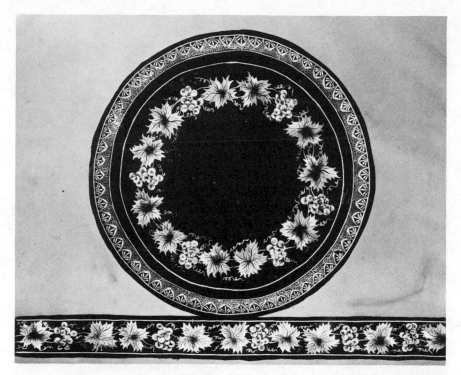

Fig. 41. Design for a round wall clock or a tray, done in the freehand-bronzed method. The squiggles of the border are polished with copper bronze which is also used in combination with gold on the leaves. Grapes are done in silver and gold and each has a small thin white, toned down brushstroke. The brushstroke border and striping are in semi-transparent creamy white. The curlicues are polished with gold powder and the veinings on the leaves are done in black.

LEAVES AND ACORNS

Leaves and acorns, as well as other forms, may be done with a combination of metallic colors—pale gold, copper-bronze, and orange-bronze are usual. They are applied heavily and one section is blended into another, permitting some of the black of the design to show. (See Figs. 35, 40a, 40e, 40h, the shells of 41, 43, and 44.)

MISCELLANEOUS

A miscellany of design forms have been used with the freehand-bronze technique. Again, sections of each of the subjects should be done which do not touch one another. The shepherd (see Fig. 36) was done in this way. It took three days to complete the whole, but each section—the head, the coat,

Fig. 42. Freehand-bronzed design for a plate warmer. The background is a rich, deep red and the bronzing is done in gold. A stencil was used to give form to the large fruit at the left, but it could have been done with a charcoal stump which was used for the fruit at the right (as can be clearly seen in the photograph). Leaf veins and other detail in black.

the socks, shoes, etc.—is an independent unit which touches but does not blend into another. To use stencils for these sectional divisions would make the units look artificial. The house (see Fig. 36) was also done in sections with no stencils. A sharp-pointed charcoal stump and the velvet square were used for all the above mentioned units. Animals like the sheep in Figs. 36 and 37 were given a woolly look by using a heavily loaded, sharp-pointed charcoal stump. The bronzing powders were applied into a wet-tacky surface. These units are done with silver lining powder and a little pale gold. The sheep, however, are mostly done with pale gold with a few highlights of silver. Each sheep was also done separately, twenty-four hours apart. Every section of a unit was allowed to dry thoroughly. It was then placed under warm running water to remove excess powder. The tray was allowed to drip-dry and the next touching unit was then done. Patience is the primary requirement, for it took almost two weeks, doing only a little each day, to complete this design. Clouds and tree foliage were done after the first coat of varnish was applied, when the surface became the degree of tackiness necessary for using the velvet square. These units were built-up on each of several successive Spar varnish coats to give them added depth and perspective. A

70

variety of metallic colors are used to give depth and contrast to the scene. Striping carried out the copper and brown tones and is of burnt umber, English vermilion, and flesh ochre. Each of these colors was used separately.

THE TRANSPARENT PAINT WASH

Transparent painting appears over freehand bronzing, but only if this form of decoration is done on a metal surface. Most wooden surfaces which are decorated in this technique are devoid of transparent washes. Metal articles appear both with and without this treatment. Peaches and other fruits are given a naturalistic appearance by a shaded wash of alizarin in combination with transparent green and yellow tones. Flowers often appear with alizarin accented with opaque yellow paint to form their centers and stamens. Along with the bronzed units, other units are painted over the metal leaf or bronze band with transparent green and other colors. Leaves may be done in this way, accented by a center of rubbed-in gold powder and with superimposed veins of burnt umber or black.

Fig. 43. Printed and painted sheet iron plate. England, possibly Bilston, about 1840. The central unit and leaf border are printed, with color painted on top. The leaves seem to have been bronzed in gold powder with a stump. (*Courtesy of Cooper Union Museum*)

71

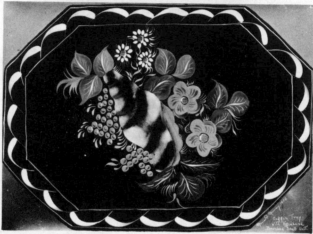

Fig. 44. Design of freehand-bronzed shells with Pennsylvania Dutch painting. *Top:* Cannister design. The shell is freehand bronzed on black with gold powder, and is accented with sign-writer's red brushstrokes. The large daisy-like flowers are English vermilion accented by fine white brushstrokes; the smaller flowers are white. The centers of all flowers are delicate and trellis-like, done in country-tin yellow. Leaves are green, and other detail is in yellow. Berries are English vermilion with alizarin and white strokes. *Bottom:* Design for large coffin tray with one-inch flange, on which a brush-stroke border would appear with two fine yellow stripes. This design would all be on the floor. The shell is freehand bronzed in gold, accented with vermilion strokes, and the inside of the shell which shows at right is also vermilion with alizarin shaded over it to give depth.

OPAQUE PAINTING COMBINED WITH FREEHAND BRONZING

Stylized flowers of opaque colors are often included in borders consisting of freehand bronzing and are combined with transparent painting. They are usually accented with the same color as the transparent paint, made darker, or they are done with a color contrast. Off shades of white are used to form flowers and buds. These are painted as brushstroke combinations to form a border against bands of solid black, gold, or other colors. (See Figs. 4 and 32.)

72

PONTYPOOL BORDERS ON METAL-LEAF BANDS

Pontypool, metal-leaf borders consist of bands of gold or silver-leaf (palladium may also be used). These are applied on the flange of the tray and may be combined with scenic designs done on the floor which may be either stenciled on or painted. The designs on these metal bands are often painted with intricate brushstroke and line decorations and with units of black which are freehand bronzed and then given a realistic appearance by transparent washes. These trays originated in England and were copied less intricately in America with transparent color detail in combination with the opaque type of painting. The latter were done in the manner called "Bristoe."

STRIPING A FREEHAND BRONZED ARTICLE

Plan your stripes for your type of tray as suggested in Chapter III. Many stripes of varying widths, done in two shades of bronzing powder and also painted with white paint and in colors, are an important feature of any article of Pontypool influence. Trays often have one or more stripes on the under side of the flange. It is believed that the craftsman practiced his striping on the back of the tray before proceeding with the top of it. Some of the handsomest trays also carry a beautifully detailed gold leaf border on the back of the flange. This border is banded on each side with a narrow stripe. A fine stripe always borders each gold-leaf band on both sides. This stripe is usually done in an off shade of white or in a blending color. Another follows beside this one, also on each side of the band. This one is usually done in gold powder. If the tray does not have a design on the floor it will have several stripes in varying shades of bronzing powders and of several widths, spaced to give good proportion (see Fig. 4). When a tray is banded on the floor, as well as on the flange the same arrangement is done on both bands. In addition, there will be two or three stripes in the center, varying in width and blending with the colors of the other stripes unless they are done with bronzing powders of several shades. (See Fig. 4.)

VI. *The Stencil—*
Its Decorative Influence

The stencil was one of the first tools used for the mass production of decorative commodities and for informative posters. India spread the gospel of Buddhism with large posters which were made in quantity with specially cut stencils. Buddhism was introduced to China by these posters, but the stencil idea did not come into full flower until many hundreds of years later. The Japanese, during our Christian times, used it to produce their prints for screens and wall hangings. Stenciling became a highly skilled art. The Japanese stencil was cut with a sharp knife from a parchment-like paper. It was so intricately detailed that raw silk or human hair were interwoven to hold delicate parts together (see Fig. 45). Their stencils were used with watercolors and other pigments. Only occasionally were they used in combination with bronzing powders.

The art of stencil-decoration was introduced to England during the seventeenth century. To satisfy the demand of the American colonies for decorated housewares at low cost, England produced, at a later date, many types of pieces with stenciled motifs. These were trays for the most part. They were made with conventional, scenic, and naturalistic designs. Many were hand-done while still others were produced by a printed method (see Fig. 71). Sometimes the printed type were combined with the stencil and with other types of decoration.

Craftsmen of the seventeenth and early eighteenth centuries designed many ornately carved and gilded household articles which were too costly for the American colonies to import. Tools and skilled craftsmen were scarce in Colonial America and the artists on this side of the Atlantic learned to do a type of decoration which utilized the stencil as a kind of guide. Bronzing powders were made here and were also imported and with these, artists pro-

Fig. 45. XIX-century Japanese paper stencil showing the intricate detail and the inter-weaving of silk threads to keep the parts together. *(Courtesy of Cooper Union Museum)*

duced effects which were intended to be similar to, if not exactly like, the carved and gilded European articles of the rococo period.

The early stencil in America was not intricate. The outer shape of a unit was determined by the stencil outline. Detail within the shape was pains-takingly done in the freehand-bronzing method, using only a few shades of bronzing powders. Classic motifs—urns, baskets, cornucopias, etc.—were fashioned in etched gold-leaf. (See Figs. 32 and 34.) Realistic fruits, flowers, and foliage were exquisitely shaded with fine detail in bronzing powders. As time progressed, the craftsmen who were producing for commercial use, learned to depend more and more upon the quick effects obtainable by de-tailed stenciling. Time was of the essence, and decoration had to be produced faster and thus became less delicate.

Today the word "stencil" usually implies a form of decoration not wholly artistic and certainly not individualistic. With the revival by Esther Stevens Brazer of the art of stencil-cutting and stencil decoration, craftsmen and artists are once again realizing the great breadth and scope of decorative art. They are learning and applying its many individualistic uses.

SUITABLE ARTICLES TO STENCIL

TRAY TYPES

Today it is possible to purchase undecorated trays which are authentic copies of original shapes. Available also are shapes of contemporary design. The latter are not heirloom pieces as yet and therefore may be decorated to suit the individual fancy. The former, however, if they are to be authentic, must be decorated along traditional lines. The rectangular tray with rounded corners, of all sizes, is most suitable for decorating with bronzing powders in combination with the stencil. This type of tray comes with and without hand holes and may be decorated with every form of stencil design from the conventionalized and realistic to the scenic and the design with the story motif. The stenciled units of this type are usually given transparent color washes. The oval Windsor tray may also be used for stencil purposes. The cut-corner or octagonal tray with its *two-inch flange* may be stenciled in a double-bordered effect. A scene may be painted in the center of the floor.

Stenciling must *never* be done on the *coffin tray* of country-tin painting, whose flange is only one inch in depth. Nor should it be done on the Chippendale, Queen Anne or Lace Edge types. To be authentic these trays must be decorated in their special traditional techniques.

BOXES, CORNICES, BELLOWS, FOOTSTOOLS, OCCASIONAL TABLES

Many types of household accessories may be decorated by the stencil method. Boxes of all kinds, except those shaped in the Chippendale manner, lend themselves to exquisite combinations of stenciling with gold leaf and free-hand bronzing. Cornices may be built from plywood in various shapes and their decoration can be made to blend with contemporary forms of interior decoration as well as Early American and other periods (see Figs. 32, 46, 49, and 54).

Cornice boards were originally decorated and made for the express purpose of hanging Venetian blinds. Their decoration was intricate and beautifully detailed, and they indicate a decorator of the highest merit. The scenic type was popular in the Hudson valley during the late 1800's. These designs were done in a "built-up" kind of process which took the final form on several coats of varnish and so acquired depth and perspective, even before the protective varnish coats were applied. The background of a scene and the stenciled details, such as fences, tree trunks, houses, are done on the first coat of varnish. The foliage and foreground details are given greater prominence by being applied on one or more of the successive coats of varnish, when each coat becomes tacky. Foliage effects are done in a "pouncing" manner with the velvet knob and the dry bronzing powder. When the varnish is dry the entire cornice is washed to remove all the loose powder; then another coat of

Fig. 46. Stenciled wooden jewel box. The trim on sides and around the top is polished with gold powder. The basket is shaded, also in gold. Fruit is done in a combination of silver, gold, and copper lining powders. Note shaded leaf veinings and highlights on grapes. Striping is in deep yellow paint.

varnish is applied. Such details as birds in flight or other animals are given prominence by being done on one of the later varnish coats. As many as three or more of these varnish coats may be necessary for the addition of all the details required to form the final scene. Details may be done with stencils or by the method of freehand bronzing. These scenic effects are noted for their great restraint, so practiced by the artist who executed them. They are worth a great deal of serious study.

That discarded bellows in the attic may have an old design on it! If so, study it, copy it, and apply it to another bellows. If the old one can be repaired, do so, and redecorate it! Stenciling on these may be combined with gold leaf in etched units and also with freehand bronzing and may be done on black and other dark colors.

Small stools and occasional tables made by that young son of the family in his shop classes may be most attractively decorated on black or other dark colors in the stenciled technique.

Never do stenciling on wooden pieces that belong definitely to a specific period unless the period calls for this form of decoration!

SUITABLE BACKGROUNDS

Black and Dark-Colored Grounds

Stenciling must always be done on black or dark-colored backgrounds. Very dark green is especially suited to the stenciling technique. Other dark colors such as dark blue, dark brown, and dark red may also be used. Beauty in stenciling with gilding powders is attained by permitting one unit to disappear into darkness behind another. Backgrounds of light colors, such as vermilion or the pastels, would not permit this shading to be as effective. Yellow and cream white must never be used as backgrounds for stenciling. Since they so nearly resemble the bronzing powders, they do not produce the shadow necessary for good stenciling. The freehand-bronze method of painting a black unit in and then bronzing on it can be done on light colors, and stencils may be used to give form to the subject. (See border of Fig. 5 and Figs. 2, 32, 36, and 42.) Black bands may be painted on a light background. Stenciling is most effective on them.

Natural and Stained Wood

Natural wood and wood which is stained, may be stenciled upon. A band or panel of black may be painted over the grain and the stenciling done on that. Mahogany or other dark woods may be stenciled with a conventionalized design or with the fruit, flower and leaf unit, for effective results. No blacking-out is necessary behind the design because of the darkness of the wood.

Simulated Graining

When simulated graining is done, a wooden piece is first painted with barn red. A thin coat of flat black is later applied and while this is still wet it is rubbed off to form the wood grain. (See Chapter I for details in the application of a simulated wood graining.)

BASIC PRINCIPLES

Smooth backgrounds (see Chapter I) are essential for fine results in stenciling. Bronzing powders cannot be applied evenly nor can they be shaded properly if the ground on which the design is to be placed is either ridgy or lumpy. Two rubbed-down varnish coats minimize absorption of the stencil coat.

The varnish must be flowed on smoothly (see Chapter I). Practice will teach you the correct degree of tackiness into which to stencil. The Spar varnish must not be so wet that the linen stencil adheres to it and leaves its imprint. If the varnish is too dry, however, the surface will not take the powders

Fig. 47. A linen stencil showing the tracing and partial cutting. *(Courtesy of Craft Horizons)*

and the grains will simply roll around like tiny golf balls. A very large tray should be varnished early, on a perfect day. The varnish coat should be applied fairly thickly (see Chapter I). Begin the stenciling as the Spar varnish just turns the tacky stage so that the last units to be done may still be accepted by the varnish. Should an article become too dry, set it aside for twenty-four hours. Wash it under running water to remove loose powder particles, dry it, and apply another coat of varnish. Continue the stenciling from where you left off.

You cannot expect fine stenciling if a stencil is not even or if it is cut raggedly (see Figs. 13, 45, 47, and 48). A peach, a grape, any rounded unit must be accurately rounded. Points on leaves must be sharply cut. Veinings must never look like twigs and the units for overlay work must be fine and delicately cut. Care must be taken, while cutting the stencil, not to cause the cut edges to become rippled; powder particles will slip in under these misshapen edges. (See section on cutting a stencil, this chapter.)

PROPER PLACEMENT OF UNITS

Units of any stencil design must be accurately placed on the article. Before the Spar varnish is applied mark tiny silver dots, using the Eagle brand pencil. Do these where the points of leaves are to be, or draw fine lines

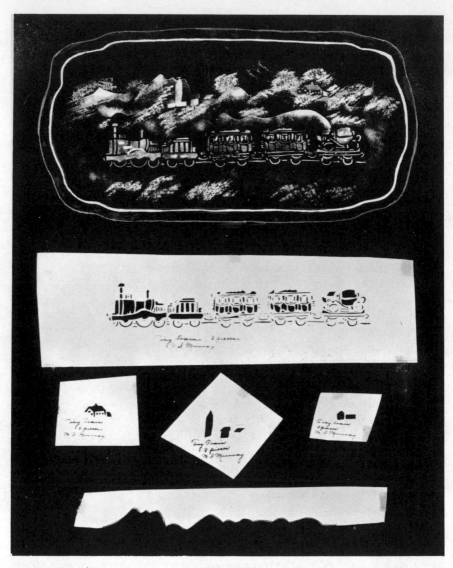

Fig. 48. The little train snuffer tray, with a few of the stencils to show the cutting of small units. The pouncing on of foliage gives it a natural background. Church steeples, hills and houses all appear in the background.

lightly to mark flower locations. These markings should be placed where the polishing of powders is to be brightest so they will not show. Since you always draw your guide lines for the striping before any varnish is applied these also will help to keep the design within bounds (see Chapter III). Make all marks as fine and as lightly as you can.

80

POLISHING AND SHADING BRONZING POWDERS

The fine linen of the stencil will adhere closely to the tacky surface, especially if the cutting has not rippled the edges. The fine powders used will not work under the stencil if you are careful to use a minimum of powder upon the velvet square. Never pick up the powder on the square from the most loaded spot on the palette. Press the index finger with the velvet wound around it on the outer edges of the palette, where the powder is the least heavy. Before beginning to polish in the unit, rub off a little of the powder from the velvet square on to the back of your other hand. Begin to polish the powder at the spot where the brightest highlight is to be and, gradually, work away from this spot. Always work from the linen into the center rather than from the center into the linen except for center highlights. This will prevent tiny powder particles from working themselves under the stencil and will thus prevent the edges of the unit from becoming cloudy. The outer edges should always be sharp except where they disappear..

All information about the velvet square and the bronze-powder palette—its size, material, method of placing powder on the palette, and storage are discussed in detail in Chapter II. (See also Figs. 12 and 13.)

It is wise to prepare several of the real-silk velvet squares. One may be reserved for the copper tones while another may be used for gold and a third for silver. Then they will be ready to use when these powder shades are not to be blended. Special work requires new squares. (See page 135.)

Every grain of powder which is used must be polished into the unit thoroughly (see Fig. 50). Never rub a freshly stenciled article. Set it aside for twenty-four hours and then wash off excess powder under running water.

Units which call for evenly shaded bronzing powders of several colors should always be done so that there are no sharp distinctions. Start with the brightest highlight—silver, for example. Polish this so as to achieve a gradual shading-off. Then pick up the pale gold and start this directly over the silver you have done, thus carrying all the excess silver out and blending it with the pale gold. Polish this pale gold and shade it off gradually. If another tone, say copper, is required, start this, also, from the silver highlight and blend this outward over the pale gold and thus into its own shading which should at this point be sparingly done and should blend into nothingness on the dark ground.

One of the distinctive qualities of stenciling with bronzing powders is the gradual disappearance, into shadow, of one unit behind another. Do the front, or central units, first and radiate out from them. Those which seem to be behind others should never end abruptly nor should they be so polished that their disappearing parts are superimposed upon the units in front of them, perspectively speaking. (See Figs. 34, 46, 49, and 50.)

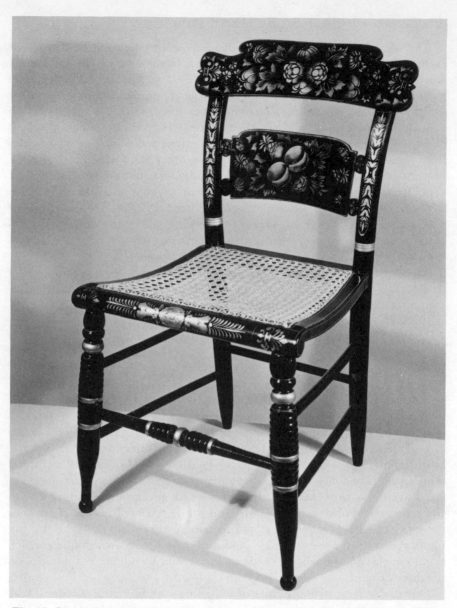

Fig. 49. Crown, button-back, Hitchcock chair. This is one of a set of four owned by the author, which were originally purchased by her great-grandfather in a set of twelve. This chair was repaired and completely redecorated by the author after studying the originals and making a pattern from them. The posts and rungs on the front legs are in gold leaf; the design on the front of the seat is etched gold leaf. The units at each end of the seat trim are stenciled in deep copper bronze, almost brown. The fruits and flowers of the two slats are done with Uhlfelder deep gold lining powder with the leaves softened by the brown copper bronze. Striping is in chrome yellow mellowed by mixing it with raw and burnt umber.

While stenciling the design care must be taken not to handle tacky areas with powder-laden fingers. Do not rest the velvet square on the article being decorated. Stencils which are used more than once should be cleaned with Carbona after each use to avoid unwanted powder imprints. Directions for cleaning are given below.

TRACING, CUTTING, CLEANING AND STORING THE STENCIL

TOOLS AND SUPPLIES NEEDED (see Fig. 13)

Only a few supplies are required for making the stencils. The material from which these are cut is a thin grade of architect's tracing linen whose transparency is evident. It is purchased by the yard, in any length required. Papers and stenciling board are never used, since these would permit the fine bronzing powders to penetrate into and under them. Trace the unit on the linen, using India ink with a fine quill pen. The stencil may be cut with a pair of well-made, sharply pointed manicure scissors with curved blades or a fine pair of imported pointed, straight-blade embroidery scissors. Some units are more easily cut with a sharp, single-edge razor blade, used against a piece of glass. Practice will help each artist to decide which method is best. A dental rubber-dam punch is also a useful tool for making the tiny round dots. (See details below.)

TRACING THE STENCIL UNIT (see Fig. 47)

An accurate drawing of the unit from which a stencil is to be cut must be placed on a flat surface. A square of architect's linen is cut so that it extends a good inch on all sides beyond the unit to be cut. If the unit is a silhouette, no allowance is required. Trace a fine line just inside the drawing, using India ink and a fine quill pen. A stencil is traced just inside the line because it is cut on the outside of the tracing line. This prevents the stencil from becoming larger after it is cut. It is possible, then, to do an intricate design delicately. The linen square is fastened down securely with small strips of masking tape while the tracing is being done. The *shiny side of the linen should always be down*. The tracing should always be done on the dull side of the linen. *The dull side of a cut stencil is always on top while stenciling is done!*

CUTTING THE STENCIL

When a pair of manicure scissors with curved edges or scissors with a straight edge are used, a little hole is made with a coarse needle at a wide

part of the unit, near the tracing line. The scissors can then begin cutting without tearing the linen or causing injury to the tips of the scissors. Scissors with curved blades are used in such a way that their curve follows that of the stencil which is being cut. Care must be taken to cut the tips of leaves so that they are sharply pointed and not jagged. Some sections of a stencil are best reached by placing the scissors so that the points come up from the under side of the linen. (Never use these scissors for any other purpose!)

Straight and curved fine lines, such as veins for leaves, are best cut with a very sharp razor blade. Use one of the corners of the blade and bear down on the traced line of the unit to be cut. *The linen should be shiny side down* on a piece of glass which has been placed on something dark. It may also be cut on a piece of glass which is placed over a light bulb. If you prefer to use scissors, merely cut along the line once with the razor blade, then cut off a

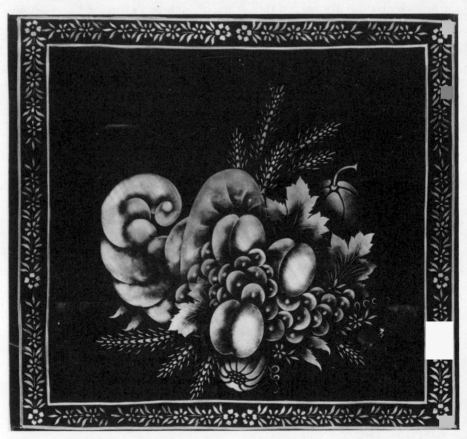

Fig. 50. Stenciled cornucopia and fruit. Notice polished units and their gradual disappearance into shadow as they approach units in front of them. See highlights of grapes, sharp-pointed forms of the leaves and their delicate veining. The border is a single unit used as a repeat. Striping is in gold.

84

minute sliver of linen *on one side only of the razor-blade cutting.* If it is a vein, widen it slightly in the middle. Some artists prefer to use the razor-blade for all types of cutting. Be sure to use a sharp blade because a dull one will cause the linen to ripple on the cut edges. (Replace razor blades often!)

Some stencil designs include tiny round dots. These are best cut with a dental rubber-dam-punch. Since this tool is expensive when purchased new, ask your dentist to let you buy his discarded one. It will punch very tiny holes and can be adjusted to fit several sizes. If it is impossible to acquire one of these tools, place the stencil, *shiny side up* on a folded tea-towel and puncture each dot with a sharp pointed No. 18 chenille needle. By puncturing the dots from the back side of the stencil into the soft folds of the cloth you force the broken threads of the tracing linen upward toward the top or dull side of the linen stencil. When all the tiny holes are completed, rub the top or dull side lightly with a No. 600 piece of sandpaper. Then blow through the holes to remove particles of dust. Larger dots can be cut with the scissors when a punch is not available.

Cleaning the Stencil

A stencil must be cleaned before it is put away. If a stencil is repeated several times in the decorative unit it must be cleaned after each use. To clean a stencil, place it upon several layers of newspaper. With a clean strip of nylon stocking, using Carbona, rub the stencil gently along its cut edges and on the back of the shiny side to remove loose powder and any varnish which may have adhered to it. Reverse the stencil and, laying it down on another section of the newspaper, repeat the cleaning. Carbona evaporates rapidly as it cleans but will not remove the sizing of the linen.

Storing the Stencil

Any groups of stencils which form a decorative unit should be labeled and numbered on the dull or top side. These should be inserted flat into a sandwich bag which is likewise labeled. If the open end of the bag holding the stencils is inserted into another bag, none of the stencils will be lost or mislaid. These bags holding the stencils can be stored in boxes and when you have a number of them they may be filed alphabetically.

VARNISHING A SURFACE FOR STENCILING

Quick-drying Spar varnish is best to stencil into. *(Never use Hour varnish or clear service-seal.* They do not remain tacky long enough.) Spar varnish must be applied with the brush which is kept for this purpose only (see Chapter I). Flow the varnish over the entire area by gliding or pulling the loaded

brush across the surface. Use no more pressure than that caused by the actual weight of the brush. Bubbles are quick to form at any time but will be less likely to do so when this precaution is taken. Never press the brush down to remove varnish (see Chapter I).

Set the varnished article aside where a minimum of dust will attack it. It will take a few hours, depending upon the humidity and upon the thickness of the varnish coat, before the surface becomes tacky to the correct degree.

STENCILING NATURALISTIC AND CONVENTIONAL UNITS

General Rules

The complete area of some stencil units should be polished. Other units are done in one bronze color only and are given a bright highlight which shades off into shadow. Still others shade from one light bronze color to another and perhaps a third, becoming less intense before the shadings disappear into nothingness. In all instances, the polishing must be smooth and evenly distributed according to the requirement of the unit (see Figs. 50, 51, and 52).

Single units are those which can be formed by using only one stencil, like individual grapes and certain flowers. The article may also be completely decorated in single-unit stencil designs (see Fig. 52).

Fitted units are those stencils which require more than one part to complete them and are therefore cut to fit within one another. Among them are leaves and their veinings, flowers which are made in two or more parts, peaches which require two stencil shapes, and those stencil units whose finishing touches are done by the overlay method on a transparent color wash which is applied over their carefully shaded outlines. (See Figs. 50, 51g, k, l, o, s, i, u, and 52.)

Silhouette stencils are those which form the actual design and are done in reverse. They must be shaded with bronzing powders on all edges, forming a clouded effect on the background. Some are conventional and are incorporated into borders; others are naturalized and come in the shape of birds, flowers, fruit, etc. (see Figs. 51p, s, u).

Single- and Fitted-Unit Fruits, Grains, etc.

Peaches and persimmons (see Figs. 34, 50, and 52a, b, e) are stenciled in two parts. One type of peach consists of two parts; an oval section and another which is shaped like a new moon, the concave side of which should fit accurately one of the oval sides. To stencil a peach, place the oval piece in its proper position, shiny linen side down, and begin at its center by polishing a highlight, shaded to almost nothing, on all sides except the one upon

86

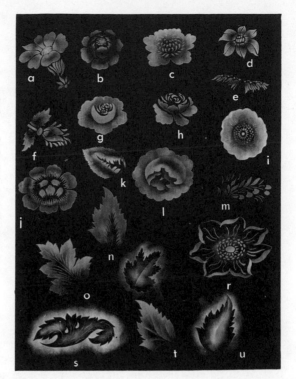

Fig. 51. Stenciled flowers and leaves, showing types and methods of doing them. Single-unit types: a, b, d, e, f, h, j. Fitted-unit types: c, g, i, l, o, r. Silhouette types: p, s, u. Leaves with stencil-fitted veining: i. Leaves with S-veining: i, p, u. Leaves with superimposed veins, polished in after a wash of transparent color: s. Silhouetted veining: k, n. Silhouetted leaves: p, u.

which the half moon is to fit. This edge should be sharply polished. To finish the peach, place the half-moon section in its correct place and polish this only on its outer edges, leaving shadow as it approaches the oval shape. There are also other variations in the shapes of peach sections for stenciling. These are used less frequently.

The persimmon is shaped so that it is not quite round; its second part consists of a rounded dot and three or more units which are elongated. The nearly round part is polished in the center and remains almost in shadow on all sides except at the top of the fruit which is kept as dark as possible. The second piece is placed over the dark section, at the top of the fruit, where it is to form the bud end. It is highly polished at the part where the dot is and is shaded to nothing below the dot. This part of the fruit should blend gradually into the highlight forming the center.

Single-unit stencils of grain, wheat, etc. are usually polished solidly except where another unit overlaps them.

Strawberries are done like any single unit. Their seeds are stenciled on as tiny dots. Sometimes these dots are done as an overlay on tacky, transparent alizarin washes. They may also be painted on with off white or yellow paint.

Grapes, plums, apples, pears and melons are usually done in single units. Grapes are given a highlight with a rolled point of the velvet square dipped

87

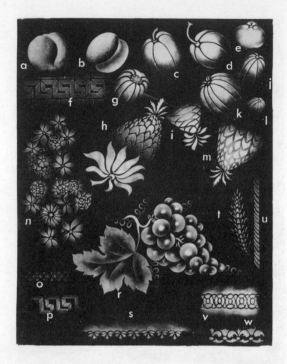

Fig. 52. Stenciled fruit and miscellaneous units. (See text in Chapter VI for descriptions.) Peaches: a, b. Melons: c, d, g, j, k, l. Persimmon: e. Pineapples: h, i, m. Grapes with S-curved stenciled leaf: r. Single ornamental design: n. Border units: f, o, p, s, u, v, w. Wheat: t.

into silver powder (see Figs. 50 and 52r). These are polished with pale gold, leaving one edge in darkness. This gives them the necessary highlighted roundness. When grapes are used in clusters it is usual to cut three sizes of stencils. These overlap one another to form a natural-looking bunch of fruit. Plums, apples and pears are given a less sharp highlight to form their shapes and are shaded to darkness on their outer edges. Melons always appear partly behind other fruits or units. The melon shape is polished highly with pale gold at the top of the fruit and this is also blended gradually into a deep copper tone which finally disappears into nothingness as it approaches the unit in front of it. (See Figs. 52c, d, g, k, i, and l.)

Pineapples are done in three or more ways (see Figs. 49 and 52). Some are cut intricately and only one piece is required which also includes the leaf end (Fig. 52j). The stencil is highly polished at the top or leaf end and in the center but it is shaded as the outer edges are approached. They must shade into complete shadow before they approach the unit in front of them. When the stencil is removed a kind of smudging is done in the center, shading it off at the edges. Copper bronze is usually used for this effect since it is darker than pale gold. Another type of pineapple consists of three parts (Fig. 52h). The outer outline of the whole pineapple is cut out of linen. It is polished lightly on the outer edges, especially the leaf end, using either a copper or an orange tone of powder. The second part has intricate cut-outs which form the detail of the pineapple. This part is placed directly over the first stenciled

section. It is polished at the leaf end, and in the middle, but is shaded to nothingness where another unit appears. The third part consists of the intricately cut leaf end. This is placed so that there is a slight space between it and the pineapple. It is polished with gold. The third type is done like a one piece design. The bud-end is then polished in and the stem end is shaded to give it depth (see Fig. 52m).

Single leaves intended merely as a background for the design are polished on the outer edges of the stencil with a dark shade of copper lining powder. They appear as leaf shadows behind the rest of the design and may or may not be veined. (See Figs. 49 and 50.)

Veined leaves are most commonly used. Veinings are cut so that they follow the contour of the leaf. These lines should be as delicate as possible. They should taper gracefully but should not waver in their cutting. The leaves are polished on the outer edges; then the veins are applied by polishing in either gold or silver powder. Both leaf and veinings disappear into the background before the units in front of them are reached. (See Figs. 34, 50, 51o, and 52r.)

The S-curves of leaves with S-curved shaded veinings (see Fig. 51t, u) are cut along two edges of the stencil, being careful to allow a wide enough margin of linen between them and the leaf (see Fig. 51s, p, u). The leaf is polished lightly on the outer edges, leaving the center black over a larger area than for other types. The S-curve is then placed at the correct angle and it is lightly rubbed, close to its edges, so that the cut edge forms the vein and the powders disappear altogether not too far from it. This is repeated to form the veins which start from the center veins (see Fig. 51t).

Veins of leaves may also be superimposed on transparent color. The main leaf is polished on its edges and is very lightly shaded in the center. A wash of transparent color is applied and when tacky the veins are applied on it in silver or pale gold (see Fig. 51s).

Acanthus leaves are often given a naturalistic appearance by polishing them lightly on the edges and then applying a specially cut stencil which is placed and polished in such a way that it forms a turn back. Veinings are cut to the shape of the leaf and are polished in the usual way (see Fig. 51s).

Some leaves are veined with a silhouette (see Figs. 51k, n), which is intricately cut. The leaf is polished on its outer edges and is gradually blended into the silhouetted veinings which are centered. These are highly polished along the edges but are shaded so that they become incorporated with the blending of highlights along the outer edges of the leaf. A single line often appears within the silhouette.

Any leaf shape may be used in reverse as a silhouette (see Figs. 51p, s, u). The stencil leaf is placed on the varnish and it is rubbed all around with gold or silver to form a kind of clouded or smudged effect around the leaf form. When the leaf stencil is removed the center is lightly polished with gold or silver. A coat of transparent color is applied twenty-four hours later and when this is tacky the vein stencil is polished, using gold or silver.

89

Single- and Fitted-Unit Flowers

The fitted-unit type of flower (see Fig. 51g, l, r) consists of several stencil parts. The main part of the flower outline is polished on its outer edges leaving the center dark. The remaining stencil parts are fitted singly one over another to form the complete flower. This type of flower is also formed more simply by the use of only two stencils—the one to form the outer shape and another which, when polished in, forms the center.

The single-unit type of flower stencil (Fig. 51a, b, c, d, e, f, h) includes all the petals and dots to form the center. These flowers are either solidly polished or may be shaded. When the stencil is lifted a pink tone may be applied to the center of it by pressing a finger into copper lining powder and applying it over the section where the dots appear.

The single-unit type with added accents is done in two sections. The outer form of the flower is polished on the edges of the stencil. It is left dark in the center. Petals cut like brushstrokes on another piece of linen, are polished over the first form with a contrasting color of powder. Their centers may also be finger-rubbed as indicated above. (See Fig. 51i.)

The turn-backs on the outer edges of the petals of the freehand-bronzed rose may be polished with gold. The center of the rose is done with a combination of stencil units which, placed at their correct angles, form additional highlights and should be polished at their tips, only, and then should be carefully shaded into the rest of the flower. These stenciled sections are then unified with strokes in the freehand-bronzed technique, using the stump, velvet knobs and velvet squares. Their colors range from silver to pale gold. (See Fig. 40a.)

Single Ornamental Designs

These consist of single stencil-units which are so cut that fruit, flower, and foliage are all intertwined to form a single design. They appear as parts of the central designs of trays and are also used as border units (see Fig. 52f, o, p, s, u, v, w). They are difficult to cut because of their intricacy. Often they are used as single units which cover parts of or the entire floor of a tray (see Fig. 52n).

The Conventionalized Stencil

Conventionalized silhouettes are often used to add a note of interest to a stenciled tray of the double-bordered and scenic-painted types. They appear in the corners of the flange border (see Fig. 52) and may also be used to give a lacy effect to the more naturalistic form of border on the floor of the tray. The Greek key of classic origin is sometimes used to unify a bordered effect. Flowers are often given a conventionalized form and the acanthus leaf is also made to look like a scroll (see Fig. 51s).

The Repeat Stencil

Leaves are most effective when they are repeated to form a border. One leaf stencil is laid in the same position all around the edge of a tray or any other article. The leaf is polished at its tip and shaded so it seems to be behind the one next to it. An interesting effect is obtained when pale gold powder is used to stencil the leaf and then, after all the border is completed, copper bronze powder is polished in to cover all of the black area of the border which remains behind the gold. (See Figs. 36 and 53.)

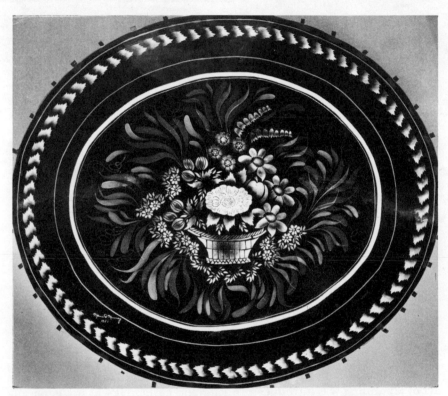

Fig. 53. Stenciled flower basket with gold-leaf unit, which is stenciled, etched and shaded with burnt umber. The brushstrokes are in country-tin green and yellow. The flange is a repeated leaf, stenciled so as to shade it into the unit beyond it. Striping is in off-yellow and the wide band is in painted gold. There are transparent blue, green, and rose washes over the stenciled flowers and leaves.

The Sea-Shell Unit

Sea shells are used in many shapes and appear as silhouettes and as regularly stenciled units. They are an interesting variation of the usual type of design. They were first used in tray designs in 1840. The designer, George Neville of Wolverhampton, England, was responsible for them.

91

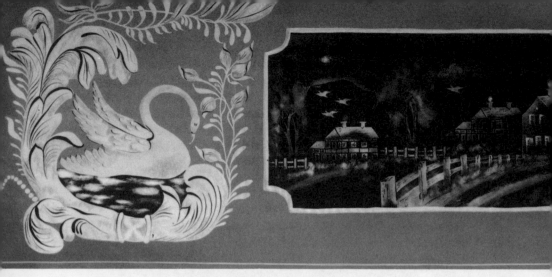

Fig. 54. A straight cornice board done on a dark green background. The central scene is done on a black band. The ends of this type are reminiscent of the Victorian decorative mode with the rather ornate swans and the leaf and featherlike formations. These units are in etched gold leaf with bold, black brushstrokes for accent. The freehand bronzing, to indicate the water around the swans, is done on black service-seal. The broad band around the scene and the narrow stripe around the entire outer edges of the cornice board are done in gold, painted on.

STENCILED SCENIC EFFECTS

THE ORIENTAL TYPE

The tray of Oriental influence appeared not before 1825 even though the art of japanning was introduced to England earlier. It was not generally used by designers who seemed to prefer other types. They are stenciled with intricately cut units which, though seemingly spotty in their cutting, are actually unified in appearance, because of their exquisite colorings of transparent washes. These colors make them jewel-like. They include peacocks against Oriental settings, Chinese fishermen and other objects. Perspective is disregarded in this type, as it is in the truly Oriental design. Often these are bordered with painted units on metal-leaf bands. Borders of this type may be done in the American Bristoe manner, without freehand-bronzing, or in the Pontypool manner with units richly shaded with bronzing powders (see Fig. 4).

92

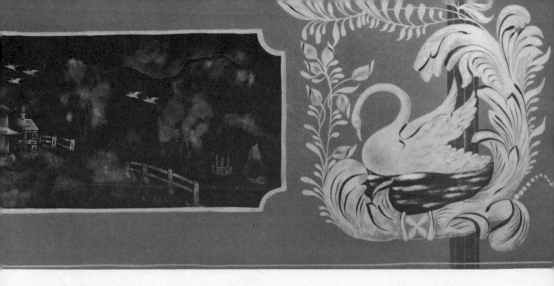

THE STORY TYPE

The story type of design includes people and animals superimposed upon a scenic background of trees and other forms of foliage (see Fig. 36).

THE TRAIN TRAY

The early type of train was also included among design forms. It appears against a backdrop of hills with church steeples and with people not only in the train but often in the foreground (see Fig. 48).

LANDSCAPES ON CORNICES

Cornices were decorated with landscape designs which were delicately stenciled in combination with gold-leaf units which appear at the outer ends. These types originated in New York State and include houses, barnyards, animals, free-wheeler boats, and other details. They were also stenciled in combination with the freehand-bronzing method (see Fig. 54).

TRANSPARENT WASHES OVER STENCILING

Stencil designs on tin are usually done with transparent color washes over them. They may also appear without these washes. If the piece is to be decorated in the traditional way, stenciling on wood must never be done with transparent color washes. In wooden articles the designs are skillfully shaded with bronzing powders of one or several shades. Wooden articles are often enriched by the use of etched gold-leaf units in combination with the stenciled design.

Transparent color washes are of several colors: Indian yellow with burnt umber to give it greater tone and depth; Green (made by mixing Prussian Blue and Indian Yellow with a little raw umber); Prussian Blue, toned down with raw umber to give it a softened shade or a turquoise cast; Reds (mixed by using alizarin crimson with burnt umber for a tone bordering on orange or raw umber for a true red); Paynes' gray combined with alizarin for an interesting purplish, mauve shade. Other combinations may be blended from these colors. To apply them use a broad soft brush. Mix the varnish and pigment thoroughly. Shade these colors in such a way that they are well blended and no distinctions are left between the deep tones and the lighter tones at the place where they begin to fade into one another or where they disappear altogether. These transparent washes acquire various tones depending upon the color of the powder beneath them. Silver is usually used with blue, but if the color is to appear greenish the blue wash is applied over gold. Green is usually painted over gold, but may also be done over silver for a sharper shade. Reds and yellows are done over both silver and gold.

THE STENCIL WITH OTHER TECHNIQUES

Gold Leaf Combined with the Stencil

When gold leaf is stenciled on a design, the unit is cut as a regular stencil. It is placed on the article while the surface is tacky. Gold leaf is gently pressed into the unit as it would be done if you were laying it. The stencil is lifted off carefully so that no metal-leaf particles will be deposited where they are not wanted. This type of stencil should have a larger margin on the linen beyond the cut part in order to avoid spilling the gold leaf beyond the design unit. The gold-leaf form is etched, as usual, and later transparent color may be applied (see Fig. 53).

Etched gold-leaf units of classic origin—urns, cornucopias, baskets, etc.—are combined with intricate stencil detail which includes freehand-bronzing of a highly skilled type. Articles decorated in this way belong to an early period in American history. These pieces were intended, in part, as substitutes for the intricately carved and gilded rococo furnishings of France, so prevalent during the early eighteenth century. Since the American colonists considered them too expensive to import, they developed their own unique method of decoration. (See Figs. 34 and 49.)

The Stencil with Freehand-Bronzing

When the stencil is used with freehand-bronzing, it merely outlines certain units but does not form any detail within the outlines. The detail is done with stumps, knobs, buttons, and velvet squares. Very early types of decoration employed this method (see Fig. 34). The stencil is also used with freehand-bronzing for sharp accents (see Fig. 40a).

STENCIL DESIGNS ACCENTED WITH BRUSHSTROKES

These appear in greens and yellows, on black grounds (see Fig. 53). When the silhouette is used in a semi-realistic fashion, black brushstrokes are used to represent small leaves and other detail on backgrounds of the clouded type.

SUITABLE TYPES OF STRIPING

THE PAINTED STRIPE

For the most part, the painted stripe on stenciled articles, is done in a dark yellow shade made by mixing chrome yellow with burnt and raw umber. The stripe will not crawl and it will dry faster when it is painted with chrome yellow ground-in-japan paint mixed with Spar varnish. It is wise to do the striping after two coats of varnish have been applied over the design for protection. Double-border trays are striped on both sides of each border with the yellow stripe which was originally intended to look like old gold. Scenic-type trays are bordered on both sides of the flange with the yellow stripe. The scenes are banded by a broad ¼ inch band, done with bronzing powders.

THE BRONZE BAND

The bronze band is always used on the scenic tray and is placed about ½ inch inside the bend on the floor of the tray and helps to frame the scene. It is done by mixing pale gold bronzing powder with varnish on the aluminum palette. These bands may be done on the flat ground, before varnish is applied. When they are tacky, gold powder may be rubbed in for added smoothness. Wash the tray before varnishing it to remove all excess powder!

The stenciled band is done with straight edges of tracing linen. These bandings appear on the floor of the tray of double-bordered design. They are done on the floor only and may be shaded or lightly polished. They are combined with the yellow painted stripes but never appear with the painted bronze stripe or in combination with gold-leaf stripes. The latter should never be used on stenciled articles, but may be used with the freehand-bronze type.

VII. *Freehand Brushwork Techniques*

BRUSHSTROKE PROCEDURES

SELECTING THE BRUSH

The best brush to use in order to form brushstrokes of many different shapes and sizes is a No. 2 square-tipped French quill (see Fig. 14). It is made of soft badger hair which is resilient and flexible. The hairs are inserted into a quill and are about ¾ inch long. The square tip of this type of brush is needed for good brushstroke formation. With this brush an artist may form the tiniest stroke imaginable, do the finest hair-line possible and may also execute a wide, thick brushstroke, depending on the paint consistency and the way the brush is held and used.

USING PAINT AND VARNISH

Specific rules for using and for mixing shades and colors suitable for various styles of decoration are given in Chapters VIII (Country-Tin), and Chapters X and XI (Lace-Edge and Chippendale). The regular artists' oil paint in tubes is used. It is mixed with Spar varnish (see Chapter II).

The paint and Spar varnish are mixed with the quill on an aluminum-foil square which is used in lieu of a palette. The foil will not absorb the oil in the paint or the Spar varnish as the paper palettes do. (Never use waxed paper for the purpose. The wax will soften or even melt and it will prevent the paint from drying properly.) Dip a clean brush into the varnish, which has been placed in a discarded bottle cap. Mix the paint and the varnish, using a gentle over–under stroking motion, until the correct consistency is acquired—not too thick and pigmenty, not too runny due to an excess of varnish, and very smooth to avoid streakiness and lumpiness.

Brushing Off Excess Paint

Well-formed brushstrokes cannot be achieved unless the brush is properly loaded. If there is too much varnish in relation to the amount of pigment, the stroke will be uneven and there will be ragged or feathery edges. If the brush is too dry, or there is too much pigment in relation to the varnish, the strokes will be incomplete, and the paint will be lumpy, with a grainy appearance. Puddled or spotty brushwork results from using the brush too wet at one time and too dry at another on the same unit. This unevenness will cause unequal distribution of varnish and pigment and the brushwork will dry unattractively and become spotty in appearance.

Before placing the first brushstroke on the design, brush off the excess paint which has accumulated in mixing. To brush off excess paint do a few under and over strokings on a clean section of the palette, permitting some of the paint to remain in the brush for almost the full length of its badger hairs. These long ¾-inch hairs will thereby properly feed the paint while the stroke is being made, especially when the right amount of paint is allowed to remain on them. When the varnish becomes too gummy or stringy it will retard proper brushstroke-formation and the varnish in the cap should be replaced.

Practicing for Proper Formation (see Fig. 24)

Practice and yet more practice will result in the proper formation of brushstrokes. The quill is flattened during the process of brushing off the excess paint. This flattened quill is then laid on the design and sufficient pressure is added to spread the hairs to the required width for forming the thick end of the stroke. This position is retained while the hand is *slowly* moved in the direction the stroke is intended to go. The pressure is gradually released while permitting one edge of the flattened brush to finish the stroke as a fine line or tail. It should be remembered that varnish is a liquid and must therefore find its own level. Because of this factor the pigment, which has been thoroughly blended in the correct proportion with the varnish, also levels itself into graceful shadings.

HOW TO PAINT BRUSHSTROKE SHAPES
(see Fig. 24)

The Right-to-Left Stroke

The right-to-left stroke is done by pressing the brush down to broaden its tip. Draw it slowly downward toward your left, lifting the pressure as the stroke turns. Twist the wrist toward your right as the tail of the stroke turns to the right, using the narrow edge of the brush to form the graceful tail of a properly formed brushstroke.

The Left-to-Right Stroke

For the left-to-right stroke, press the brush down to broaden its tip, draw it slowly to the right; then lift the pressure as you begin to turn the stroke leftwards. Twist the wrist toward your left so that you do the tail with the narrow edge of the brush, drawing it carefully downwards toward your left and finally lifting the brush completely off the design, thus completing the well-made stroke.

The Straight Stroke

The straight stroke is done from top to bottom. With the flattened brush press downward according to the width required to form the wide end. While drawing the brush straight down, twist the wrist so that the narrowed part or edge of the brush may form the fine tail. Lift the brush off very gradually while on its downward journey. This stroke may also be done horizontally.

The Elongated S-Stroke

The elongated S-stroke is pointed at each of its ends and is broad in the middle. Work the brush on the palette so that it is not too heavily loaded and the badger hairs are very flattened. Lay the brush down so that the narrow knife-like edge forms one end of the elongated S. Bear down on the brush to broaden the stroke in the middle and, turning so that the brush goes in the other direction, twist your wrist so that you again end the S-stroke in a fine point by again using the edge of the flattened brush.

The Wide Leaf-Forming Stroke

Wide leaf-forming units are done in two or three strokes depending upon the size or width of the leaf to be painted. Some are rounded at the end, others are pointed. Do one side, bearing down heavily for the wide section of the leaf and lifting again toward its tip end. Repeat on the other side doing it in such a way that one side of the brush barely touches the side of the stroke which was previously painted. Always begin leaves from their stem end. The varnish and paint will level off and form an attractive shading. When three or more strokes are necessary to complete a wide or large leaf do the two outer ones first and connect them with central strokes only just overlapping the inner edges of the first two. *Do not work over any strokes—it will spoil their appearance and make them spotty.*

The Slim Long-Line Stroke

The slim long-line stroke looks like a line but it is distinctive because one end is just slightly broader than the remainder of it. It may be pointed at the

slightly broader end or may be rounded. It is done with almost no bearing down and the brush is held knife-like while it is being done in order that the stroke shall be fine. The correct consistency of paint and varnish and the proper loading of the brush are important factors.

CONTINUOUS S-STROKE LINE DECORATION

S-stroke continuous line decoration is done by pressing down and lifting with a continual repetition of this rhythm until the line is completed. Do each initial S-stroke as explained above, but do not lift the brush completely off the design between each S. Keep the brush gliding until it needs to be refilled. When you lay the brush down again after refilling it, be careful that no puddle is left and that no join shows.

BRUSHWORK EFFECTS

BRUSHSTROKE COMPOSITIONS

The use of contrasting colors adds to the attractiveness of the various shapes and sizes of brushstrokes. These can be used in repeat formation for bordered effects or to decorate an article. When done on country-tin pieces (see Chapter VIII) they must be done with the traditional colors for this type of painting. (See Figs. 55, 56, 57, 58, 59, 60 and 61.)

Gold leaf may also be applied on these brushstroke combinations. This form of decoration may be used as delicate lace-edge borders (see Chapters X and XI) or may be used to decorate an assortment of household articles. (See Figs. 19, 22, 38, and 62.)

The scroll-type border, often done on "Chippendale" pieces (see Fig. 6), and on Gallery trays (see Fig. 61) is done with a brushstroke. Its width variations are delicately done and it uses all the types of brushstrokes mentioned earlier (see Fig. 63).

SUPERIMPOSED BRUSHSTROKES

The superimposed brushstroke is done on painted shapes, such as a leaf or a flower. The brushstrokes may be done in alizarin crimson toned down with burnt or raw umber on solidly painted shapes done in English vermilion. These strokes serve to give shape to flowers. Other strokes are done in semi-transparent white and may be done alone or in combination with the darker alizarin strokes. (See Fig. 64.) On floated or glazed color these brushstrokes add the note of realism which is so important in the advanced forms of painting. (See Fig. 65.) Painted or gold-leaf leaves are given a final finished appearance by the elongated pointed stroke which serves as a central vein

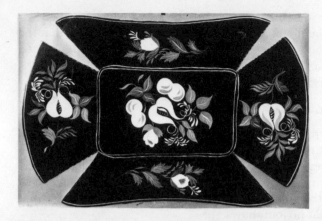

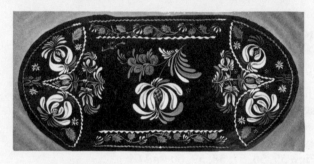

Fig. 55. Two designs for country-tin bread trays. *Top:* Units are of English vermilion with superimposed alizarin brushstrokes. The yellow is a mustard shade, and the greens are not dark. Veinings are yellow. *Bottom:* The rope effect is in light blue, flowers are English vermilion with alizarin overstrokes. Leaves are green with black veins and brushstrokes are green and country-tin yellow.

with smaller ones added to give the leaves greater interest. (See Figs. 28 and 31.)

Brushstrokes for Minor Details

All styles of painting employ the brushstroke for minor details. Country-tin and Chippendale painting are done in green and are similar except that some of the latter are dusted with bronzing powders. Minor details of lace-edge consist of delicate clumps of nosegays made up of tiny, rather chubby brushstrokes combined with larger strokes. These are done in the wide range of colors and shadings which are so typically lace-edge. (See Figs. 19, 20, and 62.) See Chapter XI for doing the small nosegays of lace-edge.

Stippled or Pounced Foliage Effects

The stippled or pounced foliage effects appear only in the scenic stenciled type of tray and on the scenes of reverse-painting-on-glass-panels for mirrors and clocks. Pouncing may be done with a stiff, short-bristled artist's brush which may be cut in a layer-like formation so the bristles are not all the same length. A stiff poster brush may also be used. The tip of the brush is

dipped into paint with almost no varnish and it is stippled or pounced along while held in a vertical position. Green in various shades, including large quantities of Chrome yellow, are used for these effects, on scenic-type trays as well as on glass (see Fig. 90). Stippling is done with a small piece of sponge. The smaller the holes of the sponge the smaller the stippled effect will be. This appears in greens and Chrome yellow and is also done with burnt umber and black on glass panels. (See Figs. 88 and 90.)

SQUIGGLES OF PONTYPOOL BORDERS

The squiggles for Pontypool borders are sometimes done with a fine brush and paint over which bronzing powders may be polished or gold leaf laid, when the medium is tacky. The finest squiggles, however, are done by using an architect's ruling pen and enamel from a freshly opened can (see Fig. 49). This technique, also known as Stormont, may be done with Sig-nette (see page 25).

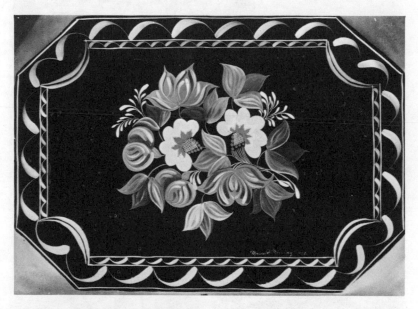

Fig. 56. Design for a large coffin tray. Central flowers are mustard-yellow with vermilion centers and transparent white. Tiny stem lines, cross-hatching, striping and border strokes are country-tin yellow. Top left-hand unit with four points is in vermilion with alizarin and white strokes, as are the double ball effect and the single one with the four-sectional flower between and below the white ones. All the rest is green, painted on so that it shades in a streaky manner with highlights of chrome yellow. The striping and border strokes would appear on the floor, with a repeat of strokes on the one-inch flange which would also carry two yellow stripes three-eighths of an inch away from the outer edge and from the bend at the floor.

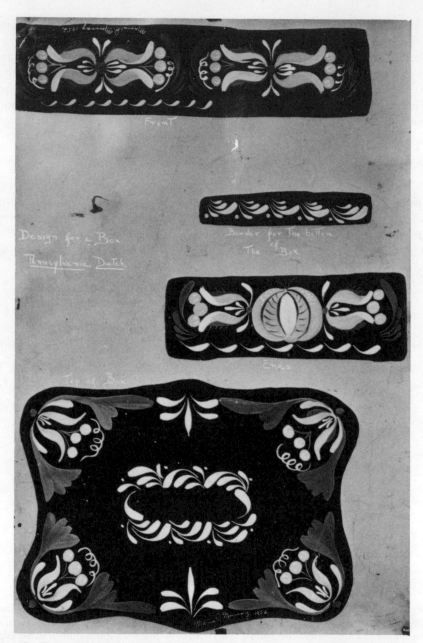

Fig. 57. Design for a Pennsylvania Dutch box. Central stroke formation at the top, those forming borders and flanking the tulip forms and the curlicues are in country-tin yellow. Tulip shapes and the round melon-like form are vermilion; the dark strokes are dark green; the center of the melon is mustard color with burnt umber lines and chrome yellow dots. No white appears in this design.

102

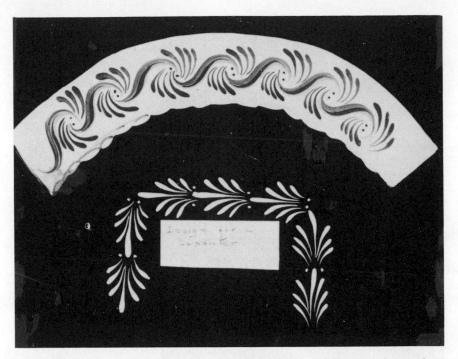

Fig. 58. Design for a cannister. *Top:* painted putty-white band. The S strokes are done in vermilion first, with toned-down alizarin covering half the width after the vermilion is dry. Then a green stroke is superimposed in the middle. The dots are also vermilion. All other brushstrokes are green. The bottom scalloped effect is due to yellow strokes which border the edge as a rope. *Bottom:* The design is all in country-tin yellow and any striping would also be in this color.

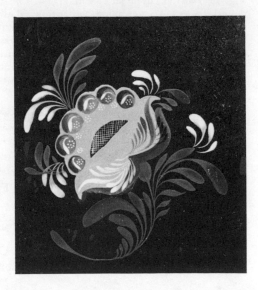

Fig. 59. Country-tin unit design. Large flower is in vermilion; circles at top of it and the dark strokes are toned-down alizarin. White strokes and dots on the flower are toned-down creamy white. Criss-crossing and the light strokes outside the flower are in country-tin yellow. The remainder is in country-tin green.

103

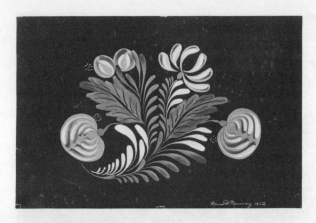

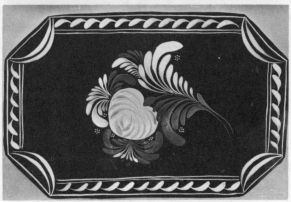

Fig. 60. Two designs for small coffin trays. *Top:* The tulip and buds at the top, and the round shapes are in vermilion. Superimposed alizarin strokes are allowed to dry thoroughly before the white ones are applied. The strokes on the black ground and the dot formations are in country-tin yellow. The leaves and all other strokes are green, with black veins. *Bottom:* Central unit is vermilion with superimposed alizarin strokes. White strokes are applied when the alizarin is dry. Strokes against the black, border, striping, and dots are in country-tin yellow. All others are green.

CURLICUES OF COUNTRY-TIN, CHIPPENDALE AND OTHER PAINTING

Curlicues appear in green on both the country-tin and Chippendale types. They are best done with a scroller or a sharp-pointed thin brush made of a few red sable hairs. The brush is properly loaded and is held in a vertical position while these are being done. (See Figs. 10, 79, 80, and 81.)

DRIPS OR TENDRIL MOSS OF CHIPPENDALE

Drips or tendril moss effects appear on Chippendale and on some Gallery trays. These may be done with extreme delicacy using pigment and varnish

104

and a No. 2 French quill, if the quill is flattened and used as a knife blade. They may also be done with Plax and a pen. If necessary, dilute the Plax slightly with turpentine to make it flow more easily. Too much turpentine will cause the Plax to spread on the design. (See Figs, 6, 25, and 26.) The drips and tendril moss forms of brush-work are always done with metal leaf —usually gold unless silver is called for. They may also be done with Signette (see page 25).

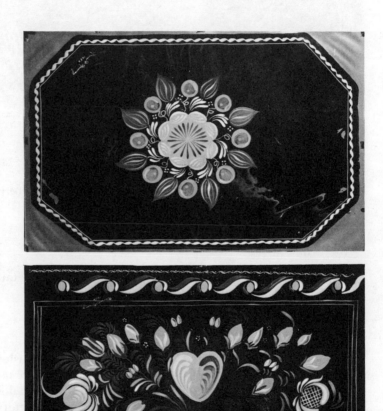

Fig. 61. Two Pennsylvania Dutch designs—Geometric Circle and Heart. The circle is made of English vermilion with alizarin and white strokes. Smaller vermilion circles are accented with alizarin within them, a yellow dot, and a white stroke. Large leaves are green with yellow strokes to match the curlicues, dots, and strokes between them. The heart, tulips, and buds are in vermilion, with the largest buds in light blue. Green is used for leaf-forming strokes. Border strokes are yellow and green with red ovals. The rope design is light blue with red dots. Striping is in toned-down yellow.

Fig. 62. Oval lace-edge design showing detail of a peach and strawberry. *(Courtesy of Craft Horizons)*

HOW TO STRIPE

The kinds of brushes used for striping are discussed in detail in Chapter II. (See also Fig. 4.)

MIXING THE PAINT

The paint for striping is mixed in the same way as for brushstroke-painting. When yellow stripes of the mustardy-yellow shade are used, they are done over the second coat of varnish after it has been rubbed down. Chrome yellow, in oil, has a tendency to feather or crawl and therefore it is best to use chrome yellow in japan, mixed with raw and burnt umber to tone it down. When a bronze stripe is required, use the correct shade of bronzing powder mixed with varnish. Stripes are often done in gold leaf in which case this metal is laid upon a bronzed stripe when it becomes tacky and, of course, before any varnish coats are applied. Other colors may be used for striping including English vermilion in combination with its darker shades, Venetian red, flesh ochre, and other colors. The white stripe is largely used on Pontypool pieces; it is titanium white mixed with raw umber and a little yellow ochre to give it a creamy shade.

106

LOADING THE STRIPER

A striper mixes the pigment with the Spar varnish and then the excess must be brushed out of it so that it will not be too loaded. Long-haired stripers are used to make long lines, so that the striper need not be refilled as frequently. The stripe is thereby less spotty and can be done as a continuous line.

HOLDING THE STRIPER

To stripe, hold the brush as you would a pen. *The direction for striping is toward you.* Place your pinky along the edge of the article to be striped, and use it as a guide to keep the brush in a straight line. Turn the article so that you always stripe in this position. Do the painted striping directly over your

Fig. 63. Design for a tilt-top table. The table is of papier-mâché and is owned by Mrs. Clyde B. Holmes. The rose is almost white with a pink cast and the modeling shows clearly. The leaves are also modeled with floated green over the modeling and additional white strokes for the third step. The bird's wing is partly of silver leaf with blue over it and partly of gold leaf with alizarin. The body, head, and tail are of gold leaf shaded with burnt umber. The iris is modeled and floated or glazed in blue, alizarin, and shades of both with accents in chrome yellow. The background is black.

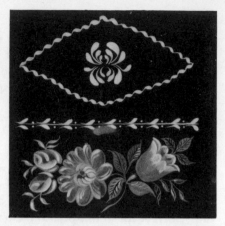

Fig. 64. Steps for doing country-tin painting. *Steps 1 and 2* show the solidly painted forms of flower and buds as they appear in English vermilion. When this is dry, toned-down alizarin brushstrokes are applied. The tulip is shaped by shading with alizarin instead of with brushstrokes. *Steps 3 and 4* show the green leaves and stems painted in opaque green; the country-tin mustard-yellow banding and composition are done. White strokes are applied over steps one and two to give form to the flowers and buds, after the alizarin strokes are dry. Leaves are veined in black and white strokes. This design is suitable for a cannister or a tin box. *(Courtesy of Craft Horizons)*

silver guide lines (see Chapter III). When there are several stripes, do those in the center first so that they will not be disturbed while the others are being done. *Always do painted stripes after you have applied the second coat of varnish and have rubbed this down with wet sandpaper.* Erasures and corrections can be made without damaging the design. Stripes which are either bronzed or done in metal leaf must be done first, before any varnish coats are applied (see below and page 10 on tortoise-shell backgrounds).

TYPES OF STRIPES

There are two types of stripes, with varying degrees of width for each. The very fine hair-line stripe is done with almost no bearing-down on the brush. The artist uses only the sharpest and finest point of his striper brush. The wider the stripe becomes the more pressure is applied. The broad band is done a section at a time, doing both outer edges in a semi-fine stripe and then going back to fill in the middle part. These broad bands are always done in bronzing powders and are best when painted on the flat background before protective varnishing is applied. When these bands are tacky, polish in more bronzing powder with the velvet square. Some are done in gold leaf, also. Note: the broad side of a brush will also make a wide band.

108

 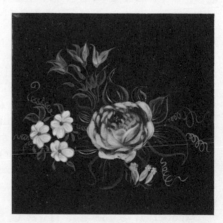

Fig. 65. Details and steps for floating a rose. *Step 1:* The rose is modeled in semi-transparent white and white strokes are superimposed while the modeling is still wet. *Step 2:* This is the floated or glazed step as it looks when there is no undercoat of modeling. Note the shading of dark and light colors. The center is yellow, toned down with burnt umber, shading into light pink with very dark, soft shadings of alizarin also mixed with burnt umber. *Step 3:* This shows the rose when the floating is done over Step 1, with the additional veiled brushstrokes done in soft, creamy white (titanium plus raw umber plus yellow ochre) into the semi-wet floated No. 2 stage. *Step 4:* A finished rose, after it has dried and the veiling has settled into the semi-wet floated or glazed layer. *(Courtesy of Craft Horizons)*

VIII. *Painted Styles of Layman and Apprentice in America*

THE FUSION OF ASIATIC AND EUROPEAN STYLES IN AMERICA

The pioneering spirit in America, which helped to promote and to expand commerce, scientific inventions and artistic forms of all kinds, has always been an integral part of our nation. In our country all the characteristic attainments and social orders known to the world are represented. Our forebears came here from many places and started their new lives. Their faith and unbounded courage made them succeed in all of their enterprises. Their artistic endeavors cannot be classified under separate headings. None are actually primitive nor are they pioneer, folk or amateurish. Their decorative art is for the most part that which was produced by the layman, the trained craftsman, or by the apprentice.

Dagobert D. Runes and Harry G. Schrickell, editors of the *Encyclopedia of the Arts,* explain folk art as: "Basically . . . an aspect of folk lore which characterizes the change of a group from a primitive to a rural status. It is a part of the pattern of the folkways of the group, the mores of which may dominate, while the arts liberate in a complex of traditions. . . . It is comparable to primitive art only if survival elements predominate; it is peasant art only if unsophisticated and strongly traditional elements are patent; . . . it is regional, provincial, colonial, or frontier, dependent upon the geographical, political or environmental setting of its expression. Folk art is never autocratic, dictated by fashion, or fostered by a nation. It is founded on traditional techniques; it concentrates on things rather than on ideas; its craftsmen know the satisfaction of recreation rather than that of creation."

The Puritan and Pilgrim movements, with their desire for liberty and independence, received their first impetus during the reign of Queen Elizabeth I. In 1600, the British East India Company was founded. It was in full

operation and imported many foreign articles from the Orient and from other parts of the world while Charles I and James I were on the English throne. Their reigns were marked by incompetency. Many political disorders and much corruption followed, with the result that the New England Puritans at first associated all forms of art with everything which appealed to the senses. In the words of Elizabeth Robbins Pennell, they "not only had no time for art but no place for it in their scheme of salvation." Consequently, for a short time at least, there was a subdued and repressed spirit in their art forms. Simplicity and dignity in design replaced the elaborately ornate. They strove to produce the purely functional and practical articles required for their homes.

During the Restoration Period of Charles II, England was greatly influenced by the lavishness and extravagance of Louis XVI of France. At this time, the American Colonies and particularly New England, the Crown Colony, benefitted from all the importations of the East India Company. Such luxury stuffs as majolica, faience, Portobello ware, Oriental lacquer and other articles of foreign make, were well known to the colonists. Traditional decoration which appeared on the housewares imported into the American Colonies, inspired the layman and the apprentice to develop his own style. The American decorations were sometimes religious in character. When they were symbolical, their design units were drawn from American, European and Asiatic sources.

The Dutch came to America from the Netherlands at a later date than the Puritans. Other nationalities were also represented here. Besides the English, Scotch, Welsh and Irish, there were the Germans from the Palatinate, the Swedes, the French and the Swiss. All left their imprint on the decorative pieces they produced on this side of the Atlantic. The Dutch had been navigators for many generations and had traded in distant parts of the world. They came to America primarily for commerce and not for colonization. Their "patroons" ("patron" was the English equivalent word: it was used to distinguish those who would finance colonists from those who would take colonization only on their own account) found conditions along our waterways not unlike those of their native Netherlands. They traded in their own ships along the entire coast from Newfoundland to Florida and up into all of the river estuaries along the way. The seventeenth-century Dutchman was devout, industrious and thrifty. His tastes were luxurious and his trading instinct shrewd and sharp. He made his home in New York along the Hudson River and called the area "Nieuw Amsterdam."

The French Huguenots introduced new forms of decorative painting. Paul Revere, of American birth, is better known as a silversmith. His father came from the French mainland and the Isle of Guernsey and bore the French name of Apollos De Revoire.* Both father and son were also known as de-

* From the *Dictionary of American Bibliography,* Edited by Dumas Malone. Platt-Roberdeau. (XVIII vols.) Charles Scribner's Sons, New York, 1935.

signers. They produced articles in tin and in other metals besides silver. Other French artists contributed to the decorative arts of those times. The tulip and bird designs which were found in New England, originally, but were later attributed to German influence in Pennsylvania, are examples of French types of design motifs.

The Germans, who settled in Pennsylvania, were never navigators or leaders in the important voyages of discovery. The first German settlement in America was in Germantown, north of Philadelphia. It occurred in 1683 and William Penn is associated with these beginnings. He spread his Quaker doctrines in Holland and in Germany during two trips which he made, one in 1671 and another in 1677. His Quaker followers were of high social standing as well as those of the serving classes, who in their new homeland became property owners. The area now known as Pennsylvania was granted to William Penn as payment for services rendered and for advances made to England by his father, Admiral Penn. This grant covered land which had already been settled by the Swedes and the Dutch and which England took over. Immigration was increased during the early part of the eighteenth century because of the destructive wars, the petty tyrants and the religious persecution suffered in the southwestern part of Germany, called the Palatinate. Würtemberg and Baden, in this order, furnished the largest number of Palatine immigrants during this time. The Mennonites and the Amish from Switzerland, the Quakers and others all benefitted from the right to practice their separate religious beliefs in America.

The Swiss brought to Pennsylvania the tradition of birth and marriage certificates. Ecriteau and Fracturschriften, as this sort of work was called by them, was done by the Swiss. It was a survival of the medieval manuscript style of illuminated writing. "The first book on the subject, as we know it, was compiled in Switzerland by Boltzen and was published there in 1548. The German pirated edition was published in Rufach in 1566. The first known book on penwork is Italian. The deeds issued by William Penn and his heirs were the finest penwork known in Pennsylvania."* In America, the Cloisters of the Seventh Day Baptists at Ephrata, Pennsylvania, became known for this form of writing. "Every initial letter done at Ephrata would seem to be taken from a face of *Batard Gothik* issued by a Dutch (Netherlands) Typefounder.* (Figs. 66, 67, and 68.)

Many of the fractur motifs used by the Swiss and later by the Pennsylvania German settlers were of Indo-Persian tradition and were patterned after the designs of damask cloth and other Asiatic works of art. Fractur painting required the artist to hold his brush in the upright position of the Chinese. The designs were often of Chinese influence. The inception of Chinese decorative principles is an interesting story. In 600 B.C. Emperor Wa Tei of the Chow dynasty of China, penetrated as far as the mountains which

* Quoted from Mr. Carl W. Drepperd, on the consulting staff of *Spinning Wheel* magazine, published by Spinning Wheel Publishers, Taneytown, Md.

Fig. 66. Pennsylvania German Fractur. Cut-out, dated 1776, ink and watercolor. *(From exhibit of Early American Arts and Crafts at the New-York Historical Society)*

Fig. 67. Pennsylvania German Fractur. **Birth** and baptismal certificate for Christian Kaupp, 1775; hand illuminated. *(From exhibit of Early American Arts and Crafts at The New-York Historical Society)*

113

Fig. 68. Pennsylvania German Fractur. Birth and baptismal certificate for Maria Magdalena Kaup, 1811; hand illuminated. *(From exhibit of Early American Arts and Crafts at The New-York Historical Society)*

divide the Tibet from western Asia. There the "Queen of Sheba" was met and the friendship led to the later Turkestan campaigns which established a permanent caravan trade across "The Roof of the World" and beyond the vast deserts between China and Rome. Due to the jealousy of the Parthians, the intermediate people, wars were fought, with the result that some Asiatics established permanent homes in Central Europe. They brought with them the cult and the artistry as well as the techniques of China.

STYLES OF ARTICLES

Wooden Pennsylvania-German Articles

"Woodenware—racks, stands, etc., were at first carved (in Pennsylvania) in the Swedish, Dutch and Swiss traditions. The next step was scratch-carving with color laid in and then all the carving was imitated in paint. It is a cheapening of the basic technique, substituting brush and pigment for knife and chisel."* (Fig. 69.) Later wooden articles of many shapes and sizes were made in Pennsylvania. One type of woodenware which was unique was produced by Joseph Lehn who lived near Lititz, Lancaster County, from 1798 to 1892. He produced everything from wooden buckets to small boxes. He first made his articles on a wood-turning lathe and then decorated them in the technique used for china-painting. The Staffordshire pottery and china which was imported from England were his source of inspiration (Fig. 70).

* Quoted from Mr. Carl W. Drepperd.

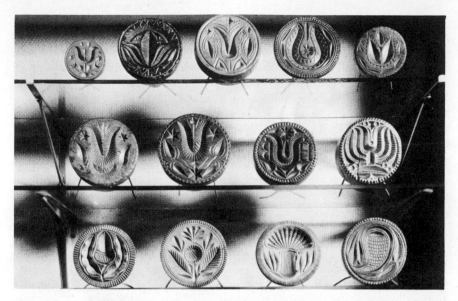

Fig. 69. Early XIX-century butter molds. *(From exhibit of Early American Arts and Crafts at The New-York Historical Society)*

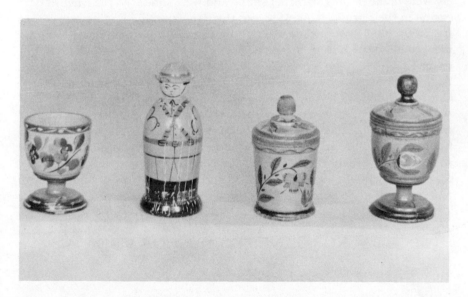

Fig. 70. Four pieces of woodenware by Joseph Lehn of Clay, near Lititz, Pennsylvania, who did his turning and decorating of woodenware from the 1850's until the late 1880's. The photograph shows an example of the small chalice forms that are painted on the inside as well as the outside, two covered spice boxes which were unpainted on the inside, and a figural penny bank. *(Courtesy of Mr. Carl Drepperd)*

During the last half of the eighteenth century there were boxes of all kinds including dough troughs, trinket, deed and document boxes; boxes for storing knives, candles and salt and also the splint box for brides which was made in an oval shape and was decorated with the figures of a man and a woman and all of the other units suitable to them on the occasion of their marriage. These boxes were crude replicas of the Medieval Italian Cassoni. They were known as "Kas" and Dower Chests. Each of these wooden pieces was fashioned in its own particular style and was decorated with the motifs which are now considered typically Pennsylvania (Fig. 71). Many of these boxes were brought to America by the immigrants who used their pictorial, floral and geometric designs as models. Other wooden articles include mirror frames, spoon racks, sewing stands, covered pails and buckets, clothes brushes, stools and containers for spices, herbs and other culinary supplies.

AMERICAN TINWARE (see Fig. 72)

Trays produced early in the American colonies were never very large, due to the dimensions of the tin-plate which was imported from England. The largest were pieced across their width. Their decorative units were balanced (Fig. 82), both sides of the tray being equal. Trays of the flat, wafer-like variety were made in the cut-corner shape and were similar to the English type except in their proportions. Whereas the flanges on the English cut-corner tray were about two inches wide, those of the American version were no more than one inch wide (see Fig. 73). (Compare Figs. 18 and 35 for differences.) The American type was called a "Coffin Tray" (Fig. 18) because of its resemblance to the lid of the coffin of those times. Other tray shapes included the apple dish which was deep, with flanges curving gracefully outward from the bottom section which was about four inches square. Bread trays were of the same pattern but were elongated with one deeply curved flange at each of the narrower ends. Snuffer trays were also made of several shapes. Other practical tinware included coffee pots (Figs. 83, 84, and 85), tea pots and caddies, cookie boxes, deed and document boxes, candle sconces and many other household articles (see Figs. 74, 75, 76, and 77).

BACKGROUNDS FOR DECORATION

BLACK

While the quality and type of decoration varied slightly in different communities, black was the background which was most often used. It was made by mixing certain resins with chimney soot. Today a good quality of flat black is applied in several thin coats. Each is rubbed down to smoothness. (See Chapter I.)

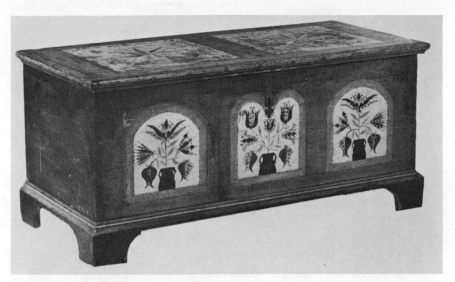

Fig. 71. Dower chest, probably made by Johann Rank, Jonestown, Dauphin County, Pennsylvania. Dated 1904. There are pots of tulips in the three arched panels on the front; geometric symbols on top. *(From exhibit of Early American Arts and Crafts at The New-York Historical Society)*

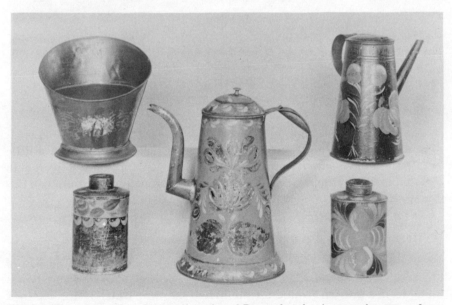

Fig. 72. Five pieces of professionally painted Pennsylvania pieces as they came from the factory (not home painted or home decorated examples). They are japanned in various colors with the decoration in contrasting colors. The piece at the upper right is a display item as used in many grocery stores. *(Courtesy of Mr. Carl Drepperd)*

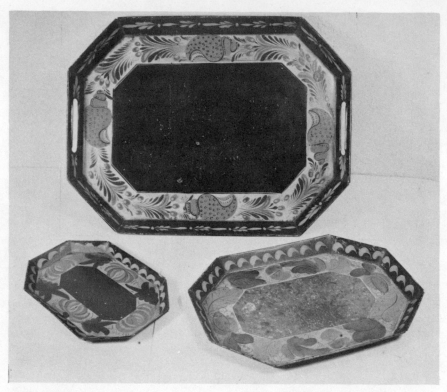

Fig. 73. Pennsylvania-German painted tin octagonal trays. Owned by Dr. and Mrs. Earl Robacker. *(Courtesy Antiques Magazine)*

ASPHALTUM

Asphaltum as a background material is discussed in detail in Chapter I. The old-time decorators often thinned it with varnish and added a little transparent red to give it a reddish cast when it was applied to shiny metal. All shapes of tin articles described in this chapter may be decorated on this background.

WHITE BANDS ON BLACK AND ON ASPHALTUM

White appears often in the form of semi-transparent bands on the floor of the coffin tray and on other articles such as document boxes. These bands often form a grayish ground for the bright painting which is applied over them. The bands appear on deed boxes, trays and coffee pots, as well as syrup jugs and other accessories. The designs on the coffee pots are often done over circles which cover almost the entire side of each pot, with the

spout coming between them on one side and the handle on the other side. (See Figs. 80 and 84.) This type of painting is of Pennsylvania German influence.

Brilliantly Colored Grounds

Brilliantly colored backgrounds were often used. Wooden articles appear to have been stained with brilliant dyes before the decoration was applied, with the backgrounds often done in a patterned blocking of contrasting colors and tones. Tinware was also painted with coats of opaque pigments, in a wide range of bright colors. Many of these pieces were imported from England.

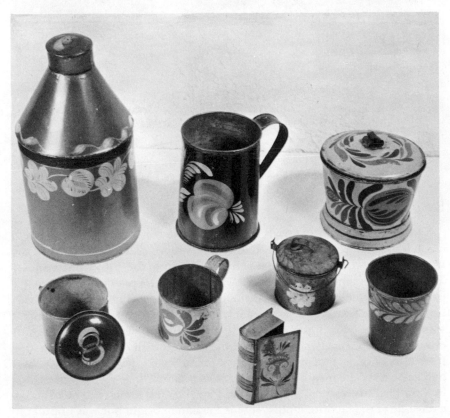

Fig. 74. Canister, cup, pails, and sugar bowl of Pennsylvania-German painted tin. Owned by Dr. and Mrs. Earl Robacker. *(Courtesy Antiques Magazine)*

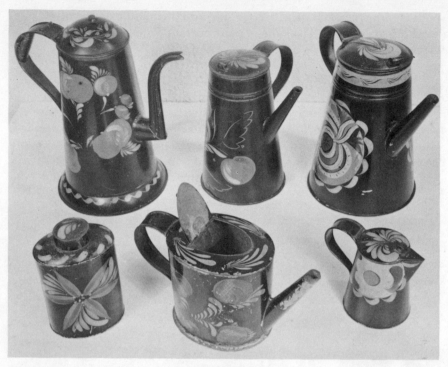

Fig. 75. Canister, teapot, and coffee pot of Pennsylvania-German painted tin. Owned by Dr. and Mrs. Earl Robacker. *(Courtesy Antiques Magazine)*

MOTIFS MOST FREQUENTLY USED

SYMBOLIC PAINTING

The designs used in Pennsylvania-German decoration were intended to teach a specific truth or lesson. The symbols represented the beauty of the home and also the fundamental religious ideals of the Bible, particularly The Song of Solomon and the New Testament. The pot of earth often appears. It represents the earth and the baser elements. The design was built up into stems, leaves and particularly the heart which was broad since it stood for all good things. It was done geometrically from three circles. A crown often appears denoting righteousness and with it a circle suggesting the trinity of perfection. Stars of several points were used. Each pointed star had its own special meaning and taught its lesson. Turtle-doves represented love and beauty and the peacock stood for spiritual majesty. The tulip became one of the favorite motifs. It was Persian in origin but was popular in Central Europe because of its simplicity and richness. It appears in various shapes on many objects. The Pennsylvania German settlers were known as

a people who did not fraternize with other nationalities; therefore, they be-came individualists and their designs remained uniform. Their decorations resembled the style of the folk art of their European forebears much more than did the decorations of other American communities. New World objects appear in decorative designs—men and women and national heroes are used in combination with the eagle. Many flower shapes, other than the tulip, are usually stylized and are often of Persian origin for their forms were used in early damasks. They were originally copied as block-printed designs and were used in crewel work on cloth. The Asiatic pomegranate appears in many decorative forms.

STYLIZED BRUSHWORK OF COUNTRY-TIN PAINTING
(see Figs. 56, 59, and 60)

Many types of Early American tinware were produced. Esther Stevens Brazer called these by the term "Country-Tin." Originally this type of tin-ware was known as "Our Country Tin," but these pieces are becoming known today as "Country-Tin," so this term will be employed here. In most

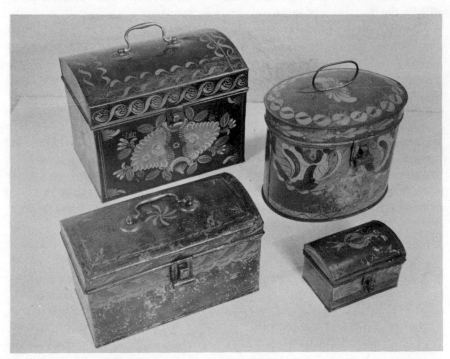

Fig. 76. Document boxes and canister of Pennsylvania-German painted tin. Owned by Dr. and Mrs. Earl Robacker. *(Courtesy Antiques Magazine)*

121

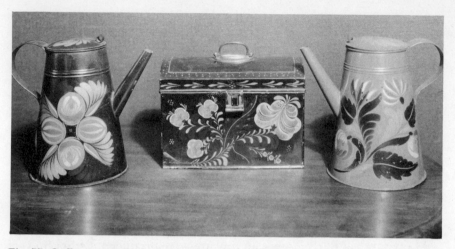

Fig. 77. Coffee pots and a document box of Pennsylvania-German painted tin. Owners unknown. *(Courtesy Antiques Magazine)*

instances these pieces of tin were decorated by the apprentice and occasionally by the daughters of some well-known craftsman.

Country-tin designs were not symbolical except as they were copied from the Pennsylvania German. Most of the painting of country-tin designs was of stylized flowers, fruit, and leaves. It consists for the most part of brushstroke formations which were made into attractive compositions. The designs are done in green, an off-shade of yellow, and English vermilion. Occasionally blue and light pink appear. The brushstrokes often seem like exercises done by the apprentice. The tulips were painted in another style and each of the vermilion strokes which forms them is embellished by superimposed strokes done in alizarin and also in white. When the heart appears, its shape is more elongated than the Pennsylvania German. Many country-tin articles were delicately decorated with flowers which were made to look, in a stylized way, like the more intricate naturalistic painted articles of advanced techniques.

PAINTS AND COLORS USED

Yellow, gray, gray-green and red earth clays have been used to make paints for centuries. The earths are ground to a fine powder and resins are added. Some earth colors were mixed with whiskey or other liquors. Varnish which gave them greater stability was made from the gum drips found on the trunks of cherry trees. In sections where there was no red clay, the yellow variety was baked to turn it red or brick dust was used for a less brilliant color.

Fig. 78. *Steps illustrating the process of inlaid mother-of-pearl.* (1) Drawing shows the actual units to be rendered in mother-of-pearl and the painted treatment over them. The solid black lines indicate the shape of the unit. The broken lines show the required shape of a cut piece of mother-of-pearl which is to form a given unit.

(2) A fragment of pearl. The dotted lines show the shape of each unit. The solid black lines indicate where to cut the pearl to form the basic unit.

(3) Method of building up the background thickness so it will be level with the pearl units. The dotted lines are done in India ink on the mother-of-pearl. In the drawing they show the actual shape required for each unit.

(4) Ground-coat detail, completed, to form the actual shapes required for each unit.

(5) Border and corner treatment, appropriate for this design, to be done in gold leaf.

How to paint this design. Leaves and stems are done in opaque green which is a dark-bluish shade and blends with little contrast on the black background of the article to be designed.

Leaf petals which form the detail of the mother-of-pearl units are done in semi-opaque, rather transparent, yellow-green, to permit the opalescent pearl to show beneath them. Each petal leaf is accented with fine strokes of creamy white on its outer edges so they show against black (titanium white plus raw umber and a lot of yellow ochre). All of the small strokes forming the detail at the opening end of the pearl flowers are done with the same creamy white.

The large leaves are accented, to form the veins, with broad strokes of darker green and also with smaller and finer strokes of burnt umber. The tiny leaves are accented with very fine brushstrokes of chrome yellow and burnt umber, used separately.

This design is appropriate for a box top and should be framed by a wide gold band (⅜ inch) with a fine gold stripe inside of it. (See step 5.) The corners may be decorated in gold leaf with a delicate unit such as is shown in step 5.

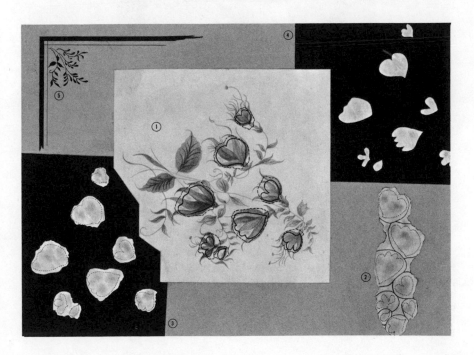

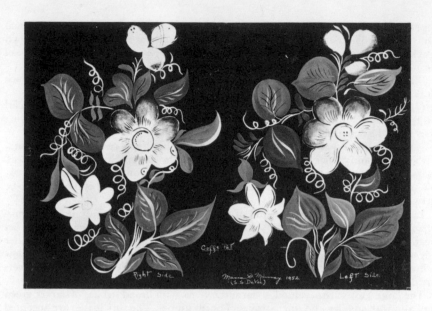

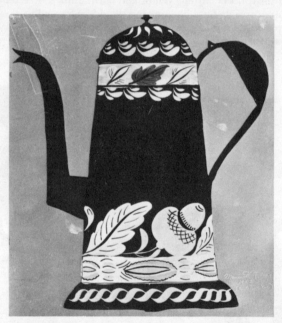

Fig. 79. Pennsylvania-German coffee pot design. *Top:* Design showing the use of finger painting to acquire a shaded effect on a flower, done in blue and red on white, with black lines and dots. The leaves are of country-tin green with yellow veins, stems, and curlicues, accented with black veinings. *Bottom:* Typical arrangement of units and brushstrokes done in country-tin yellow with English vermilion and green leaves. Black is used for accent.

124

Many dyes were extracted from plants and these were made into color pigments. Skunk cabbage and wintergreen produced greens. Madder produced a deep red. The roots, berries and bark of trees and the shells of nuts, were boiled to give many desired shades.

A few paints were imported from Europe and Asia. Blue seldom appears in the country-tin decoration of New England because it came from the indigo plant of Asia. A wider range of color including blue was used in the Pennsylvania German decorations since the Dutch traders along the coastline imported what the German settlers of Pennsylvania required. Vermilion was popular in all sections. Cinnabar was no longer imported from China to produce vermilion. It was made in England of mercuric sulphide. It was less brilliant in color, but was less expensive to produce and was within the budget of the American colonist. For this reason vermilion varies in shade and intensity according to the locality in which it was used.

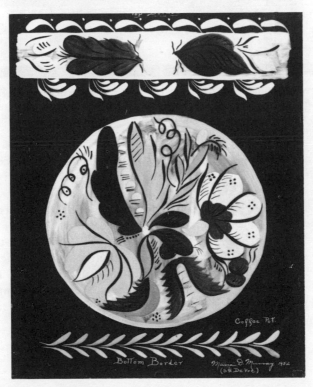

Fig. 80. Pennsylvania German coffee pot design on white circles. The brushstrokes that form the border are yellow. Designs are done on semi-transparent white circles and bands (on both sides of the coffee pot), in English vermilion, a muted orange, mustard yellow, deep green, and black for accent.

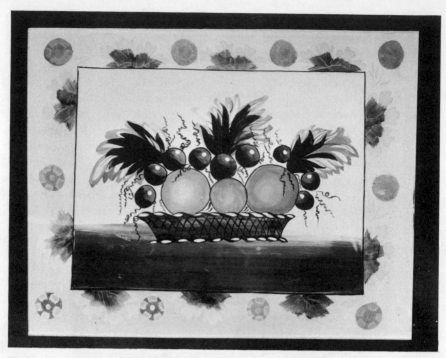

Fig. 81. Reverse painted glass panel of a basket of fruit. The design is crude in its detail but charming. The border is stenciled on a pink beige ground. Line detail is in burnt umber. The fruits are deep red; the leaves are in three shades of green; the basket rests on a brown and yellow shaded ground, with blue sky behind it.

Today country-tin is decorated with English vermilion in combination with the superimposed brushstrokes which are done with alizarin toned down with burnt or raw umber and with thin white strokes of titanium white toned down with raw umber and yellow ochre. Borders are formed by yellow brushstrokes made from mixing chrome yellow with raw and burnt umber and Spar varnish. These strokes are applied in a semi-transparent way. Leaves or the brushstrokes representing them, are made by mixing chrome yellow with raw umber and adding a little Prussian blue and Spar varnish. Green appears in various shades depending on the quantity of each color used when these are mixed together. The greens are never done with thick pigment and are usually semi-transparent, also.

BRUSHSTROKE COMBINATIONS

The Large Units

Large units are done in English vermilion. In the Pennsylvania German types they may also be done in toned-down white, and in off-yellow or even

126

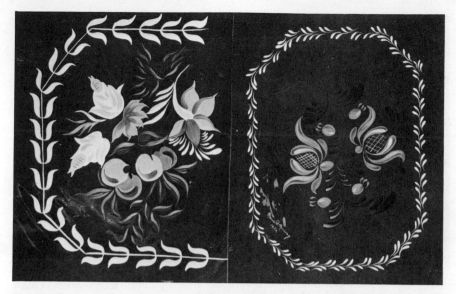

Fig. 82. Two tray designs for country-tin and Pennsylvania German painting. *Right:* Unusual tray design with brushstroke arrangements done in off-white. Tulips and buds are in red with alizarin and white strokes. The leaf-forming brushstrokes are accented with burnt umber and white. *Left:* Design used for the pierced-coffin type of large tray, which is repeated on each half.

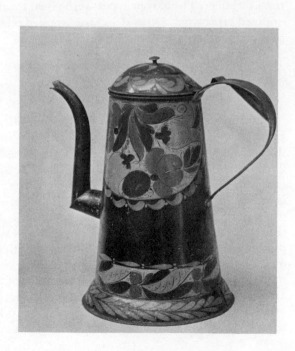

Fig. 83. XIX-century Pennsylvania German coffee pot. Note the white band and circle which appear beneath the design, and the brushstroke formation. *(Courtesy of Metropolitan Museum of Art)*

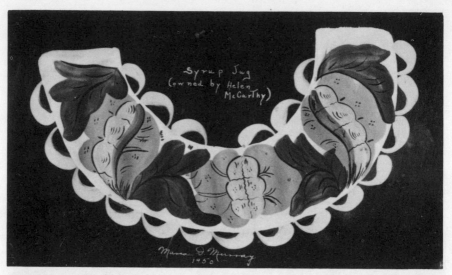

Fig. 84. Syrup jug, Pennsylvania German, done on an asphaltum base—reddish coloring on shiny metal. The band is transparent white; the medium gray shapes are English vermilion; lighter tones represent a deep mustard-yellow. The leaves are dark green and brushstrokes along the edges of the white band are in country-tin yellow. All the fine lines, veins, and dots are in black.

in a deep blue. Designs done at a later date were gracefully shaded to give a realistic effect. The earlier types were given form by the addition of superimposed brushwork. Often detail was applied on white shapes by the finger-painting method. (See Figs. 64 and 86.)

The Superimposed Brushstroke
(see Figs. 24, 55, 56, 59, 60, and 64)

Superimposed brushstrokes on English vermilion shapes appear in alizarin crimson which is made richer and darker by mixing it with burnt or raw umber. They are beautifully tapered and shaped and appear to have been done by an experienced hand. The off-white strokes, made by mixing titanium white with raw umber and yellow ochre, are painted with a brush which is more heavily loaded on one side than on the other, though it is never so wet that the stroke feathers or runs at the edges. After the paint is mixed on the palette, stroke the brush over it in such a way that you pick up slightly more pigment on one side of the flattened bristles and a less pigmenty varnish mixture on the opposite side. The outer curve of a stroke should be done more heavily than its inner curve. The liquid of the varnish will level itself and will blend gracefully with the paint (see Fig. 24). The white strokes are often overlapped on the alizarin strokes. If this is done, two or three days should elapse before the white strokes are put on. Alizarin is a very slow-

drying paint. White strokes are also done beside but not touching the alizarin ones. Often the leaf shapes take white strokes representing veinings. White strokes do not usually appear on a black background.

Brushstroke Border Effects

Brushstroke border effects (see Figs. 18, 55, 56, 57, and 58) are achieved by combining brushstroke formations into attractive compositions. These are done in yellow which is made from mixing chrome yellow with a little raw and burnt umber. They are never done too thickly and are semi-transparent; therefore there should be a large proportion of varnish with the paint. However, the brush must not be so wet that the strokes feather. These also are more attractive when the paint and varnish are mixed on the brush so that there is more pigment on their outer curves, giving them a gracefully shaded effect. These strokes are done directly on the black background and because they are not too thick with paint they appear transparent and have a toned-down greenish look with attractive shadings. Some of the old articles were also done in more pigmenty and less transparent strokes.

The Curlicue and Leaf-Forming Strokes (see Fig. 24)

The curlicue appears often in green. It is done with a mixture of chrome yellow (in japan, so it will not feather as much), raw umber and Prussian blue. Use a sharply pointed brush of the scroller variety or a small-pointed French quill. The brush should be held in the upright position of the Chinese technique while you rest the hand that holds it over the wrist of the other hand. Move your arm in rhythm with the curlicue but hold the hand in one position, permitting only the tip of the brush to glide upon the surface. Leaves and tiny strokes are done in the same green mixture using oil paint in chrome yellow. They should be applied smoothly, with graceful shadings which result from mixing the pigment and Spar varnish as it is done for the other strokes.

Detail Work

Detail work may be done in black. Veinings are often applied on the green by using black service-seal. Yellow and white may be used separately for veinings. White and yellow often appear as delicate fine lines to form a trellis-like center to a flower, or as dots for the same purpose (see Fig. 24).

STRIPING ON COUNTRY-TIN AND PENNSYLVANIA GERMAN ARTICLES

Striping on articles of the country-tin and Pennsylvania German type is always done in off-yellow. Do it after two coats of protective varnish have been applied and rubbed down. To avoid a feathered effect, use japan chrome yellow rather than oil paint. Tone it down by mixing it with raw and burnt umber. Follow directions for striping as given in Chapter VII.

Never use gold leaf with Pennsylvania German or country-tin painting. Never stencil on a country-tin or a Pennsylvania German article!

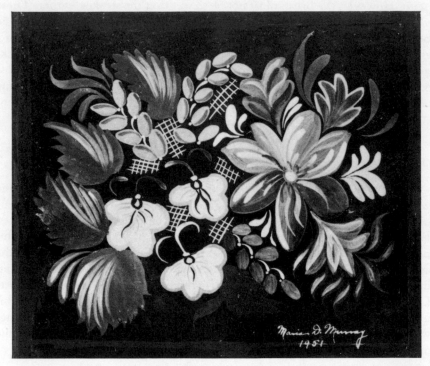

Fig. 85. Country-tin design with pansies. The large flower at left is first done solidly in Prussian blue with a little raw umber. The three bottom petals are given a wash of transparent, lighter blue (titanium white, raw umber, Prussian blue) when the foundation is dry, and the three top petals receive a bluer, more opaque coat. The foundation is left alone, however, for an edge of 1/16 of an inch. Semi-transparent white and yellow strokes are superimposed on a dry surface. The center is yellow, surrounded by alizarin. The brushstroke arrangement at the right is pink. All other bright units, except the pansies and leaves, are vermilion with white or alizarin strokes superimposed. Leaves are green with yellow, fuzzy stroke effects; the bottom of the pansies is a dark mustard over which lighter yellow is applied, leaving a border of ⅛ inch of the mustard. The lighter yellow is also used for the cross-hatching. The tops of the pansies are a mixture of alizarin and Prussian with white strokes.

130

Fig. 86. Interesting units for small white boxes. The berries are English vermilion with overstrokes of toned-down white and alizarin. Leaves are green with black veinings. All striping is black on a white ground.

IX. *Reverse Decoration on Glass Panels*

During the Gothic era, glass decoration was achieved by most complicated methods. Stained glass panels were at first used in castles and were of heraldic motifs. Later the panels were made for churches. Early private homes were also equipped with leaded glass windows.

With scientific progress glass was improved, and the sheets became thinner, larger, and more transparent. England is known to have levied taxes on glass panels which exceeded certain measurements, after they were placed into their frames. This led to the use of piecing, without leading, when glass was made into mirrors or was used in other ways. Surface painting on glass was not practical because it flaked off and could not be cleaned. Firing painted glass was a technical process and it became very costly. Artists, therefore, decorated glass in reverse and acquired effects similar to those of stained glass pictures, though they were no longer of a transparent nature. The painting hid the piecing of the panels; it also made household articles non-taxable and decorative (see Figs. 87 and 88).

Every technique known to the decorative arts was employed to produce artistic effects. Some panels are of etched glass combined with painting; others are cut crystal. Some glass panels were, doubtless, painted by the layman and were rather crudely done. Their decorative qualities and composition forms are engaging, however. Others were exquisitely done and every detail indicates the masterful ability of the experienced artist. Reverse painting on glass became very popular as an accomplishment by the young ladies of the Victorian Era.

PLACEMENT OF GLASS PANELS

Clocks (see Fig. 87)

Hand-painted glass panels done in reverse appear on clocks of the Terry or mantel type. These are placed in the frame of the door and are so executed that the shiny brass pendulum is seen swinging to and fro, behind a section of clear glass, framed by decoration. The banjo, wall-type clock, comes with decorated panels in the door of its bottom box and often on the neck beneath the clock face. Replacing a broken panel on an old clock can be an interesting undertaking for any artist.

Mirrors (see Fig. 88)

Wall mirrors were elaborately confined within carved and gilded frames. The small glass panels at the top were done in a combination of techniques. Some had delicate reverse etchings representing the portrait of a national hero. The etched portrait on crystal was surrounded by painting. Others represent local scenes and landscapes and included portraits of family units. Some of the American variety were less intricate than those of Europe and had panels which were etched in gold leaf. These panels were also stenciled and painted. National historic scenes and events, rural life, and individuals as well as still life were depicted on them.

Wall Pictures

Wall pictures were done in etched gold leaf and they were also painted and stenciled in the way mirrors and clocks were.

Contemporary Possibilities

Attractively boxed glass-paneled lighting fixtures, to be used as reading lamps over a bed, or as groupings of lighted pictures over a couch or a mantel, are excellent possibilities for intricate and beautifully executed glass-painting. For another type, an old picture frame, backed by a built-in box, to house the fluorescent fixtures, could also be decorated in the traditional manner. Wooden trays could be done with glass tops, also attractively decorated, to eliminate the usual lace or linen doily. An old-time round dining table can be lowered and converted into an attractive and commodious coffee or cocktail table to be used in a large room. Its glass top could be impressively decorated in the simple traditional, classic, or oriental manner and it would be a conversation piece for any home.

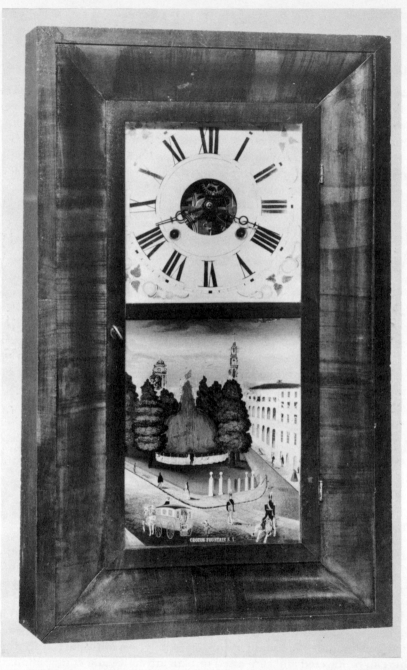

Fig. 87. Mahogany mantel clock, with view of Croton water fountain, City Hall Park, New York City, ca. 1846. *(Courtesy of The New-York Historical Society, New York City)*

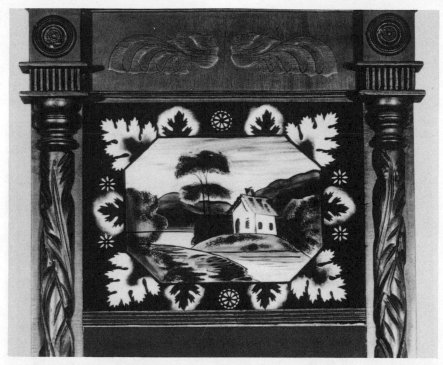

Fig. 88. Mirror with reverse painted glass panel. The border is stenciled. Shades of green are used for foliage; the line detail and pouncing are in burnt umber. The house has a red roof and white walls shaded and accented with burnt umber.

SUPPLIES AND EQUIPMENT

FOR STENCILED GLASS (see Figs. 81, 88, and 89)

For stenciling on glass, bronzing powders, the palette, and the velvet are needed. Also, a good drying Spar varnish, a box cover to be used while the varnish becomes tacky, architects' linen for cutting the stencils and a good pair of scissors or a sharp razor blade. You will also need a tracing indicating the exact position of each stenciled unit.

To stencil on glass use a new square of real silk velvet. Hem it on all four sides to keep it from raveling. Remove all of the lint from the square by rubbing it against the sticky side of a piece of Scotch Tape. If you use an old square of velvet which has powders on it you will, perhaps, mix two shades on the glass. On glass, gold stenciling must be truly gold while silver must not be blended with another tone. On the other hand, when copper tones are required, they must be positively copper in the shade required. This rule holds for glass stenciling only.

To avoid lumpiness in the powder, strain each of the required shades or colors separately through a double piece of nylon stocking. Place them in small quantity in little piles on a clean piece of aluminum foil. This will also help you to keep the shades apart, since the mohair palette will permit them to mix together. *Always use lining powders.*

Fig. 89. Glass panel for a mantel clock. This design shows the rather primitive type of painting which was so often found on glass. The detail is black; the house is white with shadings of blue, a red roof and side walls of burnt umber. The lawn within the posts is green, shaded with yellow. The trees and foliage are first pounced lightly with black for shading and then with several shades of green (from blue-green to yellow-green). The horizon is roughly done with raw umber and the sky shades from orange to pale and deep blue. The unit in the border is stenciled in gold, and then Prussian blue, toned down with raw umber, is pounced on.

For Gold-Leaf Decoration (Fig. 90)

The best size to use when laying metal leaf on glass is Knox gelatin. The unmounted gold leaf marked "XX For Gilding on Glass" is the best type to purchase, because it has fewer pinholes than the other kinds. The artist requires a flat soft brush for applying the size—one which does not shed hairs. A specially prepared frame, with a glass top and a place to hold an electric light bulb, is useful. The tracing for decorating the outline to be done in gold

136

leaf is visible when placed over the light in the box, if the room is dark. There must also be a stylus to edge the design and a coarse tapestry-type needle to etch the shadows and other details. We seldom use the fine No. 8 needle etching tools for etching metal-leaf on glass. Black service-seal is used to back the *edged* and *etched* design before brushing off the excess gold leaf. Cotton to remove the unwanted gold leaf and brushes of the usual types should always be ready.

FOR PAINTING ON GLASS (see Figs. 81, 88, 89, and 90)

For painting on glass the same paints are used as for painting on other materials. India ink and a fine pen are essential when this form of line and detail work are required. Flat white or enamel paint from a can cling better to a glass surface than the titanium oil paint and should be on hand. A flat brush and pieces of sponge are used for stippled effects. Brushes such as are used for other processes should also be ready.

PREPARING THE GLASS

Choose the thin glass that is used on framed pictures. Thicker glass will distort the decoration. The glass should be cut to the proper dimensions for the frame into which it is to be placed. This will avoid further cutting after the decoration is applied, *and* the possibility of breakage.

The glass, for all techniques, must be washed in Ivory soap and water, rinsed carefully and wiped with a lintless cloth. Do not handle it in order to avoid fingerprints. *Do not clean the glass with Carbona or other cleaners. These leave a film on the glass which causes the oil paint to separate before it is fully dry.* If erasures with Carbona are necessary, the glass must be washed with soap and water before additional decoration is applied, in order to remove all traces of film. This film will cause the paint to curdle as it hardens.

Make an accurate tracing on a piece of transparent tracing paper, so the drawing can be seen on the under side. Since the decoration is to be done in reverse, attach the glass to the *under side of the tracing* by using masking tape. When the decoration is done the units will then face in the right direction.

GENERAL DIRECTIONS

APPLYING THE BORDER STRIPE (see Figs. 81, 87, 88, and 90)

The border stripe is always done first. It is carefully striped, each of the four sides being done separately and crossed at the corners. Lines extending be-

Fig. 90. Painted glass panel, with a Mount Vernon scene. Copied by the author from an original clock. The gold-leaf oval in the center is etched, painted on the back with black, and has black linework, as do the scene and house. The foreground is painted in shades of green and yellow; the band framing the picture is lined with black and done in a copper-bronze. The sky has a red glow close to the horizon, shading into a soft blue above it. The border is stenciled in silver, copper, and gold and is painted on the back with black. The entire picture, except for the center of the oval, is given a white coating. *(Courtesy of Mr. Emil Wilde, clock expert and collector)*

yond the corner are carefully and immediately wiped off with a piece of nylon stocking. These bands or stripes are done in black or in burnt umber, depending on the design.

OUTLINES AND DETAIL

Often when details and outlines in black occur over painted designs (see Figs. 89 and 90), they are done with pen and ink. Carefully apply the Spar varnish on the glass as you would on tin, in a flowing sort of way, avoiding lint and dust particles (see Chapter I). When the varnish is thoroughly dry (twenty-four or more hours later) proceed to draw the lines in lightly and accurately using a crow-quill pen and India ink.

Varnish is not necessary when lines are done with black service-seal. These black paint lines are usually done when the design calls for a gold-leaf unit

138

or border, and therefore no varnish should be applied to which the metal might adhere. When black service-seal is too runny, place a little in a bottle cap, cover it with a piece of lintless cloth, to keep dust out of it, and allow it to stand for a short while in order that it may oxidize and thicken. Use a fine scroller brush for extremely fine detail or flatten the No. 2 French quill and use it as a knife blade is used for slicing.

Burnt umber detail is often used in the painted designs (see Figs. 81 and 88). It is done in the same way as black lines which are done with service-seal. Use very little varnish with the burnt umber, so the paint will not be too runny and spread.

PROCEDURE WHEN COMBINING TECHNIQUES

Gold leaf and all its required steps *(edging, etching,* and *backing)* are done first, before the painted design is applied (see Fig. 90).

Do glass stenciling last to avoid strewing powders (see Figs. 81 and 88). However, pictorial centers are simpler to do if stenciled borders are completed first. Use masking tape to block off sections within the striping.

OIL PAINTING ON GLASS

Do the border striping and the black or brown outlines and details first. This is followed by the brightly colored units done, often, with a transparent color. When these are dry they are backed with a solid and even coat of white enamel paint. (This clings to the glass surface more closely than titanium white.) Such units may also be done with opaque colors.

Foliage is pounced in by using a piece of sponge ¼ inch wide (see Fig. 53). The paint is used *very dry* (using very little varnish). Yellow highlights are done first with japan chrome yellow, for quicker drying. When the yellow is dry shade in the nearest green tone to the yellow and when this is also dry add the dark green tones, being careful to keep them within the bounds of the design unit. For the effect of fur, or for shading to give roundness to an animal, such as a dog or a horse, do stippling by using a poster brush with bristles that are not too soft. Do the stippling very close together and very fine, in colors or with black, according to the requirements of the design.

Other details—houses, trunks of trees, the human figure—are done next.

The backing behind individual units follows (in either white or black), and when these units are dry, the background behind each individual one is painted in with a broad brush. No attempt is made to make these completely opaque at this time. This will be a separate process and will be done after all the other decoration is done and everything is thoroughly dry.

To do the sky use white enamel or flat paint from a can, and a wide brush

139

(see Figs. 87, 88, and 90). Arrange little dabs of Indian yellow (or yellow lake), Prussian blue and English vermilion on your aluminum palette. *Use no varnish!* Use the liquid in the enamel paint to mix the oil paints. Thus you avoid curdling the paint mixture. Paint the entire sky area with the white, *not too heavily.* While it is still very wet pick up a little English vermilion and work this into the very wet white at the place nearest the horizon; then do the same with the yellow; last of all do the blue, making it darker at the top of the picture to give distance in the sky, being careful to blend all of the colors together attractively. *Also, use your finger to blend them more.**

Another way to paint the sky on a piece of reverse-painted glass is to use transparent colors (see Chapter II, section on tube oil paints) with the slow varnish described above. These are carefully blended together and shaded so that the sky is darkest at the top of the picture. Before doing these be sure to place the glass panel over white paper. When the colors are thoroughly dry white enamel paint is painted in a solid coat behind them to give the colors an opaque appearance.

STENCILING ON GLASS

APPLYING THE VARNISH

Apply the Spar varnish to the area to be stenciled by flowing it on evenly and smoothly, using that special varnish brush. Use the brush less heavily loaded than you would for applying a protective coat. Heat the varnish and warm the glass so that neither will be too cold. This will prevent the varnish from drying in ridges due to improper leveling. (If these ridges form they will give the appearance of a flaw in the glass.) Do several work-out strokes with the brush on another clean surface to remove all the turpentine in which it soaked. After flowing the varnish on the glass, pick out lint and dust particles which may settle and burst all bubbles (use the tip of a clean brush). Do this immediately after flowing the varnish. Masking tape, placed directly on the stripe line, will keep the varnish within bounds.

NECESSARY PRECAUTIONS

Place the glass under a box lid to prevent dust from adhering to the varnish while it grows tacky (choose a dry day for stenciling on glass). When you stencil, use the powder sparingly and do not let it scatter. Place the stencil so that all of its edges are sealed to the tacky varnish; then no loose powder will slip in under the linen. Do not use a stencil a second time before first washing it off, on both sides with Carbona, while you hold it on a piece of newspaper. *Do this on both sides of the stencil each time you use it.*

* Suggested by Mrs. Arthur Chivers, Meriden, New Hampshire.

Applying the Stencil Units

Silhouette stencils are done so that their edges appear in sharp relief against shaded backgrounds of gilding powder. All units must be polished with sufficient powder so that they become opaque—yet they must shade off gradually into transparency. (See central leaf units of the border of Fig. 88.)

Regular stenciling is shaded off in the same way as when this technique is applied to any other surface. Care must be taken to do the top detail—leaf veinings, etc.—first and before the remainder of the unit is done. Never rub the glass after stenciling it. Twenty-four hours later, wash it gently under running water to remove excess powder. (See border of Fig. 88.)

Painting the Backgrounds Behind the Stenciled Units

Some stenciled borders are backed by stippled effects done with paint, while others are given a solid band of a contrasting color such as green or red (see Figs. 81, 88, and 90).

APPLYING METAL LEAF ON GLASS
(See oval for viewing the pendulum, Fig. 90)

Use a small, clean wine glass. Into it place ⅛ teaspoon of Knox gelatin and add one teaspoon of cold water. Allow the gelatin to soften. Fill the glass with boiling water to melt the gelatin. Brush this size on the clean pane of glass which you are to decorate, after the stripe and all of the painted black detail has been done, if this is required. (Often the black detail results from the etching done into the leaf while it is still soft. The lines made by etching the metal leaf cause the breaks in this fine substance and permits the black paint with which it is backed to show.)

Close the window to avoid a draught and hold your breath for this step! Lift the metal leaf out of the book (it must be the unmounted variety called for gilding on glass) or use a gilder's tip which you have rubbed against your hair to give it that electrical quality. *(Never use wax paper to pick up the leaf for glass decoration.)* Pick up the leaf with the gilder's tip from one of its straight edges, not from a corner of the metal. Lay the leaf on the gelatin size (while the size is very wet) so that the leaf covers the area on which it is to be applied.

Stand the pane of glass slightly on edge, so that the excess gelatin size will run off and will also fill in all the spaces beneath the leaf. Allow the glass to dry in this position for about three hours.

Prepare the box, with the light bulb behind another piece of glass (preferably of the frosted variety to minimize the glare), to be used as a table surface. When the size is dry, place the glass to be decorated on the frosted glass of the box with the light on. Use a dark room so that the traced design be-

hind the gold leaf will show. Do not handle the gold leaf, for it is extremely delicate at this stage.

Use a stylus, *heavily,* all around the outer edges of the design unit or units to mark or edge the places for applying the black paint later on.

Use a tapestry needle (do not use the fine etching tool or needle which is used for other types of gold-leaf etching when that is done on metal and wood) and etch in or scratch in all the detail which appears within the units you have just edged or outlined—the veinings, detail lines, shaded effects, etc. (See Oval for Viewing the Pendulum, Fig. 90.)

When the gold leaf is thoroughly dry (about twenty-four hours after application) the edged outlines of all the units are covered smoothly with a thin coat of black service-seal. (Thin the service-seal with a little Spar varnish.) Allow it to dry thoroughly, also, before proceeding with the next step.

All excess leaf which lies beyond the black service-seal units is wiped off carefully with a piece of wet cotton.

When all the decoration has been completed it is again allowed to dry thoroughly. Light colors to give the effect of water or sky are next applied. When these colors are dry the entire glass panel is then covered with a smooth coat of white enamel or with another coat of black service-seal. A border of conventional design may be backed by any color desired to accentuate the brightness of the metal leaf. These coats of paint help to seal and to protect the design. Asphaltum which is often applied as a last coat tends to remain in a semi-soft state and it gives a certain protective elasticity which should help to avoid cracking from dry atmospheric conditions. When it is used it should be applied when everything else is thoroughly dry, about two or three weeks later.

X. *Decorative Modes of Heirloom Pieces*

CONSTRUCTION OF HEIRLOOM PIECES

MATERIALS USED

Papier-mâché. Papier-mâché was invented by Henry Clay, the japanner from Birmingham and, in 1772, England issued a patent for it. It was so named by the French who later used it. This product gave the European artist a medium which was cheaper and easier to shape than tin or iron. The Chinese and Japanese techniques of inlay and of surface decoration, which had been painstakingly practiced on lacquered pieces, could be applied on papier-mâché more quickly. It required fewer processes and was cheaper to produce, in Europe, than lacquer.

Metal. Tin was discovered, in England, by the early Romans during their occupation of the British Isles. At first England could roll her tin-encrusted iron into sheets of limited size and it was used for making the smaller types of household accessories. It was later produced in larger sheets and the more sturdy trays called "waiters" came into being. The large tray was so called because it replaced the servant during the less formal times of the day.

Wood. Wood was not used for trays, except when they were lacquered in the oriental manner, but it was used for boxes of intricate design and for occasional furniture such as fire-screens and tilt-top tables on which decorative painting was applied. It was also used in combination with papier-mâché. (See Fig. 63.)

DISTINCTIVE TRAYS AND ACCESSORIES

Chippendale (see Fig. 23). The Chippendale tray was also known as "pie-crust" and Gothic. The latter title referred to its pointed style which resem-

bled the arch and vault of the thirteenth, fourteenth, and fifteenth centuries. The stylistic character of the Chippendale decorative pieces, and the prevailing desire for elegance during the seventeenth century, contributed to the enrichment of the rooms in which these pieces were used. The tray was made in several sizes and came in three types. The Sandwich Chippendale was known for its ledge-like edge which gave the tray a squared off appearance on its outer edges, as No. 1 in the drawing below.

The two other types had flanges with a more gradual, rounded sloping. One had a separate ridge which followed all around the flange at the point where it formed the floor of the tray. All of the better-made trays are wire-bound on their edges.

The Chippendale or Gothic tray comes in many sizes, large and small. The edges are always rolled and are wire bound except in the very small canapé size (see 1a, 1b, and 1c). The small sizes come both rolled and bound or plain.

(1) The *sandwich rim* is flattened on its outer edges and is about one inch wide on the flattened rim. It then curves gently outward before it reaches the floor (see 1a).

(2) The usual type of Chippendale tray has a rim which slopes gently outward with two undulations before it reaches the outer edges (see 1b). Another type of tray has an extra roll which surrounds the floor and then forms the sloping, undulating flange (see 1c).

The kidney-shaped Chippendale trays (see Fig. 6) were supposed to have been specially made for the stout mammies of Southern Colonial America, so these genial folk could more easily carry breakfast to their mistresses. This type of tray is rather scarce though replicas of it are now being produced in metal and papier-mâché by the Period Art Reproductions, Inc. (see Where to Buy section).

The oval Chippendale tray has a scalloped type of flange. It slopes gracefully and gradually to the floor. Old trays of this type are very scarce, and

144

are most valuable. They were called Victoria trays but do not belong to the Victorian period. Hand screens and boxes which were intended for trinkets were made in Chippendale Gothic style. Fire screens were decorated in the Chippendale manner as were some of the rectangular trays with outer flanges in the flat ledge-like style of the sandwich type. These latter are known as the Sheraton type of tray. Decorated articles in the Chippendale style generally had Queen Anne and Georgian characteristics. They were known for their fine construction and their designs were inspired by the Chinese, the Gothic and the French rococo. These pieces are in part considered to belong to England's late Renaissance Period.

Oblong Tray Types. (1) The *Sheraton oblong tray,* as this type is called, without hand-holes, has a Sandwich edge which is similar to the Chippendale Sandwich. It is flattened for about one inch all around the outer edges. The flange beneath it curves gently outward before it reaches the floor (see 1a). This type of oblong tray is of very old vintage and it was produced in several sizes. The edges are rolled and wire bound (see 1a).

(2) The more modern, and more usual oblong tray, has flanges which curve gently outward (see 2a). This type comes both with and without hand holes and its edges are also rolled and wire bound (see 2a).

Lace edge. The lace-edge trays are simpler in design than those of the Chippendale class. Their floral designs are often reproductions which are similar to Van Huysum's paintings. Lace-edge trays are lighter than the Chippendale and are extremely elegant. They are made in all shapes: round, both large and small; oval and rectangular. Their pierced flanges are about one inch wide and curve gently outward culminating in delicately scalloped edges. The early trays were pierced and then were turned by hand. The corners were folded and riveted to keep them trim and square and were not pierced. It is believed that Paul Revere later produced these trays in America at a lower price than the imported ones, and that they were decorated by

the craftsmen-artists of New England. The designs of this type of tray are reminiscent of the decorations which the Adam brothers, Robert and James, produced. It is very likely that important pieces were actually painted by artists associated with the workshops of the noted brothers. Among these artists were Zucchi and Angelica Kauffmann. The Adam brothers drew their inspiration from Greek and Roman art. Besides their nosegay patterns, the lace-edge trays are known for their urn and ribbon-like twinings, so typical of the decorative motifs used by the Adam brothers, both in their furniture decorations, and in their interior trimmings of rooms. The brothers are known to have decorated all kinds of home accessories so they would blend with their surroundings. It is possible the lace-edge tray was originally one of their designs. The Hanbury Mills of Pontypool produced household articles which were comparatively heat-resistant and were not damaged by water. The Allgoods there learned the technique of the tortoiseshell ground which was used exclusively on the lace-edge type of tray.

Gallery trays. Gallery-type trays were oval, with flanges which were placed at right angles to the floor or were slanted outward. The flanges were made

Oval Gallery Trays. The edges of these trays are rolled and may or may not be wire bound. (See 1b, 1c, and 2b.)

(1) *The oval gallery tray,* with the slanted 2-inch flange and with the hand holes, may be unpierced (see 1a) or it may be pierced with the "keyhole" pattern (see 1a). Its flange may also be set at right angles to the floor, and may be solid with no piercing.

(2) Another type of oval gallery tray may have a brass flange set at right angles to the floor (see 2b). Its piercing is intricate and delicate, which necessitates that it be cut from a softer metal than iron. (See 2a.) Its brass flange is always painted black.

146

of solid metal when they slanted. They were pierced in a keyhole pattern when the flanges were at right angles. The edges are rolled and are also wire bound.

Octagonal trays (see Fig. 35). Cut-corner, or octagonal trays, came into being during the neo-classic period and were large, with massively made flanges which slanted outward from the floor. It is said that the corners were cut to make them easier to carry through doorways without injuring their edges.

The Octagonal tray consists of two types (the edges of both are rolled and wire bound [see 1a and 2a]):

(1) *The cut-corner tray* comes with hand holes. Its flange slants gently outward and is 1½ to 2 inches deep. It comes in small sizes and also in a large tray which measures 18 by 26 inches.

(2) *The coffin tray* never has hand holes and its flange is no more than ¾ inch in depth. Its flange is much narrower in the small canapé type. The largest among the antique pieces is often pieced in the middle and measures 15¾ by 10¼ inches. The early trays of this size were pieced because of the size of the tin plate of those times. The large size, today, comes unpieced.

Rectangular trays (see Figs. 4, 5, and 28). The earliest rectangular tray was made with sandwich edges which were horizontal while the more recent types are gently curved. Many of the earlier trays were made of papier mâché while the latter were of tin, with wire-bound edges. The flanges of the latter type slope gently outward from the floor and are not squared on their edges as were the Sheraton type.

Oval Windsor trays (see Fig. 22). The Victorian period produced the oval Windsor-type tray which had narrow outward curving flanges ending in a ¾-inch strip of horizontal metal which was rolled and also wire-bound.

DECORATIVE MODES

STYLES OF GOLD-LEAF DECORATION

Chippendale. Gold leaf on the Chippendale type of tray and on all accessories of this style is finely done with a pen or a fine brush. It appears in scroll-type borders with much drippy moss and many tendrils. The bordered effects also form part of the central design either in shapes like baskets or trellised cornucopias or because they intertwine with the painted units. Delicacy of workmanship is the keynote of the gold-leaf decoration on the articles of Chippendale influence. Bird wings are often treated with metal leaf before transparent color is applied. This treatment gives them a translucent effect. (See Figs. 6, 8, 9, 23, 25, and 26.)

Lace edge. Lace-edge gold-leaf borders consist of delicate brushstroke compositions or groupings which are never too wide and merely form a fine border for the painted nosegays within. No other gold-leaf units are ever used on these trays. (See Figs. 19, 20, 21, and 62.) The corners of oblong lace-edge trays are decorated with brushstroke formations which are like spandrel fans. The fine stripe ⅛ inch away from the edge is also of gold-leaf.

Gallery trays. Gallery trays with unpierced flanges are often elaborately decorated in double-bordered effects with gold-leaf units of etched workmanship and with burnt or raw umber shadings. These borders are often exquisitely accented by white touches. They often have central figures also done in etched gold-leaf and white. The pierced gallery tray is also painted as a lace-edge oval and on this type the gold-leaf border is delicately done in brushstroke combinations as it is on the regular lace-edge type. Delicate scroll-type borders often outline the naturalistic floral units in the center.

Cut-corner trays (see Fig. 35). The cut-corner or octagonal type of tray appears in single- and double-bordered arrangements in gold or silver leaf with etched designs which are delicately done and accented with raw and burnt umber. These trays also appear with central scenic arrangements bordered with bands of etched gold leaf and the same gold-leaf design repeated on the flange. Stenciled effects are also done on this type of tray. (See Chapter VI.)

Rectangular trays (see Fig. 28). Rectangular trays with the gently sloping flanges are often painted in the Pontypool style which is done on bands of metal leaf covering almost all or only certain sections of the flange. When only sections appear to be banded in gold leaf, the intermediate spaces may be decorated with acanthus leaves done in etched gold leaf or in other ways. (See Figs. 4, 5, and 28.) Others are decorated in single etched gold-leaf borders on the outer flange. The sandwich type of rectangular tray (also known as Sheraton) appears with intricate gold-leaf units which are intended to accent the freehand bronzing and other painted work. The latter are always decorated in the Chippendale manner.

CHARACTERISTIC STYLE OF BRUSHWORK

Chippendale (see Figs. 7, 8, 9, 25, and 26). Chippendale decoration is both transparent and opaque. Leaves are done in combined color mixtures and may be transparent over the smudged bronzed background or may be opaque. Brushstrokes applied for accent purposes are generally done while the design is still slightly wet, thus giving a softened appearance. Flowers and buds are done in the floated or glazed technique and are accented by brushstrokes which are applied while the glazing is wet. (See Fig. 65.) From the tiniest forget-me-not to the largest flower, all are intricately done with exquisite detail. Curlicues, fine stems, and leaf detail are all done with the finest lines possible. Freehand bronzing appears often on leaves when the background of the tray is black but never when it is smudged.

Lace edge (see Figs. 19 and 62). Lace-edge brushwork is unique in that the brushstrokes are shorter and stubbier than in other painted techniques. The paint mixtures are very different and employ only raw umber and no burnt umber for toning down. The brushwork of the lace-edge type is opaque except when floated or glazed work is done. This is often made semi-transparent by the addition of yellow ochre. The general effect is that of more intense highlights contrasted by dark tones, and the designs are scattered into nosegays around the larger central figure, thus giving an all-over pattern effect. (See Figs. 19, 21, and 62.) Also see page 158 for doing small nosegays.

Scenic designs. The scenic cut-corner, Windsor, rectangular and Chippendale trays are painted in a flat brushwork manner which is done by an overlay and a floated method of painting. This type is similar to glass painting but is not done in reverse and is seldom of a primitive nature. The scenes are generally sea-side, local homestead, farm, or country-side in type. It is similar to painting on canvas except that the paint is applied so it is very level with the surface. The varnish coats, just as on other types are for protection and the smoothness of painting technique is very necessary.

Scenic effects on other accessories. Coffee urns, tea-caddies, and bread trays from Pontypool were often decorated with scenes. These are delicately done and are most effective and unique (see Fig. 33). These are decorated with etched and painted gold leaf and are also done in the Oriental manner.

149

XI. *Techniques of Master Craftsmen*

Decorative painting on papier-mâché, metal, and wood was usually done over black backgrounds for contrast. The designs were never applied in a thick or lumpy manner. Gesso was used as a paint primer during the time of such masters as Rembrandt, Rubens and others. Their highlights were done with white lead which increased in translucency with age and permitted more light to pass through the film of paint from the gesso beneath it. Any tendency to yellow with age was corrected by a bleaching process which constantly took place between the two media.

Lead paint, however, will not withstand high temperatures as does the newer type of paint made from titanium. It is therefore not practical for trays. Today, therefore, we use titanium paint exclusively to acquire both semi-transparent and completely opaque results. The highlights of flowers are done more heavily in their modeled stage and their darker accents are merely the result of the thinner pigment which permits the dark background of the tray to show through the white. (See Fig. 28.) The technique of painting flowers and other units in the manner of the old masters consists of a building-up process, done over a period of two or more days. The result is one of complete smoothness to the touch and yet each unit seems to be alive in its rounded and well-formed shape. Highlights are applied over the glazing while the floated color is still wet or after it is completely dry.

The acanthus leaf which was used first by the Greek artists of sculpture, and many flower shapes were done as smooth surfaced ornaments and were introduced during the reigns of William and Mary, Queen Anne and George I. Tulip details with parrots and cockatoo birds were of Dutch origin by way of the Orient. The acanthus ornament of the Dutch artist was more spiky, more complicated and had greater contrasts of highlights than when it was

done by the English artist. The acanthus was supplanted during Stuart days by the charming and delicate seaweed or spider-web patterns which are so prevalent on the Chippendale decorated articles.

FLOATED OR GLAZED COLOR WORK

All flowers, small and large, and some leaves and birds are modeled in the three steps discussed below—foundation in white and also in vermilion (modeling is done in white only and in shaded pink tones for the Victorian rose), floating, and veiling. (See Fig. 65.)

Preparing Foundations of Units

Modeled white units. For modeling the foundation units in white, to be later floated and veiled, regular Spar varnish and pigment are used. Prepare the varnish in a bottle cap and place dabs of titanium white, raw umber, and yellow ochre on the aluminum-foil palette. Using a large No. 10 Grumbacker poster brush or a wide, short, soft-bristled brush (see Fig. 14), mix the white with varnish and a little of the raw umber and yellow ochre to acquire a creamy consistency. The mixture should be fairly wet with varnish and not too pigmenty or thick with paint. Apply an over-all coating of this mixture, very smoothly, to form the complete flower shape as it was outlined by the tracing. Use more raw umber to darken the white and apply this to form the center of the flower and other dark parts. With a No. 2 square-tipped French quill or a small flat poster brush, apply brushstrokes to make the petals and to give the general contour required to form the flower shape. For these brushstrokes use a thicker and less wet mixture of white, one which is more pigmenty and is also whiter than the over-all coat. Do these brushstrokes on the still wet first coat. As the strokes and the semi-transparent background dry they blend together to form the basic shape of the flower. Allow at least twenty-four hours for this to dry before applying the floated color. (See Fig. 65.)

English vermilion units. English vermilion is painted as a flat even coat, in the shape of the unit, to form red or pink flowers which are later floated and formed by the veiling process. This is not usually modeled at this stage. It is applied smoothly and is a flat nondescript sort of form. It is allowed to dry for about twenty-four hours before any type of modeling takes place.

Often a rose shape is painted with a mixture of alizarin, raw umber and a little yellow ochre. The latter helps to lessen the transparency of the flower shape, though it should be semitransparent for that nebulous appearance when the flower is completed. Over this painted form, while it is still very wet, paint in the brushstrokes which are to give roundness to this unit. Use

English vermilion in strokes of varying sizes to form the under petals of the rose. When this is dry, paint on another coat of the first mixture to help soften the vermilion strokes, which should have dried in a blended sort of way. The off-white over petals are then painted on with a large water-color brush to give this flower added charm. In the lace-edge variety these over-strokes, forming the top petals are usually one sided in their appearance and are rather quaint and informal looking. These may be done while the former coat is still wet for a softened effect or after that coat is thoroughly dry for a very crisp effect.

Metal-leaf units. When metal leaf is used to form flower foundations it is laid in a round patch and about a week is allowed for it to dry and harden thoroughly. Use gold leaf for a yellow rose and silver or palladium leaf for a red one. Before doing any of the floated or glazed work, apply graceful white strokes around the metal-leaf unit making them more transparent and whiter at the top of the flower and larger or wider, darker and thicker at the bottom to acquire perspective. These strokes of white should help to soften and hide the hard edges of the metal-leaf patch. The floating technique and veiling done over metal leaf gives a flower a translucent effect. Metal leaf used this way is a kind of substitute for mother-of-pearl which must be inlaid by a special process into the flat-black coats of paint before the true forms can be modeled.

Mother-of-pearl units (see Fig. 78). This brittle substance comes in thin sheets 1 inch by 4½ inches, in rather uneven shapes. It is very much thicker than metal leaf. A piece is first soaked in water for a few hours. The size required for the design unit is cut under water with sharp manicure or embroidery scissors to avoid splitting or cracking it. (Mother-of-pearl may be purchased from Pearl Products Inc., 103 E. Glenside Ave., Glenside, Pa.) The specially cut shape is applied to its proper place by cementing it down on Spar varnish when the varnish becomes tacky. For the sections which require the mother-of-pearl, flow the varnish *directly on the priming coat before any flat paint has been applied.* Also flow the same varnish on each piece of mother-of-pearl which is to be used. When the varnish on the article and on the pearl has become tacky, press each piece of mother-of-pearl down on the required section. To help these pieces of pearl to adhere closely to the surface, while the varnish hardens, put something heavy on each—a cup, or a small glass, whose base does not extend beyond the pearl units. Wait at least three days for the varnish to dry before doing the next step. At this stage, the surface of the pearl will be higher than the rest of the background surrounding it. When the coats of flat paint are applied they are brushed on so that each coat comes only to the edges of the pearl. As each coat is applied the surface of the article is built up and eventually becomes level with the mother-of-pearl units. When there is no bevel or division to the touch, between the background of the article and the pearl units, we then apply our flat coats so as to cover not only the floor but also the parts of the pearl which are not

required to form the decorative unit—flowers, leaves, birds' wings, etc. These units are either floated and painted in the same manner as other types or they are decorated with brushstrokes, only. As many as fourteen or more coats of thin flat paint may be necessary to properly inlay the mother-of-pearl. Care must be taken to avoid brush marks on the surface if thicker flat paint is used than advised in Chapter I.

Mother-of-pearl may also be imitated. Lay palladium leaf (or silver leaf) in the usual way, on the prepared flat-paint surface and in the actual shape of the design unit. A week later, apply *slow varnish* (¾ Spar varnish, ¼ raw linseed oil) over each metal-leaf unit so the varnish covers all of the surface to within an ⅛ inch of its outer edges. Into the varnish float Prussian blue toned down with raw umber and alizarin crimson, also toned down with raw umber. Blend these colors into one another. These two shades will tint the palladium leaf in the way the genuine type of pearl is tinted. Be careful to use the pigments sparingly to obtain that charming pastel coloring of mother-of-pearl.

APPLYING FLOATED OR GLAZED BRUSHWORK

Transparent colors must be used for this process—Prussian blue, Indian yellow or yellow lake, alizarin crimson, raw and burnt umber, raw and burnt sienna. The yellows and the alizarin crimson are made richer by the addition of burnt umber, while Prussian blue is given a softened or a greenish cast when toned down with raw umber. Transparent green is made by mixing Prussian blue with raw umber and adding as much yellow lake or Indian yellow as is needed for the desired shade. Chippendale transparent green is also made with Prussian blue, alizarin crimson, and yellow lake or Indian yellow. Floated or glazed brushwork is done with varnish which dries slowly so that the correct blending of color pigments will take place. To slow the drying action of Spar varnish, mix it in the proportion of ¼ capful of raw linseed oil to ¾ capful of varnish, using that discarded bottle cap as your measure. Stir the mixture thoroughly with the large poster brush or use the short, soft-haired brush.

Wipe the brush used for mixing the oil and varnish so that there will be neither too much oil nor too much varnish on it. Dip it again into the mixture and apply a puddle of it over all of the unit to be floated. Do this to within ⅛ inch of the outside edge of the unit. (Too much varnish will cause the edges of the unit to crinkle or curl when the varnish dries and will also give an unattractive raised look to the finished article. The raised look does not disappear even when the protective varnish coats are applied.) Wipe the brush again and mix the pigment in the color required. Load the brush with pigment but do not make it too wet with varnish. Apply the brush to the parts of the flower which appear darkest—the center and other shadows— and then wipe and clean the brush. Dip it lightly into the varnish-oil mixture and brush it two or three times on a clean piece of the palette to flatten

the bristles. Gently help the paint to blend from the darkest into the lightest parts. Apply more color if it is necessary to give more depth to the unit.

When a flower or a fruit unit requires a little yellow or a chartreusy green to be blended into the other color this is applied first since it is of a lighter tone. The darker color is so floated or blended that there are no distinct divisions between the two colors and one blends gracefully into the other. This step in floating a unit merely gives a blended suggestion of a somewhat nebulous decorative unit. Set it aside for about half an hour before beginning the veiling if this technique is to be done on the still wet flower. Accents which are to have greater contrasts and are not to look as though they were blended into the floated color should be applied after the floating or glazing is thoroughly dry. Veiling, or accenting, done on semi-wet units gives a soft, blended effect because the colors settle into the varnish as it finds its own level and this helps to merge the transparent colors with the off-shade of white which is used for the veiling. Chippendale flowers are usually done in the soft blended way. Some lace-edge flowers are done when the floating is thoroughly dry and they therefore have sharper contrasts than the Chippendale flowers. Some flowers are given a nebulous, waxy look by extending the floated color beyond the solid vermilion form. A little yellow ochre is mixed with the transparent pigment to give them semi-transparent edges which show delicately against black.

APPLYING VEILING

For veiling, or accenting, use titanium white toned down with raw umber made creamy with a little yellow ochre. Use the same slow-drying varnish if it is to be applied on the partially-wet floated color.

A No. 2 square-tipped French quill or a small flat, long-haired poster brush may be used. For extremely fine detail of highlights use a fine scroller (see Fig. 9). For wider strokes use a large water-color brush.

Load the brush more heavily on one side than on the other. Deft handling of a brush for this process is necessary. It is also important that the petals or highlights should be placed accurately. Apply the largest highlight first and work around it. Each time the brush is applied to the wet floated color, a little of that color will be picked up. It will blend with the white on the brush; therefore wipe the brush with the rag each time before picking up more white from the palette before you apply it to the flower or unit which you are veiling. It is not unusual to take upwards of an hour or more, to form a given unit during the veiling process. (Slow varnish is therefore very necessary.) The more intricate the flower is the longer it will take. As the white settles and blends into the floated color it gives the contour and the dreamy realism which makes these flowers the focal point of a design. Articles which are decorated by the floated method must be kept in a level position until the units are thoroughly dry.

154

PAINTING VARIETIES OF LEAVES

Lace-Edge Leaves (see Figs. 19, 20, 21, and 62)

Pigment Mixture. The pigment mixture for lace-edge leaves is opaque and is made by mixing titanium white, raw umber, yellow ochre, and Prussian blue. The quantity of each pigment used depends on the shade desired. A great deal of white will give a light shade; while increasing the yellow ochre will give a yellower green than when the blue is more predominant. For very dark green use a little ivory black, Prussian blue, raw umber, and yellow ochre. When a still more brilliant green is required a little Indian yellow may be added. Many rich shades may be mixed but no other greens are true lace-edge greens. These, to be traditionally true, border on the bluish-green tones, and are always soft and subtle and never harsh. Add more raw umber to soften the color but never use burnt umber because it will give you a muddy color which would not be typical lace-edge painting.

Green with white accents. All leaves are first solidly painted with the green mixture. While this is still wet, the off-white highlights (titanium, yellow ochre, and a little raw umber) are painted in. When a lighter section appears on a leaf, the white is stroked or worked into the green and blended carefully. Fine white veins are done with the fine scroller brush, while the green is wet. Often these veins are done in black and for these black service-seal is used.

Vermilion base. Some lace-edge leaves are first done in English vermilion, painted flat as for a flower. Twenty-four hours later the leaves are painted in green, made rather thin for semi-transparency, and white accents are added in the usual way. Tiny marks to indicate hairs on the edge of a leaf are painted in vermilion with a fine scroller brush. These do not appear on all sides of the leaf but are interesting accents. They also appear on leaf and flower stem. The English vermilion base should show slightly beneath the green, and often it is left as a narrow border to tip the end of the leaf.

Green with vermilion and white shadings. An added note of interest is acquired by painting a leaf in green and then picking up a little English vermilion and blending this into it, also while the green is wet. Apply the white highlights and veinings as usual. Often both white and black veins are done on lace-edge leaves. Deep contrasts of tone are characteristic.

Chippendale Leaves (see Figs. 6, 8, 9, 23, 25, and 26)

Pigment mixture. Chippendale leaves, when they are done on a smudged background, are often painted in a transparent mixture, while those which appear on a black background must be of opaque green if they are to show. To mix transparent green, use Prussian blue and blend it with raw umber,

then mix in as much Indian yellow as is needed for the shade desired. Alizarin crimson is often substituted for the raw umber in Chippendale painting. Opaque green accents are worked into the transparent shapes. To mix opaque green use Prussian blue, raw umber (or alizarin crimson) and medium chrome yellow.

Opaque green leaves (see Figs. 7, 8, 9, and 23). Opaque green leaves are given charm by blending shades in such a way that the grain is apparent. Veins are done with burnt umber and often burnt umber is applied over the dry green to give an additional shading. It is not unusual to apply a few spots of very transparent white to indicate water drops and often the veinings appear in white, but these are never done on the wet green. Black veins and sometimes chrome yellow are also used on opaque leaves. Burnt umber is also used for veins of Chippendale leaves.

Transparent green leaves. Apply the transparent green mixture smoothly. Allow it to dry slightly, for about half an hour, and then brush in a few uneven strokes of opaque green over it but do not cover the complete area. Accent with raw umber or burnt umber veins. White or black may be used instead of burnt umber for veins.

Modeled leaves with transparent shading. Floated leaves are also used in Chippendale-type painting. Make a semi-transparent foundation, as for a flower; work in a few brushstrokes in heavier white to indicate a turn on one edge and heavier veinings on one side. Allow this leaf foundation to dry for twenty-four hours. The next day float the correct shade of transparent green over it. Apply chrome yellow veins very lightly into the floated paint before it is thoroughly dry. Burnt umber may be used for veins instead of chrome yellow. Sometimes spots are cleverly applied to represent tiny drops of water. They are painted in off-white, made semitransparent.

Leaves with bronze powder accents. Chippendale-type painting of the oldest variety has exquisitely freehand-bronzed leaves. These, however, never appear on the smudged background. They are done with a velvet button or a charcoal stump. Paint the green slightly brighter than for other types of leaves and use an opaque green mixture. When the paint is wet-tacky apply the stump work using pale gold bronzing powder, doing strokes to indicate veins. When the green paint is dry-tacky apply additional shading using the velvet square wrapped around the index finger.

Gold-leaf accented leaves. The turn-backs of these leaves, which are usually of the acanthus variety, are done with gold leaf, etched to show a shadow and to mark the veins. The remainder of the leaf is later painted. When this part is tacky, the veins are freehand-bronzed with the charcoal stump and then further shadings of bronzing powder for highlights are applied. Brushstroke accents in black, white, yellow or burnt umber are painted on for added interest.

TIPPING LEAF POINTS WITH GOLD LEAF

This type of decoration is found on the oldest Chippendale pieces. The unit—either a scroll border, or an acanthus leaf—is painted, in rich, soft, rather dark reds, in green or even in a lightish brown made by mixing burnt umber with a little yellow ochre and a little raw umber. The sharp points are accented with tiny, very delicate brushstrokes. These are done best with a fine scroller brush. Gold leaf is laid upon these points to give a delicate richness of detail which is quite handsome (see Fig. 8).

The gold tips must be done on the scroll border or on the acanthus leaf after these have been painted in either deep red, green, or brown on the flat ground. Since gold leaf will adhere to the slightest tackiness, even though there is no evidence of any stickiness, extra precautions are taken to avoid gold blemishes where they are not wanted. Use Hour varnish to paint the green, red or brown scrolls or leaves. Wait a week or more after painting these units so that they are thoroughly dry. Because even this precaution is not often sufficient to guarantee against the vagaries of our friend, gold leaf, we then rub talcum powder over the entire surface before we apply the tiny brushstrokes and lines for this type of gold-leaf technique. Talcum powder is more satisfactory than lithopone for this purpose because it is slightly coarser and will not adhere as closely to the decorated units. Be careful, however, to use talcum powder that does not have olive oil in it. Use pale gold lining powder, mixed with Spar varnish (or Man o'War), and the smallest, pointed scroller. Apply the strokes where the accents are required. When these are tacky, lay the gold leaf over them. Two hours later, brush off the excess leaf very gently but do not attempt to clean off all of the gold. A few days later wash the article under running water to remove remaining particles of the gold leaf and the talcum powder. Rub gently with the finger tips and use a little Ivory soap, if necessary. It is wise to apply these gold-leaf tips on the units before any other painting is done, in order to avoid stray particles of gold leaf. Any talcum powder which does not wash off will disappear after the first varnish coat is applied. Unwanted gold leaf may be painted out or carefully scraped off, before varnish is applied.

For an extremely intricate or for a large tray it is wise to apply two coats of Hour varnish over the painted scroll after the gold leaf tips are applied, so as to cover the entire tray and thereby protect the gold-leaf detail. When the varnish is thoroughly dry, rub the tray down with wet sandpaper until there are no shiny spots in evidence. Man O' War varnish should be used to paint the tips for laying the gold leaf since it reacts favorably to the Hour varnish used on the tray. It must be remembered that Hour varnish should be used for all successive protective coats and that all of the painting should be done with Man O'War varnish. These are both produced by the McCloskey Varnish Co. and will cause no trouble when used together.

Doing the small nosegays of lace-edge designs. These little nosegays seem so simple to do but to acquire the correct effect as it was done traditionally is very difficult indeed. A water-color brush of good quality should be used for these. Select the size suitable for the stroke to be done. The white and off-white strokes are done with a mixture that is semitransparent and combines titanium white with *very little* raw umber. Give this white a creamy cast by adding a little yellow lake or Indian yellow instead of using the usual yellow ochre as for other types of painting. These strokes should appear thick and pigmenty on their edges and somewhat transparent in the center with a very brushy type of texture which permits the black of the tray to show through. This effect cannot be acquired by the addition of raw umber as in other types. Mixing varnish with the paint is not at all satisfactory since a kind of floating action takes place and the pigment does not remain as it was painted. Instead of varnish use wax medium, which may be purchased from E. P. Lynch. Ask for Bohemian Guild Products, Oil Wax Medium. This substance was supposed to have been used by the Old Masters. (See Where to buy at back of book.)

To form the strokes press the laden brush down, using some force so that the paint and wax medium can be spread out. The brush is used at an almost vertical angle and is quickly lifted to leave a kind of blob of paint where a tail would ordinarily appear on any other type of brush stroke. When these strokes are to be done in color, the correct amount of the shade required is mixed with the white mixture.

Doing top accents on lace-edge flowers. The mixture of white for these accents is the same as for the above strokes. Use a larger water-color brush and the wax medium. Apply the highlights over the slightly wet undercoat which forms the flower.

XII. *Good Craftsmanship in Modern Design*

Modern mass-production in industry has replaced the one-time self-sufficiency of the individual. Today's arts and crafts reflect the speed and haste of our existence. The old-time techniques, as they were practiced during past decades, were in danger, until very recent times, of becoming almost completely lost. These tried and true methods, which are so sparklingly visible on old articles, have withstood the ravages of time. They were kept alive, during the height of their popularity, by the master-craftsman and apprentice system. Today our public schools take the place of old-time educational systems. Current policies, crowded classrooms, and work periods which are too brief, do not provide an opportunity for students to learn, much less to master, such skills. There are only an elect few who are at the helm today. In their spare time they are uncovering and discovering while they practice the nearly-lost techniques.

A modern artist, trained to produce the results described in the foregoing chapters, can draw inspiration from history, customs, traditions, and even from the land itself, for everything enters into patterns of design.

While studying the techniques of the arts of past ages, it is often necessary to copy them, and many old-time designs are being repeated. In effect, they are new editions of old motifs, for no two individuals can produce quite alike. There is a saga-like quality which characterizes certain decorative units, even though their use is no longer symbolical. Simplified methods cannot produce depth, translucency and opalescence beneath a velvety-smooth, lake-like, covering. Only time, patience, practice, study, and observance will develop the skills which are the primary requisites for heirloom results. Delicacy and beauty of detail were, and still remain, the hallmark of the masterpieces which were produced from the seventeenth through the early nineteenth centuries.

NOTES FOR COLLECTORS

The collector of decorative antiques should acquaint himself with the various design types. When genuine old pieces are found these should be preserved, but if the finish is beyond repair, the design should be carefully recorded as a pattern on plastic supersee or on black Hazenkote paper. (The latter is specially prepared to look like the flat-black ground of an article after it has been rubbed down. This paper is primarily used to prepare the pattern of an article whose design is done in the stencil method.) If the beginner feels inadequate, the piece should be sent to the nearest specialist for the tracing and recording before the design is removed and the piece is redecorated. Any old worthwhile piece should always be restored by a specialist.

Esther Stevens Brazer, during her lifetime, recorded many old designs and also trained and encouraged others to do so. While studying the old-time designs and the articles upon which these have been carefully fashioned, we learn much about the artists of the past. There is, actually, no new design on this earth; only the interpretation is new and there will be as many of these interpretations as there are artists interested in producing them.

A genuine old piece whose design is destroyed, should be decorated in the style suitable to it. Country-tin and Pennsylvania Dutch, Chippendale and lace-edge were never stenciled. Gold-leaf decoration is not appropriate for the pieces belonging to the folk art of the layman and apprentice. Color mixtures should also be considered when painting is done. Country-tin, Chippendale, and lace-edge are each different from the other. The painting techniques are also distinct in all of the styles and these differences offer the artist a vast opportunity to develop his skills.

FUNDAMENTALS OF GOOD TECHNIQUE

An artist should always begin with simple designs. Doing the simple and easy design well requires accuracy in handling the brush and all the tools and supplies necessary for this art. The artist also has the opportunity to become acquainted with the effects of weather on his work and on his supplies.

Working slowly and accurately towards advanced techniques is most advisable. Each simple design presents its own difficulties and these should be mastered before the more difficult ones are attempted. This method makes more certain the steady advancement by the artist in the decorative skills.

Learning to trace fine accurate lines for designs helps the artist by teaching him to use his hands in combination with a pen. He also acquires a much more vivid knowledge of the form and shape of the units. Before attempting to apply a design on any given object the article should be drawn on tracing paper in its accurate size. The design should be traced carefully and the dec-

orative units should be arranged so that they fit attractively within the space. Accurate tracing is also necessary when the design is applied to the surface to be decorated. The artist who practices the tracing technique with crow-quill pen and India ink also trains his hand to do his bidding for the more difficult etching of single lines and for cross-hatching on gold leaf for metal, wood, and glass.

CONTEMPORARY DESIGNS

TRAYS

Contemporary trays may be decorated to suit the fancy of the decorator, since no precedent has as yet been set and they are still not heirlooms. Do decorate them so that they can become heirlooms! Be skillful with your techniques and consider the forms and shapes of design units when applying them to the article. Protect your work against the ravages of time by varnish coats and wax. Do sign your work! Later generations will like knowing who decorated those pieces! Make a study of contemporary shapes and of those belonging to the past eras—do not confuse them!

ROUND WALL CLOCKS

These have become so commercialized today that they are produced in an assembly-line manner. They are copies of an old-time French clock which was made to look like a man's huge pocket watch. Genuine old clocks of this type are costly, while the modern decorated pieces are common and fairly inexpensive. It is not advisable to assemble one, for a clock specialist must install the clock-works and often the dial also must be painted by the artist, if it is to fit. It is altogether a costly proposition. The department-store product can be purchased, its design removed with paint remover and the fine finish and decoration of the old-time pieces applied.

REVERSE GLASS DECORATION

This can be applied to the under side of a glass table cover in a design suitable to the room it is to adorn. The old-fashioned wooden tray with its glass floor, under which grandmother placed her crocheted doily, could also be decorated. By painting the under side of the glass, the decoration is protected and yet the piece may be used freely. A picture of your own home or of some event in your life could be attractively recorded for your descendants. Follow all the required instructions and study the old-time reverse-painted glass panels of clocks and mirrors so that you acquire a first-hand knowledge of them before you apply your own good ideas!

EXPERIMENTS WITH SYNTHETICS AND MODERN SUPPLIES

New inventions and new and better supplies for artists and craftsmen are constantly appearing as a result of scientific progress. From the beginning of time until now there have been two types of decorative techniques: The lacquer era of the Orient which had its own formula and which was replaced by the papier-mâché, varnish, and paint era of the late seventeenth century in Pontypool, England. Today, we are on the threshold of a third period, that of plastic varnishes and other synthetics.

Varnishes

New types of varnishes are now available. There is the kind which must be chilled—the can must be immersed in ice while it is in use. This is a variant of the varnishes which give best results when they are heated and are applied on a warmed article. The DuPont de Nemours Company has also invented a plastic type of varnish which is colorless. It would be excellent to experiment with these on light or colored grounds over which painted decoration has been applied. If satisfactory, they would insure that the surface would remain its true color. At present these varnishes are used as surface finishes for boats. How they would react as coverings of the decorative pigments of today is not definitely known.

Paints

New types of paints are being produced by manufacturers who claim they can be applied directly on the clean, bare metal. These are poured on in the center and are sloshed over the rest of the area with a camel hair, mottler brush. They still require testing and articles painted with them need to be put to actual use before their true worth can be determined. It is best to experiment with these paints on an article of small value before they are used for articles upon which you have applied your decorative skills. These paints may not react favorably to some varnishes used for protective finishes or with the oil paints we use. This would prevent the artist from doing satisfactorily, if at all, such techniques as the one we call floated color with its accompaniment of veiling.

Decorating Plastic Surfaces

This may be another possibility. Composition board is highly satisfactory and may be used for book covers to hold magazines or pamphlets and for scrapbooks. This board should be painted as wood is. It will not warp or crack as wood often does.

WARNINGS

It is suggested that a few precautions should be kept in mind when new varnishes and paints are used. Do not interchange the varieties for this will cause a kind of crackling. Some types will even lift the base coats or cause them to curdle, even when the first coats are thoroughly dry. The natural slow-drying and fast-drying varnishes should never be used in combination with one another. Also, it is best not to combine the plastic with the resin varnishes. Manufacturers of new products claim their plastics can be used on other varnish surfaces. The decorator should experiment, but never with his most intricate pieces.

Some paints are called lacquer paints and require alcohol for diluting them. These should never be combined with paints which require turpentine to thin them. The two media will not work together favorably. Resin varnishes should never be applied over them, since these are of turpentine base. The results may be as heartbreaking as with shellac which, when used as a wood filler, may produce moisture beneath the paint and varnish coats even after it is thoroughly dry. If the article is placed in the sun, bubbles will result and the design is destroyed. (See Chapter I.)

SUITABLE DECORATION FOR MODERN PIECES

Design trends, typifying the thoughts and customs of the people, have evolved in each decorative period. There was the highly ornate period of French Rococo. Design was later simplified by the solemn thinking of Quakers and other religious sects. The Victorian era produced both good and ornate designs. These were sometimes almost confusing in their profusion. At present the trend in home decorations and its accessories is toward simplicity. Sometimes, this simplicity is almost hospital-like and institutional. Today, most surfaces are so devoid of decoration that they seem almost monotonous. Our ranch-type homes are based primarily upon the Oriental house of a single rambling floor. The rooms within this house are also spaced in very much the Oriental manner. The modern type of home in America presents a challenge to the decorative field. Decorating in the traditional manner requires skill and patience, augmented by a thorough knowledge of art forms, their good composition qualities and appropriate placement. Machine and assembly-line tactics can not produce what the individual artist is capable of accomplishing.

Appendix

WHERE TO BUY ARTISTS' AND DECORATORS' SUPPLIES

Stores in your own locality may carry the supplies you need. If they do not they doubtless will when the demand for them increases. The following list has been made for the reader's convenience; it is not intended as an advertisement for any of the stores mentioned but as a help for those living in outlying districts. Many of the dealers listed will send catalogues. Many of the stores listed here also carry trays and some also carry real silk-velvet squares.

ART STORES

Alexander's Paint Store,
137–02 Northern Boulevard,
Flushing, L. I., New York

Bordas Art Shop,
285 Huguenot Street,
New Rochelle, New York

The Conlin Company,
60–72 Elm Street,
Bridgeport, Connecticut

The Stone Co., Inc.,
19–21 Elm Street,
Danbury, Connecticut

E. P. Lynch, Inc.,
92 Weybosset Street,
Providence, Rhode Island

Nelson D. Thomas,
171 Grand Street,
White Plains, New York

Max Knoll (for stencil scissors),
94 Highland Avenue,
Highlands, New Jersey

Pearl Products, Inc.
 (for Mother-of-Pearl),
103 E. Glenside Ave.,
Glenside, Pennsylvania

Webb Products Co.
 (for Wood Dough and Metal Surfacer),
San Bernardino, California, also
Norcross, Georgia

Solo-Horton Brush Co., Inc.
 (for all kinds of brushes—send for
 complete catalogue),
940 Eighth Ave.,
New York 19, New York
Care of Mr. Victor H. Smith
Clifton, New Jersey

Hazen Paper Company
 (for "Hazenkote Black" paper),
Holyoke, Massachusetts

Gla-son Paint Products, Inc.
59 West 56th Street,
New York 19, New York

The Spellco Paint Co.,
544 Main Street,
Stamford, Connecticut

164

Novis Paint Co., Inc. (for velvet square),
182 Post Road,
Darien, Connecticut

Warm Brook Shops
(Decorated Woodenware),
Arlington, Vermont

M. Horowitz,
11 Cooper Square,
New York 3, New York

Whittemore's Art and Framing Shoppe,
Main Street,
Hanover, New Hampshire

Empire Artists' Materials,
135 East 60th Street,
New York 22, New York

The Artist Centre,
126 Main Street,
Worcester, Massachusetts

Park Studios,
P.O. Box 28D,
Arlington Heights 75, Massachusetts

J. T. Murphy Co. (Engravers)
(for Sig-nette),
409 W. Rockland St.,
Philadelphia, Pennsylvania

WHERE TO BUY TIN AND WOODEN
ARTICLES TO DECORATE

Period Art Reproductions, Inc.,
39 West 24th Street,
New York City, New York

The Village Tin Shop,
1030 Main Street,
Hingham, Massachusetts

Sidney M. Rogers,
Jewett Street,
Georgetown, Massachusetts

Adolph A. Adams,
316 East North Lane,
Conshohocken, Pennsylvania

The Kitchen Tinshop,
23 School Street,
Lisbon, New Hampshire

Hoitt and Wentworth,
559 Central Avenue,
Dover, New Hampshire

County Woodcraft Co. (for custom un-
painted furniture, including Hitchcock
and other period chairs, cornice boards,
etc.),
288 Huguenot St.,
New Rochelle, New York
Care of Mr. Charles Katz

The Tinker Shop,
142 West Main Street,
Milford, Connecticut

Mason & Sullivan,
45-55 158 Street,
Flushing 58, New York

Magnus Brush & Craft Materials,
108 Franklin St.,
New York 13, N.Y.

The Country Loft,
Newfields, New Hampshire

American Handicrafts Co., Inc.,
45-49 South Harrison St.,
East Orange, New Jersey

Bibliography

BOOKLETS, MAGAZINES, AND JOURNALS

Antiques Magazine (40 East 49th Street, New York 17, N.Y.)

American Decorated Chairs by Shirley Spaulding DeVoe (1946; available from the author, R.F.D. Bridgewater, Conn.)

Basic Instructions for Home Painting in the Early American Manner by Esther Stevens Brazer 1943, 1945, 1948; available from Dr. Clarence Brazer, "Innerwick," 31–07 Union Street, Flushing, N.Y.)

Britannica Booklet No. 1, Article on "Lacquer or Lacker" by Lt. Col. E. F. Strange, Victoria and Albert Museum.

The Bulletin (Bench and Brush Publications, Cohasset, Mass.)

Chinese Art (article in *Encyclopaedia Britannica,* 1929, 1930, 1932 editions)

Chronicle of the Museum for the Arts of Decoration of the Cooper Union (New York, N.Y., Vol. 2, No. 3, June, 1951)

The Decorator, Journal of the Historical Society of Early American Decoration and the Esther Stevens Brazer Guild (Miss Jean Wylie, 40 Fitch Avenue, Noroton Heights, Conn.)

A History of the Rise and Progress of The Arts of Design in the United States by William Dunlap (C. E. Goodspeed & Co., 3 vols., 1918, Boston)

How to Paint Tin by Shirley Spaulding DeVoe (available from the author, R.F.D., Bridgewater, Conn.)

How to Stencil Chairs by Florence E. Wright (1949; available from the author, Box 393, Ithaca, N.Y.)

Lacquer, Oriental and Western, Ancient and Modern, by Everett P. Lesley, Jr. (Cooper Union Museum for Decorative Arts, New York, N.Y., 1951)

Let's Begin Decorating by Edith Ordway Hall (available from the author, R.F.D., Alstead, N.H.)

Manual of Groundwork and Finishing by Morton Bartlett (Bench and Brush Publications, Cohasset, Mass., 1949)

Pennsylvania German Designs, A Portfolio of Silk Screen Prints, Index of American Design, The National Gallery of Art (The Metropolitan Museum of Art, New York, November, 1943)

Texts and illustrative panels on lacquer-making by Kojiro Tomita, Curator Asiatic Wing, Boston Museum of Fine Arts.

Books

American Decorative Wall Painting by Nina Fletcher Little (Old Sturbridge Village and Studio Publications, Inc., New York, N.Y., 1952)

American Folk Decoration by Jean Lipman (Oxford University Press, New York, N.Y., 1952)

American Pioneer Arts and Artists by Carl W. Drepperd (The Pond-Eckberg Co., Springfield, Mass., 1942)

Art in America by Suzanne LaFollette (Harper & Brothers, New York, 1929)

Artist's Handbook of Materials and Techniques by R. Mayer (The Viking Press, Inc., New York, N.Y., 1940)

The Book of Art and Painting by Cennino Cennini, translated by Christianna J. Herruyham (London, 1899)

The Book of Decorative Furniture (Its Form, Color, and History) by Edwin Foley (Dodge Publishing Co., New York, N,Y., 1924, 2 vols.)

Candleday Art by Marion Nicholl Rawson (E. P. Dutton & Co., Inc., New York, 1938)

Chinese Art by S. W. Bushell (Victoria and Albert Museum Handbook, Brentano's, Inc., New York, N.Y., 1919, 2 vols.)

Decorative Motives of Oriental Art by Katherine M. Ball (Dodd, Mead and Co., New York, 1927)

Dutch New York by Esther Singleton (Dodd, Mead and Co., New York, 1909.)

Early American Decorating Patterns by Peg Hall (M. Barrows and Co., Inc., New York, N.Y., 1951)

Early American Decoration by Esther Stevens Brazer (Tudor Publishing Co., New York, N.Y., 1940, 1947, 1950)

Early American Design Motifs by Suzanne E. Chapman (Dover Publications, Inc., New York, N.Y,, 1952)

Encyclopaedia of Ornament by H. Th. Bossert (Simpkin Marshall Ltd., London, 1937)

Epochs of Chinese and Japanese Art by E. F. Fenollosa (Frederick A. Stokes Co., New York, N.Y., 1911)

Folk Art, The Art of the Common Man in America, 1750-1900 by The New York Museum of Modern Art (W. W. Norton & Co., Inc., New York, 1932)

The German Element in the United States by Albert Bernhardt Faust (The Steuben Society of America, New York, 1927, 2 vols.)

History of English Glass Painting by Maurice Drake (McBride, Nast & Co., New York, N.Y,, 1913)

The Hobby Book of Stenciling and Brush-Stroke Painting by Raymond F. Yates (McGraw-Hill Book Co., New York, N.Y., 1951)

The Index of American Design by Erwin O. Christensen (The Macmillan Co., New York, N.Y., 1950)

India, A Short Cultural History by H. G. Rawlinson (D. Appleton-Century Co., Inc., New York, N.Y., 1938)

Introduction to Persian Art by A. U. Pope (Charles Scribner's Sons, New York, N.Y., 1931)

Lacquer Work (European) by G. Koizumi (Sir Isaac Pitman and Sons, Ltd., London, 1923)

New Geography of American Antiques by Carl W. Drepperd and Lurelle Van Arsdale Guild (Doubleday and Company, Inc., New York, 1948)

Notes on the Technique of Painting by Hilaire Hiler (Oxford University Press, New York, 1934)

The Painter's Methods and Materials by A. P. Laurie (J. B. Lippincott Co., Philadelphia, Pa., 1926)

The Patroon's Domain by S. G. Nissenson (New York State Historical Association Series, Number V, Columbia University Press, New York, 1937)

The Pennsylvania Dutch by Fredric Klees (The Macmillan Company, New York, 1950)

Pennsylvania Dutch Art by Ruth Adams (The World Publishing Company, Cleveland, Ohio, 1950)

Pennsylvania Dutch Stuff by Earl F. Robacker (University of Pennsylvania Press, Philadelphia, 1944)

Pennsylvania Folk Art—An Interpretation by John Joseph Stoudt (Schlechter's, 128 N. Law Street, Allentown, Pa., 1948)

Pennsylvania German Illuminated Manuscripts by Henry S. Borneman (The Pennsylvania German Society, Norristown, Pennsylvania, 1937)

Pioneer America, Its First Three Centuries by Carl W. Drepperd (Doubleday & Company, Inc., New York, 1949)

The Planting of Civilization in Western Pennsylvania by Solon J. Buck and Elizabeth Hawthorn Buck (University of Pittsburgh Press, 1939)

The Technique of the Great Painters by A. P. Laurie (Carroll and Nicholson, London, 1949; available from British Book Centre, New York, N.Y.)

A Treatise of Japanning and Varnishing by John Stalker (1688; available for consultation at Library of Congress, Washington, D.C.)

Index

abrasives (*see also* sandpaper), 15, 19, 20
acanthus (*see also* scroll borders):
 Dutch, English types, 150, 151
 gold-leaf accented, 44, 156, 157
 leaves of, *12, 47*
 as a scroll, 44, 90, 99, 157
 stenciled, 89, 90, 148–150
accessories, household, 17, *54, 61,* 69, 74, *77,* 82, 102, 105, *107, 114–122, 127,* 128, 132–143, 146
acetate sheeting, 32, 160
alcohol, 2, 7, 163
alizarin crimson, 10, 24, 57, 71, 93, 94, 122, 126–129, 153
aluminum (*see also* palette):
 foil, 21, 22, 96, 134
 leaf, 26
 lining powder, 26, 36
 metal, preparation of, 6
antiquing, 24, 56, 57
apple dish, the, 116
artist oils, *see* oil paints, tube
asphaltum, 8, 9, 10, 118, 119

backgrounds,
 asphaltum, 8, 9, 118
 clouded (*see also* stencils, silhouette), 13, 36, 94, 95
 colors to paint over, *52*
 equipment for, 29, 33
 gilded (*see also* bands), 12
 glass, reverse painted, 139–142
 japanned, 6, 7, 78, 79, 84–86, 116–119, 140

backgrounds, (cont.): light colors, 9, *59–61, 70*
 natural wood, 7, 8, *55,* 78
 paint consistency for, 2
 smoked, 8, *9, 16,* 62
 smudged, frontispiece, *13–17,* 36, 155
 tacky, 78, 79, 84, 85, 140
 tortoise-shell, 10, 11, *39,* 146
 white, 7, *49, 53,* 54, *60,* 62
bands (*see also* backgrounds):
 black, 7, 8, *60,* 78, 92
 bronzed, 35, 36, 38, *59-64,* 95
 colors, painted, 38, 62
 gilded, *12,* 35, 36, 38, 61, 64
 painted, on glass, *135, 136, 138,* 141
 stenciled, 35, 36, 62
 white, 118, 119
Batard Gothick, 112
bellows, *9, 53,* 77
benzine, 1
black service-seal, used for:
 antiquing, 24, 56, 57
 backing gold-leaf on glass, 136, 137, 142
 brushstrokes, *60*
 dry bronzing into, *27, 59, 60*
 glass, painted details, 138–139
 heirloom design types, 155
 laying metal leaf, 24, 46
 stenciling bands on color, 62
 wet-bronzing, *59,* 64, 65, 70
blemishes (*see also* bubbles):
 metal-leaf, 12, 44, 55–66, 157
 varnish, protective, 17–20

Italic page numbers refer to illustrations.

blue, Prussian, 24, 57, 93, 153, 155, 156
Boltzen, book of, 112
Boraxo, cleaning brushes with, 30
boxes:
 adorned, 76, 77, 102, 116, 121
 carry-all, metal, 21, 22
Brazer, Esther Stevens, 121, 160
"Bristoe"-American borders, 73, 92
bronze powders (see also palette):
 blending shades of, 81, 86, 91
 freehand bronzing with, 58–73, 156
 glass, reverse decoration, 140
 lining shades, 26–28, 53, 88, 156, 157
 minimum use of, 87
 polishing the, 81, 83, 86, 141
 preventing scattered dust, 140
 shading gradually off, 81, 156
 stenciling with, 75–95, 134, 140
 striping with, 35–38
 tradition of decorated wood, 93
bronzing, history of, 158
bronzing, wet, 59, 64–66, 156
brushes (see also warnings):
 asphaltum, 9
 care, preparation, storage, 22, 27, 30, 31
 dull-finish varnish, 20
 duster, metal-leaf, 29, 30
 gilder's tip, 141
 Hour varnish, 20
 loading artists', 154
 poster, Grumbacker, 151, 154
 quills, see French quills
 red sable short, 28, 29, 94, 151
 script-scroller, 28, 29, 104, 139, 154, 155, 157
 show-card, 28, 29, 94
 Spar varnish, 29, 31
 stripers, 29, 106, 107
 stroke ox-hair, 29, 31
 water-color, 28, 158
brushstrokes:
 accents of, 14, 47, 59, 62, 65, 66, 94, 99, 100, 104, 105, 128, 148–9, 155–7
 border-forming, 39, 61, 69, 99
 combinations of, 45, 47, 48, 99
 continuous S-stroke lines, 45, 99
 elongated S-strokes, 45, 99
 lace-edge type, 39, 158
 left-to-right strokes, 45, 98
 preparing paint for, 96, 97
 repeat-formation stroke, 99, 122
 right-to-left stroke, 45, 98

brushstrokes, (cont.): rules for, 96, 97
 slim-long-line stroke, 45, 98–100
 straight strokes, 45, 98
 superimposed, 53, 99, 100, 122, 128
 wide leaf-forming stroke, 45, 98
brushwork, American, history of, 110–126
bubbles, varnish, 18, 86, 140
burnt umber, see umber
buttons, see velvet, knobs

caddies, cannisters, 54, 103
cans, disposable, 18, 21
caps, bottle, disposable, 21
Carbona, 1, 18, 32, 45, 85, 137
carbon papers, 41
carving, 114, 115
certificates, 112–114
chair, Hitchcock, 82
charcoal stump, 27, 60, 64, 66, 67, 70, 156
chests, dower, 116, 117
China, 43, 74, 112, 114, 145
Chippendale painting:
 brushwork, 96, 99–101, 149, 151–154
 correct design for, 14, 15, 41, 47, 48, 160
 leaves of, 155, 156
chrome yellow, see yellow
Clay, Henry, the japanner, 143
clock types, 69, 87, 133, 134, 161
clouding, see backgrounds
coffin trays, see trays
construction of trays, 38, 143–147
cornices, 54, 59, 76, 77, 92, 93
cotton, absorbent, 137, 142
country-tin painting, 37, 76, 99, 103, 108, 116–130
cross-hatching, see etching
curlicues, 16, 47, 48, 69, 104, 129, 149

design planning (see also drawings), 34–43, 79, 80, 160, 161
document boxes, 116, 121, 122
double-bordered trays, 49, 148
drawings, 35, 41–43, 160, 161
Drepperd, Carl W., quoted, 112–114
drying-time requirements for:
 acanthus-scroll tipping, 157
 floated color, 153, 154, 156
 foundation units, 151, 152, 156
 metal-leaf laying, 52
 mother-of-pearl inlay, 52
 veiling over floated color, 154
dull-finish varnish, 18–20

Italic page numbers refer to illustrations.

dust particles, avoidance of, 86
Dutch, 111, 150

East India Company, 110, 111
edging, *see* glass decorating, metal leaf
embossment, gesso, lacquer, 43
enamel paint (*see also* glass painting *and* Plax), 22, 139, 140
eraser, artgum, 34
erasures, with Carbona, 18, 32, 34
etching (*see also* gold-leaf):
 cross-hatching, *32, 47-49, 51-55*
 imitations of, 50, 51
 metal-leaf on glass, 141
 single-line, 32, *47-51, 53, 55*, 59, *61*
 tools for, 31, *32*, 134, 141, 142

fillers (*see also* wood dough), 1-3
finger-painting method, for:
 blended sky effects on glass, 140
 rubbed paint on white, 126, 128
finishes (*see also* abrasives *and* varnishing), 1-8, 10-20
flat oil paint (*see also* paint remover):
 background types, 62, 116
 cans of, 2
 tubes and their storage, 23
floated color (*see also* foundations *and* veiling):
 how to apply (*see also* slow varnish), 153, 154
 leaves of, 156
 transparent colors for, 24
flowers, decorative:
 dry-bronzed, 13, 63, 67, 68, 71, 72, 148
 floated, 14, 15, 39, 47, 48, 51, 108, 145, 146, 149, 151, 153-155, 158
 gold-leaf, 48, 49
 painted, 53, 99, 100, 121, 122, 145, 146
 stenciled, 16, 36, 68, 72, 75, 87, 90
flowers of heirlooms, 14, 51, 52, 149
foliage, decorative, 75, 100, 139
foundations:
 English vermilion units, 151
 metal-leaf units, *52*, 148, 152
 modeled white, *see* modeling
 pearl, *see* mother-of-pearl
Fractur, 12, *113, 114*
freehand-bronzing:
 backgrounds for, *9*, 59, 61-64

freehand-bronzing, (cont.): black service-seal and, *9*, 24, *54, 59, 60*, 62
 Chippendale, *27, 47, 48*, 63, 100, 148, 156
 media for, 63, 156
 monotone decoration of, 61, 62
 overlapping units of, *9, 55*, 64, *69*
 scenic types, 59, 60, 62, 70, 76, 77
 techniques with, 9, 13, 55, 61, 62, 69, 72, 75-77, 93, 94
 types of units, how to do, 66-71
French in America, 111
French quills:
 short-pointed, 28, *29*, 104
 short stubby, 28
 sizes, uses of others, 28, *29*, 96
 square-tipped, No. 2, *29*
 doing veiled accents, 151, 154
 dry-bronzing with, 66
 fine details, 104, 105
fruits, decorative:
 dry-bronzed, *9, 12, 54, 55*, 66, *69*, 75
 lace-edge type, *40, 70*, 106
 stenciled, *36, 55*, 75, 77, 86-88
fur, effects of, on glass, 139

gelatine size, 136, 137
German, Pennsylvania, 111, 112, 125
glass decorating, reverse, on panels:
 advance preparation, 137
 brightly colored units of, 139
 decorative motifs, 126, 133, 136, 138, 139
 enamel paint for, 139
 equipment, supplies, 134-142
 finger-painting, to blend, 140
 history of, 132
 line detail, 137-139, 141, 142
 metal-leaf decoration:
 application of, 141, 142
 backing units of, 137, 142
 drainage of size, 141
 edged units, 136, 137, 141-142
 etching of, 142
 size for, how to use, 136, 137
 painted glass, 126, 134, 136, 137-140, 149
 placement of panels, 133
 sky effects, 139, 140
 stenciling on, 126, 134, 140, 141
 techniques combined, 139-142
glazing, *see* floated color
Italic page numbers refer to illustrations.

glitters, 15
gold leaf:
 bands of, *13*, 71-73, 92, 94
 borders, *16, 17, 39, 40, 54,* 71-73, 92,
 148, 157
 brushing off excess, 29, 30, *32*, 50
 corrections, *see* blemishes
 details, *13*, 41, *47, 52, 53*, 101-105, 148,
 157
 etched, *see* etching
 fundamentals of, 44-49
 gilded grounds, 12
 handling of, *32*, 44, 45
 history of, 43
 laying of, 32, 44, 49, 50
 media for laying (*see also* glass, size), *32*,
 46-49, 136, 137
 mounted kinds, 25, 44
 paint consistency for laying, 46
 Sig-nette, *see* Sig-nette
 stenciling with *91*, 94
 storage of, 44
 styles of, *14, 53, 55,* 148
 supplies for, 32
 techniques combined, *51*, 75, 93, 157
 tools for, 31, *32*, 46-48, 83-85, 137,
 142
 transparent color, *see* washes
 turnbacks of leaves, *68*
 unmounted, 25, 32, 45, 131, 136, 141
 waste, avoidance of, 25, 49, 50
grains, wood (*see also* fillers):
 filling pores, 1, 2
 natural, simulated, 7, 8, 78
green shades, mixtures for:
 Chippendale, 100, 153, 155, 156
 country-tin, 116-130
 lace-edge, 155
ground in japan, *see* flat oil paint

Hanbury Mills, 146
hand screens, 145
Hazencote, *see* paper
Hour varnish:
 asphaltum and, 9, 10
 brush for (*see also* warnings), 20
 Man O'War Varnish and, 3, 9, 10, 17,
 18, 157
 protective coats of, 10
 when not to use, 17, 18
Hubball, Thomas, 58, 59
Huguenots, French, 111

Indian yellow, *see* yellow
ink, India, 31, 35, 41, 53, 83, 137, 138
ivory black tube paint, 63, 155

James I and the Puritans, 111
Japanese decoration, 4, 43, 74, 75
japan paints, *see* flat oil paints

Kauffmann, Angelica, artist, 146
kidney-Chippendale trays, 14, 144
knobs, *see* velvet
Knox Gelatine, 136, 137

lace-edge painting (*see also* wax, medium):
 appropriate decoration for, 160
 brushes for, 28, 158
 colors of, *40*
 gold-leaf decoration, *39, 40,* 148
 history of, 145, 146
 leaves, how to do, 155, 158
 modeling flowers, 154
 nosegays, 39, 40, 100, 145, 146, 149,
 155, 158
 stripes for, *see* striping
 tortoise-shell grounds, 10, *11*
 veiling, contrasts of, 154, 158
lacquer, Oriental, 3-5, 43, 58, 143
 history of, 3, 43, 58
lamp black, 63
landscape decoration:
 cornice boards, 76, 77, *92*, 93
 glass panels, 133
 pastoral, rural, *54, 60,* 69, 70
lard oil, *see* oil
leaves, decorative (*see also* veins):
 acanthus, *see* acanthus
 Chippendale, *14, 15, 47, 48,* 151, 155,
 156
 freehand-bronzed, *16, 59, 67-69*
 lace-edge, 155, 158
 metal-leaf, *12, 39, 40, 47,* 56, 99
 painted, 28, 99, *100*
 stenciled, *36, 68, 84, 87,* 89, 91
Lehn, Joseph, wares of, 114, *115*
lemon oil, *see* oil
line etching, *see* etching
linen, architects' tracing, 31, 83, 84, 134
linseed oil, *see* oil
lithopone powder, 41, 157
Lititz, Lancaster County, Pa., 114

mahogany, stenciling on, *55,* 78

Italic page numbers refer to illustrations.

Man O'War varnish, *see* Hour varnish
masking tape, 41, 83, 137
metal leaf (*see also* gold leaf):
 palladium leaf, 25, 51, 153
 silver leaf, 25
mixtures of tube oils:
 country-tin, 122–129
 general rules for, 23, 24, 96–99
 shades of heirlooms, 149–158
 stripe colors, *see* striping
modeling (*see also* foundations):
 built-up processes, 39, 150, 154
 white units, 39, 151, 156
mohair velvet, *see* palette
mother-of-pearl:
 imitations of, 153
 inlay of, *123,* 152, 153
motifs, decorative:
 acorn, 59, 69
 basket, 14, 75, 77, *91, 126,* 148
 birds, *15–17, 40, 41, 51,* 59, 77, 92, *93, 107,* 148, 150
 classic, 44, *54, 55,* 75, *88,* 89, 90, 93, 94, 99, 148
 clouds, 60, 70
 cockatoo, Dutch, 151
 cornucopia, 54, 75, 84, 148
 flower, *see* flowers, decorative
 fountains, *14*
 fruit, *see* fruits, decorative
 heart, *105,* 120, 122
 house units, *60, 80*
 Indo-Persian, 112, 120, 121
 leaves, *see* leaves, decorative
 peacock, 120
 Pennsylvania-German, 105, 120–122
 portrait type, *40*
 pot-of-earth, *117,* 120
 seaweed details, 150
 sheep and shepherd, *60,* 69, 70
 shell, 49, 72, 91
 star, 120
 train, *80*

needle etchers, 31, *32,* 137, 142
needles, types:
 cutting dots in stencils, 85
 etching leaf on glass, 137, 142
 piercing linen, 83, 84
Neville, George, designer, 91
nosegays, *see* lace edge
nylon stocking, 9, 10, 134

oil:
 lard, for brushes, 30, 31
 lemon, rubbing down with, 19, 20
 linseed (*see also* slow varnish), 2, 3, 19, 23, 140
oil paint, tube (*see also* mixtures of tube oils):
 japan, *see* flat oil paint
 opaque, 2, 3, 24, 139, 149, 150, 155, 156
 semitransparent, 24, 150, 151, 154
 storage of, *22,* 23
 transparent, 24, 139, 140, 149, 150, 153, 155, 156
 white, *see* titanium white

paint (*see also* flat oil paint *and* oil paint, tube):
 black, 6, 63, 116, 152, 153
 diluting, 7, 23, 105
 enamel, *see* enamel paint
 simulated graining, 7, 8
 straining of (*see also* nylon), 9
paint remover, 1, 161
Palatinate Germans, 111, 112
palette, types of (*see also* velvet):
 aluminum foil, 21, 96, 134
 mohair, bronzing, 22, 26, 27, 81
 paper, 21, 45, 96
palladium, *see* metal leaf
panels, black on grains, 7, 8, 78
paper:
 Hazencote, black, 160
 stencil-board, 83
 tracing, 31, 41, 134
 wax, 21, 45, 96
papier-mâché, 143, 147, 150
Payne's gray, 36, 93, 94
pencils:
 lead, black, 34, 41
 silver, Eagle brand, 34, 79, 80
Penn, William, deeds of, 112
Pennell, Elizabeth R., quoted, 111
pens, types of:
 architect's ruling, 35, 47, 48, 53, 101
 croquille, 31, 32, 35, 83, 105, 137, 138
 small ball point, 48, 105
penwork, Italian book of, 112
piano type stenciling, *55,* 78
Plax, enamel, 48, 105
Pontypool, *12, 54,* 61, 73, 92, 146–148
pots (coffee, tea), *54,* 116, *117, 120, 122, 124, 125, 127,* 149

Italic page numbers refer to illustrations.

173

pouncing:
 foliage effects, *80,* 100, 101, 139
 paint mixtures for, 101, 139
 tools for, *22,* 100, 101
primers, metal, 6, 152
printed designs, *71*
protective varnish (*see also* varnishes):
 antiquing with, *see* antiquing
 background protection, 8, 10–12, 64
 before striping, 18
 cover for delicate work, 38, 76, 77, 157
 over finished work, 17–20
 smoothing of (*see also* abrasives), 10, 18–20, 157
Protectoid, 32
Prussian blue, *see* blue
pumice (*see also* abrasives), 19, 20
punch, dental rubber dam, 85

Quakers, doctrines of, 112, 163
Queen Anne, 145, 150
Queen Elizabeth I, 145, 150

razor blade, 27, 83, 84, 134
Rembrandt, 150
remover, paint, *see* paint remover
Renaissance, late English, 145
Revere, Paul, 111, 112, 145
reverse painting, *see* glass
ridges, how to avoid:
 brush, in paint, 7, 153
 on glass (*see also* varnishing, drips), 140
Rococo, French, 94, 145, 163
Roman art, and Adam brothers, 146
rottenstone, 19, 20
Rubens, 150
ruler (*see also* striping), 34
Runes, Dagobert, quoted, 110
Rust-i-cide, 5, 6

sandpaper, wet-dry, 5–8, 12, 16, 19
Schrickell, Harry G., quoted, 110
scissors, for stencil cutting:
 embroidery, 3, *27,* 31, 83–85, 152
 manicure, *27,* 31, 83–85, 134, 152
Scotch tape, 41, 134, 140
scroll borders, *15,* 99, 148
service-seal, clear, 17
shellac, 1
sienna, burnt, 24, 153
sienna, raw, 24, 93, 153
Sig-nette, 25, 49

silhouette, *see* stencils
single-bordered trays, 35, *36–38*
size, metal-leaf, 136, 137
slow varnish, 140, 153, 154
Spar varnish (*see also* varnishes):
 handling, 3, 17, 18, 30
 leveling quality of, 97, 128
 properties of, 3, 7, 8, 17–20, 23, 46–48, 63–65, 78, 79, 86, 140
 special brush for, 30, 31
 tube oil paints and, 96–130, 151, 153, 157
squiggles, *12, 13, 53, 69,* 101
steel wool, 5
stenciling (*see also* bronze powders):
 backgrounds for, *see* backgrounds
 basic principles of, 78–83
 borders of, 62, 148
 classic motifs, *84,* 90
 highlights of, *84*
 history of, 74, 75
 large trays, how to do, 79
 other techniques with, 94
 perspective of units, *55,* 64, *84*
 piano type, *55,* 78
 polishing design units, *55,* 81, 86
 reverse, *see* glass painting
 scenes of, *80,* 92, *93*
 shading of, 54, 59, *77,* 81, 86–91, 141
 tacky surfaces for, *see* tackiness
 tools, *see* palette *and* velvet
 tray types for, 76, 148
stencils (*see also* stenciling):
 adherence to varnish, 81, 140
 cleaning, 85, 140
 contour-forming, *70,* 79
 conventional, *59,* 90
 cutting, 27, 31, *75,* 78, *79,* 83–85
 dots, to cut, punch, 85
 how to use, 81, 83
 margin requirements of, *27,* 83
 placing stencils for bronzing, 79, 80
 repeat unit, *9, 60, 84,* 91
 silhouette, *13, 36, 87,* 89, 90, 94, 95
 single-fitted units, 86–90
 storage of, 83–85
 tools, *see* scissors *and* razor blade
 tracing units on linen, *27, 79, 80,* 83, 84
stippling, *22, 51,* 100, 101, 137, 139, 141
striping (*see also* brushes):
 artists' oil paints and, 35–38, *59*

Italic page numbers refer to illustrations.

striping, (cont.): bronze powder, *12, 13,* *35, 36,* 38, *54, 84,* 100
 Chippendale, 38
 country tin, 37, 130
 erasing errors, 18, 34
 flanges of trays, 35–38
 flat oil paints and, 23, 106
 floors of trays, 35, 38, 95
 glass panels, 137–139, 141
 gold-leaf, 38, 95, 106
 guide lines for, 34, *35,* 79, 80
 how to do, 38, 106–108
 lace-edge trays, 38
 mixtures, paint, 35–38, 95, 106
 spacing, widths, *12,* 36–38, 62, 108
 stenciled types, 35, 38
 tools for, 34
 white, *12, 13, 53, 60, 69*
stump work, *see* charcoal stump
stylus, 33, 41, 42, 137
Supersee, 32, 160
surfacers, metal (for repair), 6
surfaces (*see also* backgrounds):
 metallic, 5, 6, 143, 147, 150
 wooden, 1–5
Swiss, in Pennsylvania, 111, 112

tackiness, degree of, for:
 freehand bronzing, 63–70, 156
 metal-leaf laying, 46–50
 stenciling, 78, 79
tack-rag, the, 3
talcum powder, 157
titanium white, used for:
 accents on gallery trays, 148
 bands, *see* bands
 bird tails, *15*
 brushstrokes, decorative, *69*
 detail highlights, 29, *59, 69,* 155, 156
 heat-resistance of, 23, 150
 lace-edge nosegays, *see* nosegays
 line work, *53*
 modeling with, 151
 semitransparency and opaqueness of, *14, 51,* 150, 151
 striping with, 38
 superimposed brushstrokes, 122, 126, 128, 129
 veiled accents, *see* veiling
 water effects, *14*
tortoiseshell, *see* backgrounds
Tracelene, 32, 160

tracer, leather, 33, 41, 42
tracing paper, *see* paper
transparent paint (*see also* washes), 53
trays (*see also* construction):
 bread, *54, 100*
 card, *52*
 Chippendale, 14, 38, 46–48, 76, 99, 143, 149
 coffin, *37, 101, 104,* 116
 contemporary types, 76
 cut-corner, 38, 61, 76, 116, 146–149
 gallery, 38, 99, 146–148
 lace-edge, 38, *39,* 76, 99, *107,* 145, 148–149
 oblong, 35, 36, 49, 145, 147, 148
 octagonal, *59,* 76, 146–148
 Queen Anne, 76
 rectangular, *12, 51,* 61, 76, 147, 149
 Sheraton oblong, 145–148
 snuffer, 116
 Victoria, scalloped, 144, 145
 Windsor, oval, *16, 40,* 149
tube oil paint, *see* oil paint, tube
turpentine, spirits of:
 for cleaning brushes, 30
 for thinning paints, 3, 7, 23, 105

umber:
 burnt, 21, 24, 62, 93, 138, 139, 148, 153, 156
 raw, 24, 56, 57, 99, 148–155, 158
urns, coffee, 149

varnishes (*see also* brushes):
 fast-drying, 3, *27*
 Hour, *see* Hour varnish
 Man O'War, *see* Hour varnish
 plastic types, 162
 rubbed effect, 18, 20
 slow, to mix, *see* slow varnish
 Spar, *see* Spar varnish
 Super-Valspar, 3, 17, 18
varnishing (*see also* tack-rag):
 drips, avoidance of, 18, 19
 flowing way of, 78, 79, 85, 86
 for stenciling on glass, 138, 140
 leveling freshly done pieces, 154
 preparing articles for, 18
 warming of article and varnish, 14, 18, 140
Vaseline (*see also* oil, lard), 30

Italic page numbers refer to illustrations.

veiling (*see also* floated color *and* modeling):
 applying on wet floated color, 51, 154
 effect on heirloom types, 14, 149
 superimposed strokes of, 51, 99
 units for, 51, 150, 156
veins (*see also* leaves):
 freehand bronzed, *67,* 156
 painted, *15,* 56, *69, 70,* 99, 155
 stenciled, *77,* 84, *87,* 89
velvet, real silk (*see also* palette, mohair):
 knobs of, *27,* 64, *65–70,* 90
 rayon, static of, 27
 squares of, 27, 64–70, 81, 90, 134
vermilion, English, 23, *41, 59, 60,* 99, 122, 125–128, 151, 154, 155
Victorian period, *92,* 147, 163

warnings:
 bronzed articles, wash before varnishing, 16, 64
 brushes, for special work, never interchange, 17, 19, 30, 163
 Carbona, never use on glass, 137
 Carbon-paper, never trace with, 11, 42
 general, 163
 turpentine,
 never erase with, 18
 never interchange with alcohol, 2, 163
 never use synthetic type, 3
 varnish and varnishing,

warnings, (cont.): never dilute gummy, throw out old, 18, 97
 never interchange kinds, 17, 18, 163
 use Hour varnish only for special work, 17, 18, 157
 wax paper, never use as a paint palette, 96
washes, transparent color, over:
 freehand-bronze, on tin, 71
 metal-leaf, 94
 modeling, *16, 51*
 stenciling on tin, 87, 89, 92–94
 tradition of, for wood, 71
wax, for added protection, 20
wax medium, and tube oils, 158
white, *see* titanium white
wood (*see also* backgrounds):
 absorption of linseed oil by, 2, 3, 19
 preparation of, for japanning, 1–4
wood dough, 2
wooden articles, *see* accessories
wood paste, 3

"XX Gold-Leaf for Gilding on Glass," 136, 141

yellow (*see also* oil paint):
 chrome, 23, 129, 156
 Indian, 24, 93, 153, 154, 158
 lake, 24, 153, 158
 ochre, 23, 149, 154, 155

Zucchi, artist, 146

Italic page numbers refer to illustrations.

176